INSTALLATION ART AND THE MUSEUM

Installation Art and the Museum

Presentation and Conservation of Changing Artworks

VIVIAN VAN SAAZE

Amsterdam University Press

This book is published in print and online through the online OAPEN library (www.oapen.org)

OAPEN (Open Access Publishing in European Networks) is a collaborative initiative to develop and implement a sustainable Open Access publication model for academic books in the Humanities and Social Sciences. The OAPEN Library aims to improve the visibility and usability of high quality academic research by aggregating peer reviewed Open Access publications from across Europe.

Cover illustration: *ensemble autour de MUR* (1998) by Joëlle Tuerlinckx. Collection Stedelijk Museum voor Actuele Kunst (S.M.A.K.), Ghent, Belgium. Installation view 2003 at S.M.A.K. Photo by Dirk Pauwels. Courtesy photographer and S.M.A.K. © Joëlle Tuerlinckx

Cover design and lay-out: Sander Pinkse Boekproductie, Amsterdam

ISBN 978 90 8964 459 6
e-ISBN 978 90 4851 751 0 (pdf)
e-ISBN 978 90 4851 752 7 (ePub)
NUR 751

For Kaat

Contents

Acknowledgments

For giving me the opportunity to write this book, I thank the Faculty of Arts and Social Sciences (FASOS) at Maastricht University and the Netherlands Institute for Cultural Heritage (ICN) (now part of the Cultural Heritage Agency of the Netherlands (RCE)). Many colleagues at FASOS and RCE contributed to this research. I warmly thank you all for the many insights and constructive feedback. I am especially grateful to Renée van de Vall, Rob Zwijnenberg, and IJsbrand Hummelen, who have been invaluable during the process of research and writing. I thank you for your trust, encouragements and sharp minds. Special thanks also to Tatja Scholte, Pip Laurenson, Glenn Wharton and Sherri Irvin for commenting on earlier versions of the manuscript. I am indebted to Maaike Groot and Chantal Nicolaes for their guidance and support throughout the production phase of this book.

Furthermore, I want to express my sincere gratitude to all those involved in the Inside Installations research project for allowing me to integrate into their work and who took time out of their busy schedules to give interviews. In particular, I would like to acknowledge the museum staff of MMK in Frankfurt am Main, Bonnefantenmuseum in Maastricht, S.M.A.K. in Ghent and Van Abbemuseum in Eindhoven. It was a great pleasure to be part of your worlds and I shall be looking forward to follow future developments in the field. I am grateful to be able to continue this line of research and thank my colleagues of the research project New Strategies in the Conservation of Contemporary Art – Renée van de Vall, Deborah Cherry, Tatja Scholte, IJsbrand Hummelen, Hanna Hölling, Sanneke Stigter, Angela Matyssek, Annet Dekker, Panda de Haan and Paolo Martore – for the many fruitful conversations far beyond the edges of this book.

This book started out as a PhD project and parts of the case study research have been published in: J. Noordegraaf, C. Saba, B. Le Maître & V. Hediger

(eds), *Preserving and Exhibiting Media Art* (Amsterdam University Press, 2013); *The Electronic Media Review* (American Institute for Conservation of Historic and Artistic Works, Vol. 1, 2012); E. Hermens & T. Fiske (eds), *Art, Conservation, and Authenticities/Material, Concept, Context* (Archetype Publications, 2009); *Revista de História da Arte* (no. 8, 2011) and *Krisis: Journal for Contemporary Philosophy* (no. 1, 2009).

This book would have been far less colourful without the dedication and persistence of Kitija Vasiljeva, who helped in collecting illustrations and preparing this publication. For assistance with illustrations, I would also like to thank: Barbera Brakel; Agnes Brokerhof; Miguel-Ángel Cárdenas; Peter Cox; Evelyne Snijders; Joëlle Tuerlinckx and Corinne Giandou; Jochen Saueracker; Joe Scanlan; Carlos Ascurra at De la Cruz Collection, Miami, Florida; Christiane Berndes and Margo van de Wiel at Van Abbemuseum, Eindhoven, the Netherlands; Carole Billy at Marian Goodman, Paris, France; Ashley Brown at Casey Kaplan Gallery, New York; Géraldine Convert at Air de Paris, Paris, France; Caroline Dumalin at Galerie Micheline Szwajcer, Antwerp, Belgium; Tony Izaaks at Esther Schipper, Berlin, Germany; Dirk Pauwels at s.m.a.k., Ghent, Belgium; Bart Rutten and Hetty Wessels at Stedelijk Museum, Amsterdam, the Netherlands; Thomas Schröder at mmk, Frankfurt am Main, Germany, and Gaby Wijers at nimk, Amsterdam, the Netherlands.

The research and publication of this book has been made possible through collaboration between the Cultural Heritage Agency of the Netherlands (rce) and the Faculty of Arts and Social Sciences, Maastricht University. Other publications by the Knowledge Department Moveable Heritage, rce include *pur Facts: Conservation of Polyurethane Foam in Art and Design* (Amsterdam University Press, 2011), *Inside Installations. Theory and Practice in the Care of Complex Artworks* (Amsterdam University Press, 2011), *Victory Boogie Woogie uitgepakt* (Amsterdam University Press, 2012), *Art and Allegiance in the Dutch Golden Age* (Amsterdam University Press, 2012), and *The Artist Interview – For Conservation and Presentation of Contemporary Art: Guidelines and Practice* (Jap Sam Books, 2012).

Challenges of Installation Art

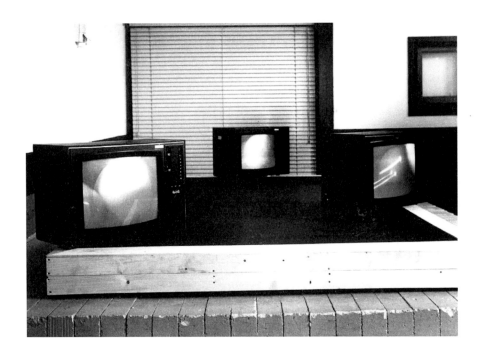

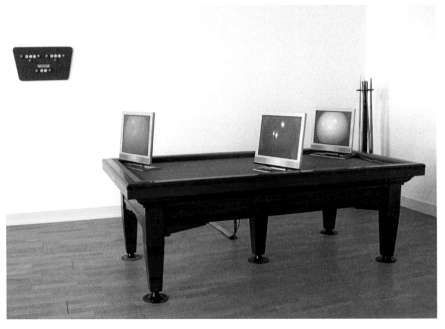

FIG. 1 – One of the earliest presentations of *25 Caramboles and Variations: A Birthday Present for a 25 Year Old* (1979) by Miguel-Ángel Cárdenas. Salon O, Leiden, the Netherlands 1980.
FIG. 2 – *25 Caramboles and Variations: A Birthday Present for a 25 Year Old* (1979) by Miguel-Ángel Cárdenas at the Netherlands Media Art Institute/Montevideo Time Based Arts (NIMk) in Amsterdam 2003. For this instalment a billiard table and flat-screens were rented.

This black-and-white picture was taken during an exhibition in 1980 at Salon O, a former exhibition centre in Leiden, the Netherlands. [figure 1] It is a picture of the work *25 Caramboles and Variations: A Birthday Present for a 25 Year Old* (1979) by Miguel-Ángel Cárdenas. We see three rather big monitors on a wooden construction suggesting a billiard table. The films on the monitors show billiard balls rolling from one screen to the next. Originally, in 1979, the images of the billiard balls were shot on black-and-white film and these images were shown on monitors placed on a real billiard table in a pub in Amsterdam. The work was, as the title indicates, a birthday present for a friend: a live event during an opening of an exhibition in a gallery near that same pub. A year later, the artist was able to shoot the images in colour film, and so he did. By that time the work had been acquired by the Stedelijk Museum in Amsterdam: three U-matic tapes and a very brief description of the work. Over the years, it was presented on several occasions and in diverse manners. Each time, the work looked very different. On one occasion, for example, the monitors were placed in the corners of an exhibition space. In this particular display, the surroundings of *25 Caramboles* became part of the work; the spectator entered, as it were, the game of the billiard balls, rolling from one corner to the other.

In 2003, nearly twenty-five years after its first presentation in the pub, the work was on loan and reinstalled at the exhibition *30 Years of Dutch Video Art* at the Netherlands Media Art Institute/Montevideo Time Based Arts (NIMk) in Amsterdam.[1] As a researcher at the Cultural Heritage Agency of the Netherlands, I was, at the time, asked to join the NIMk team in their research for this exhibition. Working closely with the head of collection, the head of conservation, the curator of the exhibition, the artists involved and the technicians, my task was to trace the histories of a number of these installations and to make an analysis of their conservation problems.[2]

For the occasion of the exhibition at NIMk, a billiard table was rented and placed in the gallery space. [figure 2] *25 Caramboles* was represented

1 The exhibition, a survey of Dutch video art from 1970 to 2000, was on display from January 11 through March 8, 2003. See also the accompanying publication *The Magnetic Era: Video Art in the Netherlands, 1970–1985* (Boomgaard and Rutten 2003).

2 The research on these installations is described in Van Saaze and Wijers (2003).

as an artwork from 1979 and this date was also mentioned on the wall label. The appearance of the work had changed noticeably by the choice of equipment, however.

Rather than three large outdated cathode ray tube (CRT) monitors, we see three thin, contemporary flat-screen plasma televisions affording the work a very different look and feel.

The decision to use flat-screens instead of larger CRT monitors was motivated by the fact that the original monitors used in earlier displays were not kept as part of the work. Moreover, in the case of *25 Caramboles*, the artist was involved in the reinstallation of the work and it was his explicit wish to use modern flat-screens instead of large monitors from the past. The artist made clear that he wanted the work to evolve along with developments in technology.

In view of long-term conservation, the Stedelijk Museum in Amsterdam, the owner of the work, is pondering how to keep this work for the future.[3] Soon, DVDs will replace the U-matic tapes or perhaps the images will be stored on a hard disk. In both cases the nostalgic clicking sounds of the U-matics, which seem to go so nicely with the ticking of the billiard balls, will be history as well. We can hardly imagine what this work will look like twenty or fifty years from now. Will we still recognise *25 Caramboles* as a work from the late 1970s, the pioneering days of video installation art? Will we still recognise *25 Caramboles* at all?

Looking back, I think what struck me most was the struggle I had in feeling confident about the decisions that were made about what kind of equipment to use. Was it appropriate to follow the artist's wishes and to use the contemporary flat-screens, giving the work a present-day feel? Or should we have strived for a version that would have assumed the appearance of a historical work by tracing down the 'original' model monitors? Weighing the consequences of these and other possibilities, I just couldn't work out what was the preferred state of this work.

Strangely enough the audience didn't really seem to care. Even the

3 The term 'conservation' is far from univocal. I will return to this discussion in the next chapter. In this book, I adopt Muñoz Viñas' use of the term 'conservation' as a blanket term: the sum of conservation activities, including restoration. Furthermore, in line with the vocabulary used in the Inside Installations project, I adopt the term 'conservator' instead of 'restorer' or 'conservator-restorer'. The term 'preservation' (the activity that avoids alterations of something over time) is here used to refer to conservation in the narrow sense, see Muñoz Viñas (2005, 14–15).

press did not pay attention to the obviously anachronistic approach.[4] Yet, measured by the principles of existing conservation ethics that favour the 'material authenticity' of a work of art, the decision to use flat-screens rather than monitors of the late 1970s might seem quite controversial. Was it indeed inappropriate to choose present-day monitors, or was this decision justified as being part and parcel of the conceptual framework of *25 Caramboles*? Works like this have led conservators to question whether conventional conservation ethics, according to which ideally neither authentic material nor technique should be changed or replaced, can be applied to these relatively new art forms, or whether they need a different approach.

The story of *25 Caramboles* is illustrative for the histories of many contemporary art installations. During the last three decades, installation artworks have become part of the mainstream in contemporary artistic practice. However, displaying and acquiring such works implies that curators and conservators have to deal with obsolete technologies, ephemeral materials and other problems concerning the care and management of these complex and hybrid works of art. Due to their conceptual, unstable, variable or process-like character, they challenge the conventional object-oriented approach to collecting and conservation. Unlike traditional painting and sculpture, these works are not always made for eternity; instead artists deliberately use ephemeral materials and include aspects of change in their conceptual framework. Their conservation has become an apparent problem for museums as well as an economic issue (Schinzel 2006, 53).

In the case of time-based media installations such as the work by Cárdenas, the technologies that determine their appearance and functioning simply fall into disrepair or become obsolete due to the pace of technological developments. Yet, numerous other types of contemporary artworks also alter in appearance and require some kind of intervention by the museum to enable their continued display. For many of these artworks the notion of art as a 'fixed' material object becomes highly problematic as *change* is built in their conceptual framework and/or is a necessary condition for their perpetuation (Weil 1992; Depocas, Ippolito

4 Although the show received many reviews in the Dutch press, none of the critics paid attention to the altered appearance of the work by Cárdenas. See, for example, Wesseling (2003).

and Jones 2003; Wharton 2005; Irvin 2006; Laurenson 2006). What, then, does it mean for a work of art if, for example, its components have been replaced or altered, or if its visual appearance has been adapted to new surroundings?

As the philosopher Boris Groys has pointed out, what comes to mind is the hypothetical case of a vessel – also known as the Greek legend of the Ship of Theseus or Theseus' paradox – which has been continuously damaged and repaired during its voyage on open seas. Supposing that piece by piece all parts of the ship have been replaced in the course of its voyage – is the vessel that reaches the shore then still the same as the ship that set sail at the beginning of its journey? The philosophical point of this example is that, for a particular purpose, it sometimes makes sense to regard two objects as identical even though for other purposes it would be best to treat them as different (Groys 1996). In the case of the vessel, it can be argued that the answer to the question is 'yes' because the ship's identity is assured by its function. With works of art, however, the answer seems more complex and will most likely depend on the position of the person or institute confronted with the question. As change comes in all sorts of forms and in different degrees, in the context of the conservation of works of art, the real question is, of course: On the basis of which criteria are decisions made about what can change and what not? Or, in other words, How do museums, in their daily working practices, deal with changing artworks?

The research reported in this study comprises an empirical investigation into the working practices of contemporary art museums involved in the presentation and conservation of installation artworks. It addresses the challenges museums are confronted with when they acquire, present, and wish to preserve installation artworks. Or, to follow up on the ship metaphor, rather than examining the artwork in the harbour, the central concern of this book is to investigate what happens during its journey at sea. On this journey, we will, like the Ship of Theseus, find ourselves in rough waters and face heavy winds. Also, we will come upon the efforts of sailors trying to lead the boat safely into the harbour before it takes on a new journey.

Rather than focusing on completed artworks, the research centres on unstable artworks and the practices in which artworks are *done*. In this sense, the book belongs to those practice studies that 'treat the field of practices as the place to study the nature and transformation of their

subject matter' (Schatzki 2001, 2). Lying in the dock (when the artwork is displayed in the museum) is considered only as a temporary outcome of its journeys. Pursuing this wet metaphor, Latour and Lowe argue that studying artworks can be compared to studying rivers:

> A given work of art should be compared not to any isolated spring but to catchment area, a river along with its estuaries, its tributaries, its rapids, its meanders, and, of course, its hidden sources. To give a name to watershed, we will use the word trajectory. A work of art – no matter the material of which it is made – has a trajectory or, to use another expression popularized by anthropologists, a career. (2011, 278)

How then to study an artwork's career? I will elaborate on my theoretical embedding and research approach later. First, I will illuminate the origins and backdrop of my questions and concerns.

INSTALLATION ART AND THE MUSEUM

The term 'installation art' is much contested and as such not easily defined. Finding a definition of the term 'installation art' is a topic in itself and one that is not straightforwardly addressed. From reference books such as *Understanding Installation Art* (Rosenthal 2003) and *Installations for the New Millennium* (De Oliveira, Oxley, and Petry 2003) we learn that a clear-cut description is lacking. In general, the term is used to describe works from the 1960s and onwards which share certain key characteristics, such as: the creation of an event, site-specificity, the focus on the theatrical, on process, spectatorship and temporality. Depending on the argument, various authors place the nature of installation art in its site-specific character (Onorato 1997), spectatorship (Reiss 1999; Bishop 2005) or the hybrid character of the installation as an art form (Suderburg 2000). Installation art has a long history and can be placed in the tradition of art movements such as action painting, dada, fluxus, minimalism, performance and conceptual art – movements which emphasise art as a process instead of the *objet fini*, and dethrone the autonomous and object-oriented character of art. This research is not the place for an expanded analysis of the literature on the historical roots of installation

art and its definition.[5] A brief look into history, however, is relevant considering installation's paradoxical intertwinement with the contemporary art museum.

Although marginal at first, today installation art has become mainstream in contemporary artistic practice. With the insight that the context in which an artwork is presented influences the experience and meaning of the work, the term 'installation' was first used in the 1970s. Initially, the term was used in the context of exhibition displays. Art historian Julie Reiss describes how, in the 1970s, the verb 'to install' was used to describe a working process that freed itself from the artist's studio and aimed for direct contact with the audience (1999, xi).[6] The essence of installation art is, according to Reiss, spectator participation. This, she argues, was connected to a political agenda: the term 'installation art' was used in the context of an artistic practice that referred to, and criticised, the ideology of the (institutional) context: an art practice that appropriated the medium of exhibition but also tried to change it.[7] These vehicles of institutional critique were aimed at escaping the boundaries of institutions and the pressure of the art market. Ephemeral and site-specific work became a strategy to break away from commercial mechanisms, and until the

5 The growing body of literature on installation art can roughly be divided into two categories: art historical works, which trace the origins of installation art (cf. Archer 1994; Selz 1996; Reiss 1999), and reception aesthetics (Rebentisch 2003; Mondloch 2005), which attempt to account for changes in spectatorship evoked by installation art. Few authors, like Bishop (2005) and Novak (2009, 2010) connect both strands in their research. With this book I want to suggest a more ethnographic investigation. For this reason, I deliberately leave out the discussion about definitions. Throughout this study, the term 'installation art' is used in the way it is applied by the actors under study. Within the Inside Installations research project, for instance, the label was used in a broad sense to indicate the category of artworks that need to be *installed*, thus implying more work than simply hanging up a painting. For more on Inside Installations, see the section on 'Doing Artworks' in this chapter.

6 Reiss focuses on the art scene of New York and describes the history of installation art as a process of commoditisation from the late 1950s to the 1990s. She takes Minimalism and Environments as a starting point and recognises a gradual assimilation of installation art into mainstream museums and galleries. A very different historical approach to installation art is presented by Davies. He labels installation art as 'the recent manifestation of the oldest tradition in art' (Davies 1997, 8), arguing that the framed, portable painting is a relatively recent phenomenon in Western art whereas in situ installation art has its roots in the non-portable ancient drawings in the caves, the tombs and the cathedrals. For Davies, installation art represents the liberation from the frame as well as from commerce (1997, 6–11). For accounts on the emergence of time-based media art (also referred to as 'electronic art' or 'new media art') as a specific category of installation art and its problematic relation with the museum, see, for example, Hanhardt (1999); Grau (2006); Paul (2006, 2008); Shanken (2009).

7 See also Bätschmann (1998).

1980s these were regarded as critical dispositions.[8] Artists showed an ever greater awareness of the conventions of the museum and actively took part in discussions of the legitimacy of the institution.[9]

Artistic practices of ephemeral and site-related art created outside of the museum became a strategy to avoid commercial mechanisms of the art market and related institutions. Temporality and site-specificity were regarded as signs of a critical attitude. Yet, despite this attitude towards museums, in the late 1980s contemporary art was brought into the centre of museum activities. Museums started to embrace and acquire installations as a historical and contemporary phenomenon (Novak 2009). Although many installation artworks of the past are no longer physically existent, others have been conserved as part of museum or private collections. Some art historians and critics argue, however, that the institutionalisation and commercialisation of this art form are at the expense of the critical social dimension of the works (Kwon 2000). Accessioning such artworks into museum collections would destroy the aspects that are considered crucial for their meaning, such as institutional critique, transition and play.[10]

The developments in artistic and gallery practices reflecting on exhibition practice also led to the rise of a climate of increasing institutional reflexivity within the museum profession, such as the introduction of theoretical perspectives into museum studies (Ross 2004). Although already present, in the late 1980s the ideology of the white cube became increasingly dominant, with MOMA New York playing a crucial role in 'defining the modernist canon and in shaping the way that modern art is looked at and understood' (Grunenberg 1999, 32). The so-called 'new museology' specifically questioned traditional museum approaches regarding issues of value, meaning, control, interpretation, authority and authenticity and is represented by academic writers with an interest in the political and ideological aspects of museum culture, such as Peter Vergo's edited volume *The New Museology* (1989) and Carol Duncan's *Civilizing Ritu-*

8 For a more expanded discussion of institutional critique, see Grunenberg (1999, 40–41). In relation to the early days of minimal art, see Kwon (2000, 39–41).

9 See Wharton and Molotch (2009).

10 An anonymous reviewer has pointed out 'the irony of the fact that installation artwork, which grew out of a movement toward ephemeral art that was largely anti-institutional in orientation, should now be so thoroughly integrated into the institutional context that we must speak of institutions as playing a role in the determination of their features' (quoted from Irvin 2006, 145).

als: Inside the Public Art Museum (1995). Within new museology, critical discourse analysis on museum practices investigates the power/knowledge structures of cultural institutions by means of their 'institutional apparatuses' and institutional technologies (such as newsletters, architecture, artworks) (Rose 2001). Examples of museum research based on critical discourse analysis are Tony Bennett's *The Birth of the Museum: History, Theory, Politics* (1995) and *Grasping the World: The Idea of the Museum*, edited by Preziosi and Farago (2004). Material cultural studies and anthropologists of material culture such as Pearce (1989, 1992) study the museum as cultural phenomenon, and focus on strategies of selection and display, and the history of collections. New museology considers the museum space merely a symbolic space but does not fully investigate the museum inside (Yaneva 2003b, 116). Like Yaneva, others have observed that museum study places emphasis on the front end of the museum and maintains a strict division between what happens in front of and behind the scenes (Handler and Gable 1997; Macdonald 2002). Hooper-Greenhill goes so far as to claim that:

> Museum workers have, until recently, remained unaware of their practices, and uncritical of the processes that they are engaged in every day. Within the practices of the museum, the aspect of criticism, or of developed reflection on day-to-day work, has been very weak indeed. (1992, 3)

In the same vein it can be argued that the behind-the-scenes museum worlds, like most of the art world, can be said to remain relatively opaque (if not, to use the words of Thornton, 'downright secretive' (2008, xvii)).[11] In museums, like in other production houses such as laboratories, daily practices involved with 'the making of' are mostly considered irrelevant to the public's eye and stay *sub rosa*. The museum has a long history of maintaining authority by manufacturing certainty, presenting itself as well-structured and employing rational practices while concealing the messier, more contested part of behind-the-scenes work. In this light, the museum can be characterised as having a confident face that is directed

11 Thornton's *Seven Days in the Art World* is a popularising ethnographic account of the Western art world and provides an inside view of many behind-the-scenes spaces and practices (such as an auction, a magazine, an artist's studio and the biennale). The conservation studio and practices of conservation are hardly addressed, however.

outwards, and a less confident face that is directed inwards. The latter face dominates the process that evolves prior to each display but is hardly made visible to outsiders. What does it mean to open up the spaces and practices behind the scenes of display? More specifically: how and by whom are decisions made in conservation dilemmas?

DECISIONS AND DISCUSSIONS

Reaching decisions in conservation is often depicted as a difficult task.[12] Barbara Appelbaum, conservator in private practice, describes such worries vividly:

> [W]e agonize, afraid that we are making the wrong choices, and are sometimes frozen into inaction by the fear of being criticized no matter which choice we make. If we 'fix' signs of age, we obliterate the object's history, but if we do not, we are not respecting the creator's intent. If we do more invasive treatment, it may not be reversible, but if we do less, the object may remain vulnerable to damage. (2007, xviii)

Particularly in conservation of contemporary art, complex and sometimes far-reaching choices have to be made as adhering to all values at the same time is often impossible. In such cases, decisions sometimes go against existing and commonly accepted ethics and beliefs, such as the rule of reversibility. Conservator and researcher Glenn Wharton:

> In certain circumstances, substitutions may be made for original materials that have degenerated and no longer represent the artist's intent. However, material replacement is in direct conflict with the conservation ethic of respecting the integrity of the authentic object. (2005, 167)

12 Most of the literature on this topic is limited to practical concerns. For a philosophical approach to 'painful decisions', see Van de Vall (1999). In this article, Renée van de Vall analyses the challenges conservators are faced with by interpreting decision-making in conservation of contemporary art in the context of moral reasoning. See also Van de Vall et al. (2008) and Van de Vall (2009).

Besides the apparent tension between replacing original materials and being faithful to the integrity of the artwork, there are also other factors that add to the complex nature of contemporary art conservation. In contemporary art values are in general more diverse, less clearly determinable, and less established than with traditional art. Moreover, the belief in – and acceptance of – a common standard, such as the scientific standard in traditional art conservation, is missing.

In contemporary art conservation, it is well-recognised that existing codes of ethics are not always successful in providing guidance for complex issues. These theoretical principles sometimes fail to offer clear grounds to steer decision-making (Sease 1998). According to Wharton, this is especially the case with contemporary art:

> Since neither legislation nor professional codes provide full guidance for navigating the difficult terrain of contemporary art, conservators continually modify their approach according to individual situations; increasingly, they work in collaboration with artists, curators, and others with interests in defining how artworks should or should not be presented. (2005, 166)

In today's conservation theory and practice it is well recognised that the role of the conservator of contemporary art is undergoing some major transformations.[13] The conservation community finds itself confronted with complex challenges and is in search of stability and reflection upon its ethical codes and related practices. From the 1990s onwards, a boost of conferences and publications has emerged on conservation problems concerning modern and contemporary art. Although this is a relatively new research area, the conservation community is already making significant attempts to capture the nature of the problems and to develop strategies that enable museum professionals in their tasks to collect, present and preserve these works.[14]

13 On the changing practice of the conservator and the need for more reflexivity in conservation practice, see, for example, Hummelen and Scholte (2004); Stoner (2005); Macedo (2006); Clavir (1998, 2002); Laurenson (2006).

14 Clearly, my research builds on the large body of work already done in this area. Examples of conferences are: "From Marble to Chocolate" on 19th- and 20th-century art (1995, Tate London), "Modern Art: Who Cares?" (1997, Foundation for the Conservation of Modern Art (sbmk) and the Netherlands Institute for Cultural Heritage (icn)), "Mortality Immortality? A Conference of Contemporary Preservation Issues" (1998, Getty Conservation Institute (gci)), "The Object in Transition: A Cross Disciplinary Conference

For many contemporary artworks the notion of art as a 'fixed' material object becomes problematic due to the use of ephemeral material or due to their conceptual, unstable, variable or process-like character. The general understanding is that the traditional storage-and-minimal-intervention approach is not always adequate for the conservation of these works because they require a more frequent and pervasive level of intervention by the museum to enable continued display. The developments in artistic practices therefore ask for a rethinking of certain concepts and established principles that belong to traditional conservation strategies, such as the notions of 'original', 'copy', 'minimal intervention', 'authenticity', 'reversibility', and 'artist's intention'. Indeed, as 'preservation' is generally understood as 'the activity that avoids alterations of something over time' (Muñoz Viñas 2005, 16), the idea of change seems to be in contradiction with what the traditional museum stands for. Or as Keene states: 'At the foundation of the conservation ethic lies the precept "thou shalt not change the nature of the object"' (quoted by Clavir 1998, 1).

Because some decisions go against the principles and practices which were developed for conserving traditional art forms, as stated above, conservators sometimes express feelings of discomfort in making decisions. Art historian and paintings conservator Cornelia Weyer argues that in installation art, the secured position consisting of the rules by which conservators live and reach decisions, is increasingly instable because the material, technical identity of the work is no longer necessarily the principal reference. Installations, for instance, require participation from the viewer as well as from the conservator (Weyer 2006).

Despite a growing body of literature on decision-making in conservation, the category of uncertainty inevitably tied up with decision-making has received little attention.[15] When it is addressed, it is usually considered negatively and depicted as something that at best needs to be ruled

on the Preservation and Study of Modern and Contemporary Art" (2008, GCI and the Getty Research Institute (GRI)), "Contemporary Art: Who Cares?" (2010, Foundation for the Conservation of Modern Art (SBMK) and the Cultural Heritage Agency of the Netherlands). Research projects and consortiums include: Archiving the Avant-Garde, Variable Media Approach, Media Matters, Documentation and Conservation of the Media Arts Heritage (DOCAM), and Inside Installations: Preservation and Presentation of Installation Art.

15 For attempts to clarify and rationalise the decision-making process, see, for example, Ashley-Smith (1999); Caple (2000); Appelbaum (2007). For an elaboration on decision-making processes in contemporary art conservation, see, for example, Hummelen (1996) and Van Wegen (1999).

out since it undermines the conservator's authority.[16] Uncertainty, however, can be regarded as an integral part of conservation and one that is not necessarily counterproductive.[17] Moreover, despite the current discomfort in the conservation community, the growing body of literature, and the many conferences on these topics, it can be argued that the conservation field in general lacks the kind of open, critical discussions that can be observed in performative art practices, such as music and theatre. Historically, preservation issues are concealed and confidentiality agreements are quite common to conservation practice. In earlier days, deliberation processes and conservation treatments took place behind closed doors, cautiously concealing them from the museum public.[18]

Tom Learner, head of contemporary art research at the Getty Conservation Institute, explains the current relative deficiency of discussions in the context of contemporary art conservation as follows:

> There are three factors that – in my opinion – seem to hamper the true extent of potential progress in these discussions, namely that conservators and art historians/curators often seem to speak two very different languages (and it is therefore rare to get a true dialogue going); that the discussion tends to remain rather broad with a barage [sic] of conservation problems, artists and materials all being debated at the same time (and it is therefore also rare to get beyond the periphery of any of the specific issues); and that many conservators are unwilling to talk openly about some of the treatments that have been undertaken (due to the very sensitive nature of many of the issues). (Learner 2008)

In addition, it can be argued that evaluation and appraisal traditionally take place within the dichotomy of original versus non-original and are therefore charged with negativity. Or put otherwise: traditionally, the aim

16 Appelbaum pays attention to 'the conservator's psyche' but describes uncertainty in treatments as an unwanted component since it may undermine authority (2007, 266–269, 374–376, 419–423).

17 Whereas the topic of dealing with uncertainty in decision-making is hardly addressed in conservation literature, it is frequently dealt with in other areas of research such as (medical) sociological studies. For further reading, see, for example, Mesman (2008). Mesman's focus is on practices in the Neonatal Intensive Care Unit, but her insights are applicable to the field of conservation in terms of studying delicate practices and thinking about issues of uncertainty.

18 In the next chapter the historical roots of this attitude of concealment and guardedness will be explored.

of conservation is defined in terms of repair, a repetition of the original state of the artwork. Consequently, restoration *activities* are not included in its result; the 'doing' is placed between brackets. Due to the quest in restoration for the original, what it *produces* as a result of this 'doing' has hardly been questioned (Pültau 2000).

Pültau and others (Van Wegen 1999; Laurenson 2006; Ippolito 2008) have drawn an analogy between the practice of conservators and that of theatre directors or musicians. Like directors and musicians, conservators and curators have to 'execute' a work and in doing so, have to relate not only to an 'original' but also to its successors. Such works encompass a performative element which is reflected in their subsequent versions. This different framework of reference opens up a whole new way of thinking about conservation practice which, according to some, is a liberating one indeed. Steve Dietz, then media curator of the Walker Art Center in Minneapolis, Minnesota (USA), pointed out: 'The burning issues of collectability and ownership and authenticity take on a whole different tone when viewed against the history of music and its notation system for replaying a core experience that is nevertheless different every time' (Dietz 2003). In the words of philosopher Boris Groys:

> [T]he supplementary character of restoration entails the need for constant adaptation to a changing cultural context. Awareness of the ceaseless adaptation will perhaps increase when the fixed framework of the universal museums crumbles, when the repetition of events takes precedence over the preservation of material objects. Given these circumstances, perhaps restoration will be recognized as a new art form, in which the restorer plays a vital interpretive role comparable to what directors and conductors have been doing for centuries. (1996, 160)

Instead of thinking in terms of loss, the concept of 'passage' (Peters 2003, 2009) between past and present allows room for productivity. In the passage of an object through time things are also created; the outcome is something new. How then can these outcomes be evaluated and judged? Weyer addresses this question when she writes that with reinstallation it is not easy to judge its success or failure, as the result is no longer valued as an object but as what she calls a reception, placing emphasis on experience rather than material authenticity (2006, 44). For Weyer, conser-

vation here enters the realm of subjectivity, a category that – as we will see – is rendered rather problematic in conservation history and theory.

To be able to think about the question of formulating and applying criteria in order to compare and evaluate conservation practices of installation art, first a different way of reasoning is needed. Because of the limitations of the traditional conservation paradigm, questions of how to evaluate what is produced can only be posed within a different conceptual framework. The central goal of my research is to provide a broader and deeper understanding of the conservation of installation art in which the issue of change is acknowledged, instead of being disregarded.

In this book, what happens in museums is central. It shows that studying these behind-the-scenes practices is not only relevant but, in the case of installation art, also necessary. Because of the dynamic and indeterminate character of these artworks, no clear line can be drawn between artwork and museum practice as they shape each other. The existing division between behind-the-scenes practice and the artwork in the public space of the gallery appears to become blurry. From this perspective, keeping the working practices backstage does not seem to be an option as events and decisions taken behind the scenes often have far-reaching consequences for the constitution of artworks.[19]

The awareness that the museum is not a neutral place is certainly not new, yet its *practices* are generally neglected in art historical and aesthetic readings. In the case of many contemporary artworks, however, these issues need to be addressed since the works can not be separated from these practices. Especially with installation artworks, it is of great importance to study these practices, as will be argued in this book. Installations can not be understood separately from the actors and museum practices in which they circulate.

This study examines day-to-day museum work by conducting participant-observation fieldwork as well as semi-structured interviews with relevant museum actors (e.g. curators, registrars, conservators, museum directors and technical staff). Its aim is to contribute to a critical reflection upon – and more systematic understanding of – the current challenges contemporary art conservators are facing. In this way, the research responds to the call for ethnographic studies of behind-the-scenes activ-

19 See also Pültau (2000).

ities in museum practices (Clifford 1998; Rose 2001; Macdonald 2001, 2002). What this study also demonstrates is that the criticism of museums as a last repository or mausoleum of 'dead' objects is fiercely challenged by contemporary artworks.

DOING ARTWORKS

The phrase 'doing artworks', which is frequently used throughout this book, refers to two levels: the level of practices studied and the analytical level. First, many contemporary artworks alter in appearance and require some degree of intervention to enable their continued display. Rather than the more accepted hands-off or preventive approach, contemporary artworks often ask for a more interventionist's approach from the museum professionals. The 'doing' refers to this level of practice as it evokes this activity and makes room for the awareness that conservation is a productive activity.

Secondly, and more importantly, the 'doing' denotes the level of research. In this sense, it has a more theoretical meaning and refers to my constructivist approach and particular attention for performativity and enactment.[20] The research starts from the premise that things are not *things in and of themselves*, but are constructed in practices. Artworks in the museum seem autonomous, but their continued existence is the result of a lot of work and effort. Artworks, in other words, need to be 'done'. Moreover, as we have learnt from the work of sociologist Howard Becker (1982, 2006), art is not the product of an individual, but 'the product of a collective work, the work that all these different people do, which, organized in one way or another, produces the result that is eventually taken to be the artwork itself' (Becker, Faulkner and Kirshenblatt-Gimblett 2006, 3).

Instead of taking the supposed object for granted, I will explore the processes that shape the artwork within practices of collecting and conservation. By describing and analysing a number of case studies using ethnographic methods, my aim is to shed light on the concepts of authenticity and artist's intent, as well as on the notion of ownership, and cre-

20 For a more elaborate discussion on 'doing' and the history of the term 'performativity', see Hoogsteyns (2008, 58–61).

ate insight into the roles and positions of the different actors in shaping museum works. By focusing on this *doing*, my aim is to introduce a theoretical perspective into the conservation field that takes its own doing into account and acknowledges change.

The research draws on theoretical texts and terminology taken from a wide spectrum ranging from medical anthropology to studies in the history of technology. What these studies share is a focus on performativity. Theoretically this research can be situated within the constructivist approach found in science and technology studies (STS). More specifically, and in line with the premise that art is a collective process, the research follows the idea that, in the process of doing art, the artwork, like any other participant (both human and non-human) is an *actant* (Latour 1987). My research approach therefore relates to actor-network theory (ANT) (here mainly associated with the writings of Bruno Latour).[21] Instead of studying the artwork as a static object, frozen in a single state, this particular approach allows me to consider the artwork's trajectory or career.[22] Rather than focusing on stability, it accounts for the artwork's transformations and indeterminacy. It helps to analyse 'art in action', and draws attention to changes, transformations, and places of friction. Such an approach allows a consideration of the constituting role of the museum and a recognition of the distinction among actors which is usually overlooked. A constructivist approach helps to open up practices: contributing to making them more transparent. By introducing a STS approach to the field of conservation, this research also aims to con-

21 With its emphasis on the material conditions of production, on materialities and practicalities, the actor-network approach is particularly useful as it recognises that, like humans, non-humans such as artworks *can be actants and are considered to have agency*. For a more elaborate discussion on actor-network theory in science and technology studies see, for example, Latour (1987, 1999a, 199b, 2005). Sociologists of art such as Yaneva (2003a, 2003b), Macdonald (2001, 2002), and Gielen (2003) have engaged in actor-network theory in order to study the dynamics and negotiation processes of art production in search for alternatives to the dominant art sociological readings of the last decennia.

22 Instead of 'trajectory' (Latour and Lowe 2011), I will from here on adopt the concept of 'career' as described in Becker et al.: '[T]here are typical sequences of movement and change in the story of any artwork, and these sequences provide, analytically, a series of points at which you can see forking paths, ways the work might have gone differently, would have gone differently *if* something had happened differently, *if* someone or something had behaved differently. That *if* is a crucial point of study, telling us where the interactions of artists and others provided alternatives to what in the end and actually did happen, making clear the contingent, rather than inevitable, character if the artwork we're trying to understand' (2006, 5). For further explanation on the concept of trajectory in social studies, see, for example, Mesman (2008).

tribute to the movement in the conservation field towards a discourse of critical reflection and discussion.[23]

The empirical materials on which I have based my findings are mainly produced during several 'ethnographical moments' in selected museums and during the meetings of the European research project Inside Installations: Preservation and Presentation of Installation Art, supported by the Culture 2000 programme of the European Commission, and coordinated by the Cultural Heritage Agency of the Netherlands.[24] In the context of this project, in a period of three years (2004–2007) around thirty artworks were studied from the perspective of conservation. The central aim of the project was to develop good practice on five topics that were considered essential for the preservation and presentation of installation art: Preservation Strategies, Artists' Participation, Documentation & Archiving Strategies, Theory and Semantics, and Networking (Knowledge Management and Information Exchange). For me, as a participant observer, the project provided access to behind-the-scenes conservation practices, and to the installation artworks in question.[25]

Although the term 'ethnography' is far from unambiguous, it is generally understood to be a methodological variation within qualitative research encompassing observation in a social setting.[26] Methodologies of ethnographic research, such as interviewing, are primarily developed in anthropological research. Today, ethnographic research is performed in a diverse range of settings, such as medical practices, science and technol-

23 Although I do not explicitly address this in my book, the fields of STS and arts might be of more interest to each other than becomes apparent at first sight. Because my research questions are directed by the field of conservation, I have, however, decided not to go into this too deeply. My theoretical concerns lie in the field of conservation practices. For a discussion on the relations between STS and the arts, see Benschop (2009).

24 Inside Installations was coordinated by the Cultural Heritage Agency of the Netherlands, and co-organised by Tate Modern, London (UK); Restaurierungszentrum der Landeshauptstadt Düsseldorf (Germany); Stedelijk Museum voor Actuele Kunst (S.M.A.K.), Ghent (Belgium); Foundation for the Conservation of Contemporary Art (SBMK) (the Netherlands); Museo Nacional Centro de Arte Reina Sofia, Madrid (Spain). Project website: www.inside-installations.org. See also Scholte and 't Hoen (2007) and Scholte and Wharton (2011).

25 I am aware that the setting of Inside Installations is a particular setting, and that the set-up of the project as well as its EU funding may have influenced the practices I observed (in fact, without the EU finance, some of the research conducted in the participating museums would probably not have been possible).

26 Book-length accounts of doing ethnographic research that have informed this section include: Hammersley and Atkinson (1995); Macdonald (2001, 2002); Mol (2003); Gielen (2003); Dumit (2004); Velthuis (2005); Mesman (2008).

ogy studies, as well as museums.[27] Usually, the position of the researcher is described as that of a 'stranger': an outsider as opposed to the insider belonging to a certain group. An important theoretical foundation of ethnographical research is that each social group has internalised its own patterns, beliefs and practices. While these have become self-evident to members of the group, an outsider has the capacity to reveal the patterns by means of observation. In the words of David Walsh:

> [A] social group has its own cultural pattern of life [...] that, as far as its members are concerned, are taken for granted, habitual and almost automatic. Members living inside the culture of their group treat it as simply how the world is and do not reflect upon the presuppositions on which it is based or the knowledge which it entails. But the stranger entering such a group does not have this insider's sense of the world, and instead finds it strange, incoherent, problematic and questionable. (1998, 218)

Clyde Kluckhohn expressed the advantage of an outside position as follows: 'it would hardly be fish who discovered the existence of water' (quoted in Hirschauer 1994, 340).

In ethnographic research, the researcher is widely acknowledged to be the primary research instrument. 'Ethnography, then, contrasts with 'scientific' methods of social science research that, based upon a universalistic model of science, emphasise its neutrality and objectivity, attempting to generate data untouched by human hands' (Walsh 1998, 217). Within the tradition of qualitative research, the idea prevails that each research and thus each analysis of a practice encompasses the subjectivity of the researcher/author. In ethnography at large (and as a response to anti-colonialist ethnography) it is thus recognised that the so-called 'outsider' brings with him his own values, preoccupations and blind spots to the research setting, thereby contributing to the construction of the research setting. Research questions and matters of interest come to the fore in *interaction* between the researcher and the research object.

27 Interestingly, many of the concerns expressed by conservators of contemporary art bring to mind similar struggles dealt with in the field of ethnographic research (Wharton 2011). Mutual methodological and theoretical concerns, such as the position of the researcher towards his or her 'research object', the notion of reflexivity, the interview as a knowledge production tool, and issues of validation, are discussed in Van Saaze (2009).

An issue I have been struggling with was finding a workable approach towards my own research field. Coming from the very same field that is now my research setting, I sometimes experienced difficulties in adopting the role of an 'outsider'. Unlike the museum professionals I studied, however, I did not bear the responsibility for a collection, nor was I in the position to perform research on a particular installation with the purpose of conservation. Nevertheless, my presence of course transformed the practices I studied and in some instances I deliberately adopted more of an interventionist approach. Specifically, I participated in the Theory and Semantics working group of the Inside Installations project and in the 'balance' working group of the Dutch Foundation for the Conservation of Contemporary Art (sbmk); I also raised questions during research meetings, shared literature references and presented several papers on the topic of my study at conservation conferences.[28]

In the stories in this book, I have attempted to reflect upon my role in the different settings I explored. While selecting and organising my field notes, I also tried to be aware of the issue of confidentiality related to delicate, sometimes politically loaded research materials. Because the access problem says something about the practice under study, it could be worthwhile to reflect upon it. Thus, instead of regarding access obstacles solely as methodological difficulties, I will try to understand them as meaningful, as a topic in themselves.

My choice of an ethnographic approach was indicated by its strong rooting in practices and by the possibility of studying art processes that are not open to other methodologies. Especially, but not only, because these processes aren't normally studied, this research offers rich materials for those interested in behind-the-scenes practices of artworks, conservation and museums. [figure 3]

28 For the Theory and Semantics group see: www.inside-installations.org. In the working group 'balance', organised by the Dutch Foundation for the Conservation of Contemporary Art (formally known as: Foundation for the Conservation of Modern Art), museum practitioners bring concrete conservation dilemmas from their own practices to the table. The case studies are then discussed within the working group, which meets on a regular basis. For more information on this working group, see www.sbmk.nl.

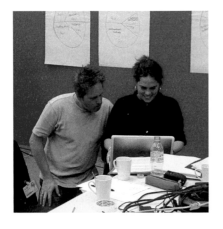

FIG. 3 – 'The observer observed': one of the members of the conservation group I have been studying asked what kind of things I was writing down during observation. Here, the conservation scientist curiously peeks into my field notes during a meeting on risk analysis in the context of a meeting scheduled by Inside Installations and hosted by Tate Modern, London, December 2006.

OUTLINE OF THE BOOK

In this book I bring together a heterogeneous group of contemporary artworks and museums. The cases, selected from the Inside Installations project, represent a variety of artistic and museum practices; the works address different themes and make use of different media technologies. Some of the works were conceived only recently, others have a longer history. In short: the works vary to a large degree and take place in different institutional practices. Taking all these differences into consideration, the variables seem endless. Diverse as these cases may seem, all four artworks have at least one thing in common: they challenge traditional museum practices of collecting and conservation. Although the selected case studies each represent a barrage of conservation challenges, in the study of each individual case a particular concept and related conservation dilemma is emphasised because it forms the most significant and interesting problem of that particular case. I use the 'obvious' cases to unearth what is at work in the less obvious ones (Becker et al. 2006, 2).

The study centres on key concepts of fine art conservation ethics and collection management as articulated in conservation literature (chapter one) and applied in current practices (chapters two to four). The first chapter introduces and discusses the two concepts that are central to this research and key in conservation ethics and practice: authenticity and artist's intent. In this chapter the origins and changing meanings of these concepts will be traced in conservation history and theory. What are the theoretical grounds for conservation practices, and what are the challenges contemporary art conservators and collection managers are facing

today? The chapter should be read as an introduction to the concepts of authenticity and artist's intention. Its purpose is to provide a historical background of the issues raised in later chapters.

Chapter two shows how, in contemporary art, the physical object is not always sufficient to go by. The chapter deals with the notion of authenticity which is explored in the first case study: *One Candle* (1988) by the artist Nam June Paik (1932–2006). Like *25 Caramboles*, *One Candle* has a longer history in which the technological equipment plays a vital role in the debates on the identity of the work. The work consists of a burning candle filmed by a video-camera and projected onto the walls by several projectors in the television colours red, green, and blue. Through the lens of *One Candle*, the concept of 'authenticity' and the object as a fixed and stable entity are problematised. Within the museum, *One Candle* is considered to be one: a coherent, original, untouched artwork that needs to be preserved. Maintaining this notion of 'oneness', however, becomes problematic when focusing on museum *practices*. Over the years, and as the result of many caring hands and minds, *One Candle* has been changed in many ways and, in fact, appears to be more than one. When the spotlight is redirected towards the practices in which *One Candle* is lit, turned on, repaired, stored, replaced, reinstalled, put on loan, copied, labelled, measured, and discussed, its multiplicity becomes visible. Yet, if *One Candle* is more than one, how many *One Candles* are there?

Chapter three examines the notion of 'artist's intention' and argues that this is not simply derived from the artist or the artwork, but is instead articulated in the interaction between the artist and museum professionals. The chapter studies successive reinstallations of works by one artist (Joëlle Tuerlinckx (1958)), in two museums (Bonnefantenmuseum, Maastricht and s.m.a.k. in Ghent). The comparison between two museum practices and their quests for the artist's intent shows that these distinct museum strategies transform the life and identity of the work of art. The chapter demonstrates that rather than being a facilitator or 'passive custodian', the curator or conservator of contemporary art can be considered to be an interpreter, mediator or even a (co-)producer of what is designated as 'the artist's intention'. Whereas the previous chapter demonstrated that the physical object does not always provide sufficient footage to go by, this chapter shows that in looking for something to hold on to, the artist (like the physical object) does not always offer a solid grip.

The third and last case study chapter concerns the acquisition and conservation of *No Ghost Just a Shell* at the Van Abbemuseum, a project initiated by French-based artists Pierre Huyghe (1962) and Philippe Parreno (1964). This chapter builds on the previous two case study chapters and seeks to deepen and further develop theoretical vocabulary introduced in earlier chapters. *No Ghost Just a Shell*, admittedly a rather extreme case in many ways, can be characterised in terms of variable objects, authors, dates and collections. Common values of material authenticity and intention seem to become obsolete categories. The case can be regarded as paradigmatic for many 'non-static' contemporary artworks in which traditional questions about the materiality of the object are being replaced by questions about ownership, authorship and copyright issues. This chapter focuses on the notion of ownership and pays particular attention to the entangled relationship between the museum, contemporary art and the art market.

The conclusion picks up the common threads running through the three case study chapters. Whilst the study started with a rather daunting account of the challenges installation art poses to museums in terms of its conservation, the study ends on a more optimistic note by focusing on its possibilities for the field of conservation and the museum field. From the empirical research, it concludes that the museum is in need of a reconceptualisation of conservation theory which acknowledges the concept of change, as well as a reframing of notions such as original, copy, version, and variation. Reconsidering these concepts by attuning them to practices opens up room for debate. The book finishes with suggesting new directions for such a discussion and returns to the initial question of how practices of contemporary art conservation may be evaluated. By this it aims to deepen and further discussion in conservation practices of contemporary art.

Key Concepts and Developments in Conservation Theory and Practice

In the introductory chapter, it was stated that for many contemporary artworks the notion of art as a 'fixed' material object has become highly problematic. These contemporary artistic practices not only upset the foundations on which art and the art world are built, but they also challenge the underlying concepts and values of fine art conservation. As a result, the existing confidence is crumbling.

This chapter explores the origins and history of these 'certainties', by analysing those concepts, which belong to what Laurenson (2001a and 2006) calls 'traditional conservation', or, in the words of Muñoz Viñas (2005) 'classical conservation'. The chapter attempts to provide more insight into the use and definitions of 'artist's intention' and 'authenticity', which form the backbone of traditional conservation theory and practice. I will explore these key concepts as articulated in pertinent conservation literature, with the aim of providing the reader with a general and basic historical background of these concepts by also placing them in a historical framework. What are the theoretical grounds for conservation practices, and how, from this, can we understand the challenges of contemporary art for today's conservators? The goal of the chapter is thus to shed more light on some of the problems conservators of contemporary art are currently facing, but also to find explanations for the relatively limited debate and the lack of open dialogue in the field of conservation.

Given its scope, this book is not the place for a lengthy philosophical discussion on the concepts of authenticity and artist's intent.[1] Therefore, to narrow the subject down, I will focus on the discourses of authenticity and artist's intention within the field of conservation, and against the background of key developments in fine art conservation practice and theory. Although both concepts are theoretically heavily charged and have become debatable in other areas such as philosophy and musicology, in conservation theory they are still widely used. Does this imply that in this field, the concepts of artist's intention and authenticity are applied uncritically? How did views about these terms develop in the field of conservation? How can we understand the different meanings ascribed to them?

1 For accounts on contemporary philosophical debates in literature and arts, see, for example, Dutton (2003) on authenticity and art, and Livingston (2003) and Bal (2002) on intention in art.

Before properly introducing the concepts of authenticity and artist's intent, I will first give a rough sketch of the emergence of the profession of conservation and the role of natural sciences in the development of this field. This, I will argue, has played an important part in the manufacturing of a representation of confidence and certainty in conservation. The evolution of conservation as a distinct profession has been described as a struggle for understanding and reorganisation. The absence of open discussion in conservation today, I will argue, can be explained by looking at these historical roots of conservation practice.

1.2 THE EMERGENCE OF CONSERVATION AS A PROFESSION

The history of restoration and conservation, like almost any history, is complex and diffuse. A thorough historical account goes beyond the aims of the research reported here, however. The far less ambitious goal of this section is to provide for the reader some historical context for the practices and concepts which are at the centre of this book. While being aware of the fact that every country and each subcategory of cultural heritage (e.g. architecture, intangible heritage, furniture, fine arts etc.) has its own particular history, although occasionally shared, I have decided to narrow my focus of attention and concentrate on influential developments in fine art (mainly painting) conservation in Europe which are, by leading conservation theorists, considered to form the legacy of today's Western conservation theory and practice.[2] This section leans on the historical research done by authors such as Lowenthal (1981, 1985), Caple (2000), Conti (2007) and Muñoz Viñas (2005). Drawing from their writings, special attention will be paid to the impact of science on the development of conservation as a distinct profession, conservation debates and controversies, and relationships between the theory and practice of conservation.[3] The central aim of this chapter is to draw a rough sketch of the origins of today's conservation policies, practices and problems.

2 Joyce H. Stoner (2005) provides a thorough account of developments in the field of art conservation in the United States.

3 For this chapter in particular, I am especially indebted to IJsbrand Hummelen for generously sharing his insights and knowledge of the history of conservation with me. Thanks also go out to Dawn Rogala for brushing up my knowledge of conservation history in the United States during our car journey from Hildesheim (Germany) to Amsterdam.

Fine art conservation as we know it today is a relatively young discipline. Before the field of conservation came into being, traditional restoration was predominantly the domain of artists and craftsmen.[4] 'In the sixteenth century, "conservation" was an inherently subjective discipline, cleaning and restoring the great and beautiful works of the past. Conservators responded to objects purely as aesthetic entities' (Caple 2000, 200). Treatment in those days was done without a scientific base and – judged by current standards – can be classified as cleaning or repairing rather than true conservation, which would include research into the relationship between the material's condition and decay (Sease 1998; Caple 2000). This could explain why, historically, there has been little to no philosophical or theoretical discourse to define the various restoration practices of the past.[5]

The beginning of today's conservation is commonly traced back to developments in the late eighteenth and nineteenth century. Most authors point to the changing notion of art in Western society, and to the time when artworks and artists started to receive special recognition as being influential for the establishment of conservation as a distinct profession and to the 'in the style of restoration of the late eighteenth century'.[6]

In Lowenthal's seminal *Our Past Before Us: Why Do We Save It?* (1981) and in his *The Past as a Foreign Country* (1985), the first books to systematically describe the changing attitudes towards artefacts from the past, the eighteenth century or the so-called 'museum era', with its romanticism, its nationalism and its historicism, is depicted as an age in which a shift in attitude towards the remains of the past occurred. This led to the surfacing of principles that continue to be widely accepted today, such

4 On the distinction between traditional restoration and conservation see Willink (1997, 14–15). Sometimes confusion arises about the terms 'restoration', 'preservation' and 'conservation'. Throughout this book I use Muñoz Viñas' broad understanding of the term 'conservation': the sum of conservation activities including restoration (all actions taken to restore an object in a known preceding state) (2005, 14). 'Restoration' refers to the reconstruction of the aesthetic appearance of an object. Although restoration can be one aspect of conservation, the latter encompasses much more. In the course of this book I will argue that the demarcations between these activities and definitions are far from absolute. On different usage of the terms 'conservation', 'restoration' and 'preservation', as well as a discussion on the terms 'conservator', 'restorer', and 'conservator-restorer', see, for example, Ex (1993, 17, 134–141); Clavir (2002); Muñoz Viñas (2005, 7–25).

5 See also Conti (2007). Based on primary sources, Conti provides a meticulous account of the history of restoration in Italy, France and England, from the Middle Ages to the end of the nineteenth century.

6 See Caple (2000, 46–59); Muñoz Viñas (2005, 2–3). As an exception to this, also earlier examples of guidelines for restoration are mentioned, such as, Pietro Edward's *Capitolo* from 1777.

as reversibility and minimum intervention.[7] Although in the eighteenth century, a more reserved approach was endorsed in theory, this was not yet executed in practice (Ex 1993, 70).

In 1849 the English critic John Ruskin published his book *The Seven Lamps of Architecture*, which was already influential in its own time. Ruskin defended the virtues and values of ancient buildings and argued strongly against rebuilding damaged buildings, especially Gothic cathedrals and churches. What was authentic about these buildings, according to Ruskin, was the entire record of changes they had undergone. In France, the architect and theorist Eugène-Emmanuel Viollet-le-Duc took a very different approach to Gothic art. According to Viollet-le-Duc, Gothic buildings were to be repaired or reconstructed. His objective was to restore the buildings to as good a state as possible, even if that condition might never have actually existed.[8] Judged by present standards, Viollet-le-Duc's now famous restoration work, for example, on the Notre Dame in Paris and the medieval fortified town of Carcassonne, are criticised as too free, too artistic and interpretive.

Today, Ruskin and Viollet-le-Duc are generally considered to be the first conservation theorists, each symbolising an extreme view on conservation: Ruskin with his restrictive approach, arguing in favour of the signs of history, and Viollet-le-Duc as the most permissive, arguing for the state of the object when it was conceived. According to Muñoz Viñas, Ruskin and Viollet-le-Duc are so often remembered and quoted because of 'their ability to clearly represent two very distinct attitudes when contemplating a conservation object' (2005, 4–5). Around that time in Europe, the rise of national independence led to increased emphasis on the preservation by each country of its own historical national culture (Caple 2000, 201).

One of the first attempts to comprehensibly define the activity of conservation is ascribed to the Austrian art historian Alois Riegl (Muñoz Viñas 2005, 37). In our time Riegl is especially mentioned for his *Der moderne Denkmalkultus*, originally published in 1903, in which he system-

7 For a more elaborate discussion of restoration in the romantic era, see Conti (2007, 269–323).

8 For a more elaborate discussion of Ruskin's and Viollet-le-Duc's approaches towards restoration see Lowenthal (1999, 7); Muñoz Viñas (2005, 5); Denslagen (2004, 118–130). Texts of both Ruskin and Viollet-le-Duc, as well as Riegl and other pivotal contributions to conservation theory are reprinted in the anthology *Historic and Philosophical Issues in the Conservation of Cultural Heritage* (Price, Talley, and Vaccaro (1996)).

atically considered the different (conflicting) values associated with con-servation objects, such as 'present-day values' and 'age value'. Such early signs of a scientific conservation approach were, in the words of Muñoz Viñas, 'scientific because the decisions were made with the aid of *soft*, historical sciences, such as archaeology, palaeography or history itself' (2005, 5). These humanistic disciplines are said to have served to form the basis for a theoretical and ethical approach to conservation activities (Tabasso 2006, 31).

The nineteenth century, however, also witnessed a growing collabora-tion between the fields of art and natural sciences (mainly chemistry and physics): museums created conservation departments and analytical labo-ratories, thereby laying the foundations of professional lab-based art con-servation and establishing a connection between conservation and science which still persists in today's art conservation theory and practice. The creation of instruments for elemental analysis and investigation (such as x-radiography and SEM analysis) has led to increasing possibilities of technical examination (Caple 2000, 201). The rise of what could be referred to as 'new scientific conservation' (Muñoz Viñas 2005, 6) laid the founda-tions of present-day professional conservation values and stimulated the development of a distinct conservation profession, as well as the discipline of what is now often called 'technical art history'. And vice versa, because as technical art history has led to an increase of physical proof, this in turn has also led to a more conservative attitude towards the remains of the past. Simply put: the more you see or know, the more you want to preserve.

In the history and development of conservation as a professional dis-cipline, a large role is attributed to the emergence of the natural scienc-es.[9] Miriam Clavir, in her article 'The Social and Historic Construction of Professional Values in Conservation', for example, considers how 'science came to dominate the methodology of the treatment of objects, and why these factors culminated in a significant shift towards scientific conserva-tion in the years around 1930' (1998, 2). Clavir lists a series of influential initiatives that were pivotal to this change: an international conference in Rome in 1930 organised by the International Museums Office of the League of Nations, the incorporation of a research laboratory in the Brit-ish Museum in 1931, and the genesis of the *Technical Studies in the Field*

9 See, for example, Hummelen (1997); Clavir (1998); Caple (2000); Villers (2004); Stoner (2005); Muñoz Viñas (2005); Janis (2005); Tabasso (2006); Appelbaum (2007, 310–318). For an analysis of the configura-tion of scientific facts in conservation of traditional art, see Versteegh (2006).

of the Fine Arts by chemist Rutherford John Gettens and George L. Stout (Clavir 1998, 2).[10] These developments, according to Clavir and others, marked the 'emergence of two fundamental beliefs in conservation, the belief in preserving the integrity of the object and the belief that the best way to do this is through the application of science' (1998, 6). Or, as stated by Dykstra: 'The use of scientific procedures promised relief from confusion and criticism caused by idiosyncratic or arbitrary restoration practices in the past' (1996, 200).

In addition, the establishment of the first professional conservation board, the International Institute for Conservation of Museum Objects, in 1950 is regarded as another important step in moving towards a scientific notion of conservation and breaking with the earlier 'unscientific' restoration tradition with its crafts and artistic origins.[11] Although the discipline of conservation as we know it today is considered to have its roots in the art and crafts skills, essentially it was the scientific understanding and ethical basis for preservation as well as the recognition of the need to create conservation records which generated the modern discipline of conservation (Caple 2000; Philippot 1996).

In terms of fine art conservation, an important name to be mentioned here is of course Cesari Brandi who introduced the term 'minimum of needed intervention' to painting conservation. As an art historian he led the Istituto Centrale del Restauro in Rome between 1939 and 1961. In 1963 he published his *Teoria del restauro*, which is widely considered to be of great importance to conservation theory today. One of his accomplishments is the introduction of a factor generally neglected in decision-making: the recognition of the object as an *art* object.[12] Next to the

10 It must be noted here that Clavir pays particular attention to developments in the English-speaking world. There is not much comparative literature available on conservation developments in different countries. Gettens and Stout, co-authors of *Painting Materials: A Short Encyclopaedia* (1942), are, for example, generally considered key figures in the American history of art conservation. Both played important roles in the starting up of the Foundation of the American Institute for Conservation (FAIC), an oral history project encompassing interviews with conservation professionals, see Stoner (2005, 41–42). The FAIC oral history archive is housed at the Winterthur Museum Library, Winterthur Delaware, US.

11 In 1959 this became the International Institute for Conservation of Historic and Artistic Works (IIC) (Clavir 1998, 3). See also Sease (1998, 98).

12 This work was only recently translated into English as *Theory of Restoration* (2005) by Cynthia Rockwell. In 2008 a large tribute conference was organised in Italy to re-examine the importance of Brandi's legacy for contemporary conservation theory. For an exploration of Brandi's work applied to contemporary art conservation policies, see, amongst others, Jokilehto (2006); Tabasso (2006); Pugliese, Ferriani and Rava (2008).

historical aspect of painting, Brandi thus placed the painting's aesthetic value on the agenda of conservators, introducing a so-called 'aesthetic' argument in conservation discussions. Another debt we owe to Brandi, according to Vaccaro (1996), is the systematisation of the concept of reversibility in restoration. This principle, indicating a more careful approach towards decisions and destructive effects of interventions in the original material, was already included in the 1961 AIC Code of Ethics.[13] This dictum, mainly followed by painting conservators, according to Caple (2000), is said to be of great importance for the public awareness of the distinction between conservators on the one hand and repairers and restorers of the past on the other. The historical awareness that, in hindsight and because of new insights, the use of materials and treatments of earlier days could be classified as failures, led to an increased attention for reversibility, minimal intervention, and non-invasive treatment – emphasising material authenticity. This also marked the rise of preventive conservation: a strategy that strives for minimal object handling and is primarily concerned with environmental adjustments.

Philippot (1996) describes how after World War II, the emerging natural science ('techno-scientific') approach started to clash with the traditional artisanship ('historico-humanist') approach. In the illustrious cleaning controversy which started in the 1940s, two parties argued over the cleaning of several paintings in the National Gallery in London. The first group (represented by the gallery's conservator, Helmut Ruhemann) defended the total cleaning of the paintings by pointing at scientific (objective, non-interpretative) proof demonstrating that the removal of the darkened protective varnish revealed the original state of the paintings 'in which the artist intended them to be seen' (quoted by Dykstra 1996, 201). The other group, among them the art historian Brandi and later Ernst Gombrich, advocated a more restricted approach by stressing the contextual, cultural dimensions of treatments.[14] Philippot considers the cleaning controversy as an important issue in the development of modern conservation and states that the problem of cleaning

13 See Appelbaum (1987) for a thorough analysis of the principle of reversibility and the different degrees of reversibility.

14 The cleaning controversy can be characterised as one of the first international public debates on fine art conservation. Representatives of both camps published widely in *The Times* and *Sunday Telegraph*. Most of this heated debate was later published in *Burlington Magazine*. For a more elaborate discussion see, amongst others, Dykstra (1996) and Hummelen (1997).

paintings since then had become a precarious subject in conservation.

Some argue that conservation ethics mainly evolves through controversies and conflicts such as these.[15] In any case, the long history of restoration and conservation controversies demonstrates that conservation activities can be considered high-risk: they can lead to heated public debates, to devaluation of the monetary and felt value of artworks, and even to the expulsion from their profession of people held responsible for supposed mistakes. Given this perspective, it will come as no surprise that the fear of harmful rumours, controversies, scandals, loss of reputation and lawsuits discourages conservators from sharing their uncertainties or supposed errors in decision-making and treatment. Moreover, it encourages the strand of concealment and secrecy in conservation. Legal agreements such as a Mutual Receipt Agreement or a Mutual Confidentiality Agreement are not uncommon in the conservation world.[16]

One of the notable attempts to limit treatments of cultural heritage objects that in a certain time and age are considered inaccurate or damaging, is the design and implementation of professional ethics codes. Only a couple of years after the publication of Brandi's *Teoria del restauro*, the first conservation code of ethics, the 'Murray Pease Report: Standards of Practice and Professional Relationships for Conservators', was implemented by the IIC-American Group (which later became the AIC). Soon after, the United Kingdom, Canada, and Australia followed, developing national codes of ethics accompanied by documents on good practice in conservation.[17] Moreover, in 1984, the International Council of Museums – Committee for Conservation (ICOM-CC) published *The Conservator-Restorer: A Definition of the Profession*.[18] Caple (2000) observes how since

15 See, for example, Caple (2000) and Marontate (2006). Other well-known conservation controversies involve the cleaning of Michelangelo's frescoes in the Sistine Chapel and Michelangelo's marble sculpture *David*.

16 See, for example, the so-called Newman Affair of the early 1990s discussed in Ex (1993, 97–105) and Van de Vall (1994). Due to a 'Mutual Receipt Agreement', the then-director of the Stedelijk Museum in Amsterdam was legally constrained from condemning the restoration treatment of Barnett Newman's *Who's Afraid of Red, Yellow and Blue III* (1967–1968) by the American conservator Daniel Goldreyer.

17 On the relationships between the codes of ethics and the more extensive good practice documents, as well as for an analysis of the codes of ethics of the British, Canadian, Australian and American professional bodies, see Sease (1998).

18 'The Conservator-Restorer: A Definition of the Profession', International Council of Museums – Committee for Conservation, 1984, www.icom-cc.org/47/about-icom-cc/definition-of-profession/. Despite the emancipation of the field and the aspirations of the ever-growing conservation community, the profession of conservator is not yet protected.

the 1960s both IIC and ICOM-CC have frequently organised international conferences and published their proceedings, which has led to an increase in specialised conservation literature but also to a decline in conservation literature in the general museum journals. The specialised bodies and professional codes increasingly caused conservators to be perceived as a separate group with its own identity and professional guidelines. All of these factors, including the development of training programmes in Europe and the US, have contributed to the development of conservation as a specialisation and an independent field of study.[19]

In the 1980s, however, influenced by the so-called communicative turn, many of the underlying assumptions of conservation faced increasing criticism.[20] In retrospect, scientific conservation after World War II was considered to be characterised by, for instance, a positivist faith in science, a climate of unbridled belief in the possibilities of scientific analysis, and new tools and technologies such as replacement or impregnation by synthetic polymers (Hummelen 1997; Caple 2000). Although for a long time science, associated with objectivity, truth and certainty, was the dominant rule and the goal of conservation treatment, in the 1980s influential conservation practitioners and thinkers such as Caroline Villers started to question the pre-eminence of 'objectivity' and condemn conservation as a 'truth-enforcement' operation. In an article published posthumously, Villers argued that the concept of 'minimal intervention', as one of the dominant attitudes in conservation in the second half of the twentieth century, derived from a positivist paradigm and was being used to construct a certain image of the modern conservator behind which one could hide one's responsibilities. Villers:

> Minimal intervention, here defined as an attitude of rational restraint, has helped to construct an image of the modern conservator as impartial. This restraint distinguishes the modern conservator from the artist-craftsman; it is the difference between an objective and a subjective approach to treatment. (2004, 4)

19 Nowadays, some conservation training programmes also offer a specialisation in modern and contemporary art conservation. For an overview: www.incca.org/education.

20 The following chapter will discuss these developments in more detail.

Indeed, traditionally, and perhaps as a consequence of the dominance of the hands-off dictum, the profession has been burdened with a persistent image of the conservator as a stuffy person, a passive custodian wearing white gloves and a white laboratory coat, tucked away in a conservation studio somewhere at the back of a museum. In its focus on the care for the material object, conservation 'can end up as an expensive nuisance in the eyes of those trying to create exhibitions, run excavations, open museums, etc. The conservator can become typecast as "an interfering nuisance with a negative attitude"' (Caple 2000, 183).[21] Such persisting stereotypes may, however, be fed by conservators who persist in portraying conservation as a distinct but generally underrated and misunderstood profession among other museum professions. Illustrative is Appelbaum's introduction to her latest book:

> We conservators have a difficult job. We work on a wide variety of things for a wide variety of owners while following ethical restrictions they are largely unaware of. We devote our professional lives to preserving for all eternity objects that we think of as the world's patrimony, even while the object's custodians use them, exhibit them, and sometimes love them to death. (2007, xvii)

Hiltrud Schinzel sums up the virtues of the conservator as follows: He (or she) has to be:

> *accurate*, tidy and meticulous, which includes the danger of turning into pedantry... *discrete and modest*, otherwise he is not able to devote himself to the work of art... *distanced*, otherwise he is not capable of finding the most objective conservational solution, but at the same time he has to be committed, otherwise he cannot develop the best possible conservational solution... *responsible* by taking the future into account, but at the same time he has to be *courageous* to ensure that the burden of

21 Based on literature research, Caple presents a rather hilarious but presumably still persistent set of stereotypes (ranging from a 'highly trained technician', 'frustrated curator' or 'pedantic nay-sayer' to an 'idle aristocrat') derived from a variety of colleagues (Caple 2000, 184). In later chapters I will come back to the relationship between conservators and curators which is generally portrayed (by conservators) as difficult.

responsibility does not make him unable to act and to assert his intentions against a more ignorant and less responsible *Umwelt.* (2004, 184–185)

Caple also expresses his fear for misunderstandings and calls on his fellow conservators to modify existing stereotypes of conservation by generating an image of confidence:

> It is [...] essential to develop conservation as a positive experience for all curators, museum directors, archaeologists, painting historians, connoisseurs and owners of objects. This is most effectively achieved through creating an image of competence which derives from running successful conservation, storage, recording or exhibition projects. (Caple 2000, 185)

A more affirmative attitude, he continues, can be stimulated through, for example, 'making difficult or awkward things happen. This creates the positive image of the conservator as an enabler.' But also through 'receiving a positive response from the public, or one's colleagues to the work which has been done. This may require publishing the successful project work' (Caple 2000, 185).

From the words of Caple and others, we learn that in the emancipation of conservation as a respected profession and in the struggle for recognition of conservation's goals and values there is little room left for an open debate or for expressing uncertainty or discomfort.[22] It can, however, be asked whether Caple's suggestion indeed leads to a more realistic, more nuanced image of conservation, or whether one myth is simply replaced by yet another. The uncertainties that can be considered an integral part of conservation knowledge and activities are compensated by the suggestion of control that tends to characterise conservation.[23]

22 Conservator Isabelle Brajer observes: 'Ignoring unsuccessful results continues to be a problem nowadays – it is an area that is hushed and overlooked, governed by taboos' (2009, 6).
23 In terms of further research it would be interesting to compare the notion of uncertainty in conservation practices with studies on dealing with uncertainty in other practices. A good starting point would be Mesman's study of uncertainty in neonatology medical practices (2008).

From the above, we have learned that conservation theory has been shaped to a great extent by its practices, and by theoreticians with a firm footing in practice. Theory and practice are in this respect very much intertwined. Prominent practitioners and pivotal figures like Ruskin, Viollet-le-Duc, Stout, Brandi, Philippot, and more recently people like Ashley-Smith, Hummelen, Laurenson, Van de Wetering, Weyer and the late Villers, play a large role in the development of conservation theory and ethics and reflect on professional practices in research institutes or museums. Commonly, they also hold teaching positions at one of the conservation training programmes, hold administrative positions at one of the professional bodies and are frequent contributors to conservation conferences, debates and edited volumes.

In terms of the relationship between theory and practice, from the above we have also learned that the history of conservation can be characterised by an apparent tension between these two. What is said and encouraged to be done in theory is not always put into practice. In this respect, theory and practice, to say the least, do not always converge. What guides conservation decisions is referred to as 'conservation theory' shaped by ethical codes, guidelines, controversies, conferences and a growing body of literature (Wharton 2005). Ethical and professional standards, so-called 'codes of ethics', have been developed by professional bodies such as the European Confederation of Conservator-Restorers' Organisation (ECCO), the International Council of Museums – Committee for Conservation (ICOM-CC), the American Institute for Conservation (AIC) and the United Kingdom Institute for Conservation (UKIC).[24] A conservation code of ethics is described as 'a statement of values, standards, and aims that guide all aspects of conservation work to which the entire profession of conservation can subscribe' (Sease 1998, 98). In relation to art, these professional codes prominently address two key concepts in conservation: authenticity and artist's intent. In the following section, these two vital concepts will be explored in more detail.

24 For a comparison and analysis of the codes of ethics of the different professional bodies see, for example, Sease (1998) and Janis (2005).

One of the central principles of conservation theory is that all conservation activities should be faithful to the 'integrity' of the authentic art object (Sease 1998; Clavir 1998, 2002; Muñoz Viñas 2005). This guideline was already stipulated in one of the first conservation codes of ethics: the American 'Murray Pease Report: Standards of Practice and Professional Relationships for Conservators' of 1963. Integrity of the artwork has been defined as including 'evidence of its origins, its original constitution, the materials of which it is composed and information which it may embody as to its maker's intentions and the technology used in its manufacture' (Ashley-Smith 1982, 2). Most codes of ethics specify different kinds of integrity: physical, aesthetic and historical. The first refers to the material components of the object. The second describes the ability of the object to create aesthetic sensations in the observer, whereas historical integrity describes the evidence that history has imprinted upon the object.[25]

In fine art conservation, the ethical issue of being faithful to the integrity or true nature of the object is often treated as akin to that of being faithful to the authenticity of the artwork and to the artist's intention (Clavir 1998, 2). The ethic of staying true to the integrity of the work of art is thus closely linked to the rigour of respecting both the authentic, original appearance of the work and the original 'artist's intent'.[26] It will come as no surprise that these two are very much tied up with each other and that they are both connected to the special status ascribed to the artist. Together with the notion of the 'artist as genius' and the concept of authorship, they form a robust cluster of values that is difficult to disentangle (Doorman 2004).

Underlying the strong belief in preserving the integrity of the object is the assumption that an object may have a true nature, intrinsic to it, that is related to its physical features, and that from these features a true state can be revealed through scientific examination. Such conservation theories bound by the notion of truth are part of what Muñoz Viñas refers to as 'classical conservation theory' (2005, 91). I will return to the idea of conservation as a truth-enforcement operation in the next chapter.

25 Compare Muñoz Viñas (2005, 66).
26 See also Wharton (2005, 164).

For now I will focus on the changing notions of authenticity and artist's intent as applied in conservation literature.

The notion of 'authenticity' has gone through many changes of definition and has been a much-debated topic amongst philosophers, from Rousseau to Heidegger and Goodman. If we take a look at the etymology of the term authenticity, we see that it is derived from the Greek word 'authentikos', which can be translated into 'made/done with one's own hands'. In conservation, authenticity is generally understood as 'authentic as original' as opposed to other definitions such as 'authentic as true to oneself' and 'authentic as trustworthy statement of fact' (MacNeil and Mak 2007, 27). According to this definition of authenticity, an artwork is authentic when the object is true to its origins. Authenticity in this sense suggests a direct relation to the past and its maker. In this definition, authenticity is strongly connected to monetary value as well as to power relations connected to the classification of real (authentic) and fake (non-authentic). Fyfe (2004), for example, explains the manufacturing of authenticity from the perspective of cultural capital.

An examination of the concept of authenticity in conservation takes us as far back as the beginning of the nineteenth century when the expression of the individual in the arts started to flourish at the expense of the idea of art as governed by strict rules. At the same time the differentiation between imitation and originality emerged; 'authentic art' in those days referred to art that was not derived from the classical canon (Denslagen 2004, 84–85). The 'museum era', with its romanticism, its nationalism and its historicism, showed a shift in attitude towards the remains of the past which is still noticeable in today's attitude towards cultural heritage. It is widely acknowledged that our contemporary understanding of authenticity is part of the legacy of the Romantic *Zeitgeist*. In the Romantic epoch the term was used so often that Lowenthal (1994, 1999), one of the few authors devoting considerable attention to the changing notion of authenticity in conservation throughout the ages, speaks of 'a cult of authenticity'.

In giant steps Muñoz Viñas walks us through the key developments in history:

> In the nineteenth century, the ideas of the enlightenment gained
> momentum and wide recognition: science became the primary
> way to reveal and avail of truths, and public access to culture and

art became an acceptable idea; romanticism consecrated the idea of the artist as a special individual and exalted the beauty of local ruins, nationalism exalted the value of national monuments as symbols of identity. As a result, artworks – and artists – acquired a special recognition, and science became the acceptable way to analyse reality. (2005, 3)

Explaining the increased attention to (material) authenticity, Lowenthal also attributes a special role to the increased significance attributed to science and new technologies:

Nineteenth-century technologies stepped up demands for authenticity. Growing knowledge of the past and skill in its delineation commanded ever-more convincing illusions of reality. And laboratory provenance and dating superseded revelation and miracles as criteria for authenticity. Expert scrutiny of sites and structures, archives, and contextual data confirmed or denied authenticity. (1999, 6)

In the twentieth century, as stated in the previous section, the urge to be truthful to material authenticity is prevalent but, in the case of a conservation object in need of treatment, other forms of authenticity can also be discerned. As discussed in the introduction to this book, in the situation of a conservation dilemma one is often presented with the choice between, for example, maintaining so-called 'conceptual authenticity' or opting for a treatment that favours 'material authenticity'.[27] But there is more. Dutch art historian Nicole Ex (1993) distinguishes among four forms of authenticity that can be valued in an artwork. She adopts Ernst van de Wetering's idea that the 'aura' (understood as the experience of authenticity) of an artwork is a subjective category that rests with the beholder, but next she argues that there are also several forms of authenticity that can rest with the *object* (Ex 1993, 94). The types of authenticity she describes are: (1) faithfulness to material authenticity, or staying true to the presumed original physical material object; (2) faithfulness to conceptual authenticity, or the prevailing of artist's intention; (3) faithfulness

27 These two forms of authenticity can be linked to a so-called concept-driven (humanistic) approach versus an object-centered (scientific) approach; two positions that, in controversies, are commonly in conflict with each other.

to contextual and functional authenticity, which, not surprisingly, refers to the original context and function of the object; (4) faithfulness to historical authenticity, which means that the history of the object is valued and made visible or left visible. Choosing an 'a-historical' or anachronistic treatment is considered opposite to a treatment that has as its aim to keep the historical authenticity intact.[28] Although the distinction among the types of authenticity has proved to be helpful in further refining the concept and application of authenticity, some argue that it has needlessly increased its complexity.[29]

Influential for a re-evaluation of the concept of authenticity in conservation was the Nara Conference on Authenticity held from 1–6 November 1994 in the city of Nara, Japan. During this expert meeting, around forty participants from nearly thirty different countries discussed the notion of authenticity in the context of world heritage. The conference was of great importance because it brought together Western and Asian thought on authenticity. The aspect of cultural diversity in principles and views was particularly highlighted.[30] The Nara Document of Authenticity reads, for example:

> All judgments about values attributed to cultural properties as well as the credibility of related information sources may differ from culture to culture, and even within the same culture. It is thus not possible to base judgments of values and authenticity within fixed criteria. On the contrary, the respect due to all cultures requires that heritage properties must be considered and judged within the cultural contexts to which they belong. (World Heritage Committee 1994)

28 Interestingly, in debates about authenticity in relation to music performances, similar forms of authenticity are distinguished: '(1) faithfulness to the composer's performance intentions; (2) faithfulness to the performance practice of the composer's lifetime; (3) faithfulness to the sound of a performance during the composer's lifetime; and (4) faithfulness to the performer's own self, not derivative of or an aping of someone else's way of playing' (Kivy 1995, 7). For a critical analysis of the concept of authenticity in music, see, for example, Taruskin (1995); Kivy (1995); Davies (2002) – and for a discussion of these critical accounts, see Peters (2009).

29 According to Denslagen (2004, 115–116), for example, the application of 'authenticity' should be reserved for historical material only.

30 See also: Ito (1995), Jokilehto (1995), and Lowenthal (1995).

Although the specific understanding of authenticity with its focus on uniqueness and materiality is persistent in Western conservation, it is widely acknowledged that increased attention to alternative notions of authenticity has influenced current Western thought. Over the years the principle of authenticity has been criticised from different angles. In the context of conservation it has been called elusive (Lowenthal 1999), a myth, a mission impossible, an ideological straightjacket (Cosgrove 1994) as well as something to escape from (Phillips 1997). This, however, is not to say that the zeal for authenticity has become obsolete. On the contrary, in our day and age, authenticity seems to matter all the more.[31] Lowenthal argues that although hard to pin down, authenticity receives ever more attention thanks to developments in art practices as well as due to increased skill and ease of replication and fabrication in art: 'As the floodwaters of primitive art, modern art, ironic art, and anti-art dissolve normative aesthetic standards, curators and collectors hold fast to any islands of authenticity they can still discern' (1989, 846). Although the concept of authenticity is much debated in conservation literature, it is also a very persistent idea, especially in relation to indeterminate contemporary artworks and the goal of maintaining an artwork's material authenticity.

Closely related to the guiding principle of respecting the integrity of the artwork and the concept of authenticity, is the notion of the artist's intention: the claim that the goal of art conservation should be to present the artwork as the artist originally intended it to be seen. Conservator Steven W. Dykstra (1996) traces the origins of this principle back to the late nineteenth century with the emergence of the natural sciences and conservation laboratories, claiming that advances in scientific analysis raised the possibility of identifying the artist's original materials and distinguishing them from later alterations or added materials. Scientific examination of the object therefore became an important source for ascertaining the artist's intent. The above-mentioned National Gallery cleaning controversy – also referred to as the Ruhemann versus Gombrich debate – set off the discussion about the role of science in relation to the concept of artist's intent when, as Dykstra writes, 'a technologically defined idea of following the artist's intentions was formalised as a principle of art conservation' (1996, 198).

31 See, for example, Doorman (2004) and Van Winkel (2007).

Interestingly, around the same time a separate debate on artist's intent arose when Wimsatt and Beardsley (later labelled 'anti-intentionalists') published their influential article 'The Intentional Fallacy' (1946) in which they argued – against the so-called intentionalists – that artist's intentions are neither available nor desirable as a standard for interpreting art. Although this text by Wimsatt and Beardsley provoked considerable debate in art criticism, literature criticism and philosophy, there was little if any crossover on this subject between these fields and art conservation (Dykstra 1996, 203). According to Dykstra, art conservators, unlike philosophers, historians and literary critics, did not take positions along the lines of intentionalism and anti-intentionalism. Instead, the community of conservators split into two ad hoc schools: aesthetic conservators (those such as Brandi and Gombrich, who let aesthetic arguments prevail) and scientific conservators (those taking science and laboratory work as points of reference for conservation). Dykstra: 'The broader issues became mired in methodological disagreement, and the principle of adherence to the artist's intentions was reduced to a casual tenet of conservation theory' (1996, 199).

Outside the conservation field, the relevance of intention for interpretation and appreciation of artworks has provided material for a long-lasting debate. Yet, although the concept of 'intention' has been the centre of much debate and contains a minefield of problems (which is to some extent also acknowledged in conservation theory), the concept of and quest for the 'original artist's intent' remains strong in conservation theory and practice. Thus, despite theoretical discussions on the subject of intention in literature and arts, in conservation practice and theory, there is a strong insistence on artist's intentions as being leading and authoritative. In conservation, the concept of 'artist's intention' plays an important role in interpretation and decision-making. Yet, in view of the messy usage of 'artist's intention' in conservation literature, conservation discourse could benefit from more conceptual clarity and consistency.

With reference to the discussions in literature and art theory, only few conservators have attempted to develop a clearer understanding of the notion of artist's intention applied to art conservation issues. Dykstra (1996), for example, turns to the work of contemporary hermeneutics to unravel the knotted meanings of the notion and builds on Richard Kuhns' (1960) philosophical account of eleven distinct variations of meaning in the usage of the term 'intent'. I will not repeat these different forms here.

What is important is that in conservation literature 'artist's intent' often coincides with 'what the artist means with the work' and becomes a facet of interpretation. Sometimes, conservators link 'intentions' directly to technical issues. In this respect conservator Joyce H. Stoner plainly argues: 'The artist's intent – the mattness, glossiness, or absence of varnish, the precision of brushwork, the roughness or smoothness of texture – must be maintained' (1985, 88).

Although many conservators realise that the artist will never be able to verbally communicate his 'deepest intentions', artist's information is considered indispensable to informed decision-making. In the context of contemporary art this information may be 'retrieved' through the work of art, the artistic process or consultation with the artist. With contemporary art conservation, when the artist is still alive, 'artist's intent' is often considered interchangeable with 'what the artist says about the work', and used as such. This approach to 'intention' as identical to 'the artist's telling' (Dykstra 1996, 208) often takes the form of consultation with living artists. Sturman expresses it as follows:

> When restoring art works from previous centuries there are few
> options beyond supposition regarding original intent and condi-
> tion. By contrast, today we are in the unique position of being able
> to document the contemporary artist's ideas and wishes for the
> conservation of his or her work. (1999, 394)

In the last decade the artist interview has become an important tool in conservation of contemporary art.[32] In addition to conducting more formal interviews at the moment of acquisition, another common practice is to consult the artist when preservation problems arise that were not anticipated during the acquisition. In case of uncertainties in how to deal with damage, obsolescence or reinstallation issues, the artist is often consulted or asked to authenticate decisions on presentation or conservation strategies. In some cases (for instance, with commissions and in situ executed installations) collaboration between artist and curator or conservator starts at the very beginning of the artistic process. This raises

32 For guidelines and examples of artist interviews for the purpose of conservation, see, for example, Weyer and Heydenreich (1996) and Beerkens et al. (2012). For early initiatives of gathering artist information on materials and techniques, see Gantzert-Castrillo (1979, 1999), Stoner (1984) and Mancusi-Ungaro (1999).

questions, such as: to what extent do ethics allow museum profession-als to put their stamp on the conceptual and physical dimensions of the work? Naturally, there is no single answer to the question of how much a conservator or curator should be involved in the creative process of the artist, just as there is no one answer to the question of how much an artist should dictate the conservation decision-making process or be involved in the conservation or restoration process.[33] Sanneke Stigter, then con-servator at the Kröller-Müller Museum in Otterlo, the Netherlands: 'The involvement of the artist in the conservation of his own work can be help-ful, but one should be aware that an artist's view evolves; any solution will tend to suit their current ideas and these can differ from the original intent' (2004, 108). Conservator Glenn Wharton explains:

> When the artist is alive and actively expressing his or her inten-tions, the focus shifts toward documenting and honoring the artist's interests. Problems arise when artists change their mind or express interests that are either unachievable or undesirable by current owners. Some artists recommend conservation strategies that dramatically alter their earlier work. Some prefer conserv-ing their own art using methods that contradict conservators' codes of ethics, such as repainting surfaces and changing original elements. Artists claiming continued rights to alter their work can come into conflict with owners, particularly when greater value is assigned to works from an artist's earlier period. (2005, 165)

Although still used in literature on conservation of contemporary art (usually in connection to the living artist and the need for artist inter-views), in the last two decades the positivist view of 'artist's intent' came under pressure and calls for alternative notions came into view (Dykstra 1996; Villers 2004). In recent years, concepts of both authenticity and artist's intention have been carefully reconsidered in contemporary art conservation literature. Much of this literature, for example, criticising the common original/copy divide, is inspired by issues of reproducibil-ity and discourses of time-based media art and sparked by performance

33 Or as Van de Wetering remarks: 'Knowing the artist's wishes and intention, however, does not auto-matically mean that the restorer's interventions should be in line with them. Consequently, one is inclined to conclude that restoration has a certain autonomy independent, to some extent, from the artist's intentions' (1996, 195–196).

theory and performance arts such as music and theatre (Rinehart 2000, 2007; Fiske 2006; Ippolito 2008; Bardiot 2010; Jones 2009). Authors such as Van Wegen (1999) have referred to the notion of 'score' in the context of contemporary art conservation and more recently Pip Laurenson, head of collection care research at Tate, London, in an already seminal article has observed that the 'notion of authenticity based on material evidence that something is real, genuine or unique is no longer relevant to a significant portion of contemporary art' (2006). Laurenson suggests that authenticity should be measured by different criteria found in, for example, the work of philosopher Stephen Davies (2001). In the same vein she advocates the redefinition of the notion of artist's intention in terms of 'work-defining' properties.[34] The artist interview, according to Laurenson, remains a means for the artist to articulate these work-defining properties (Laurenson 2006). As an alternative to the concept of 'authenticity', the notion of 'historically informed performance' was recently added to art conservation vocabulary.[35]

In sum: in recent years the concepts of authenticity and artist's intention have been scrutinised from the perspective of (though not limited to) contemporary art conservation. The general strand is that classical or traditional notions of these concepts have become problematic in light of contemporary art characteristics. Consequently, increasingly attempts are made to redefine these core concepts in conservation theory. A new frame of reference and new vocabularies and qualities such as flexible, fluid, variable and medium-independent are introduced, slowly replacing old terminologies of fixed, stable, scientific freeze-frame, material authenticity and medium-specific. In the following chapters, I will investigate how the concepts of authenticity and artist's intentions are used in

34 Building on Nelson Goodman's categories of allographic and authographic artworks, Laurenson (2006) argues that installation artworks, like musical works and theatre, can be considered as two-stage art forms because they can only be experienced when they are installed. The first phase is the actual conception by the artist and the second phase of the artwork's realisation is the act of installing the installation. In this respect, according to Laurenson, the art installation and reinstallation encompass an element of performativity.

35 From the 1960s onwards, the concept of 'historically informed performance' (HIP) was already widely used in the context of musical performance criticism: see, for example, Kivy (1993, 117–137); Lawson and Stowell (1999); Butt (2002). Only recently it has been introduced into the context of fine art conservation as an alternative way of grounding claims of authenticity. The concept was, for example, used in discussions during the conference 'Art, Conservation, and Authenticities/Material, Concept, Context' organised by the University of Glasgow, Scotland, September 12–14, 2007.

concrete practices. Are these terms both considered to be obsolete or do they still have currency in today's museum practices?

1.4 CONCLUSION

In this chapter I explored notions of so-called classical or conventional conservation theory. The adjectives 'classical' and 'conventional' already suggest that this particular body of theory lies in the past and that it has been replaced by another (more contemporary) theory of conservation. Authors such as Villers (2004) and Muñoz Viñas (2005) situate the beginning of this transformation and the rise of critical voices against the 'classical' essentialist conservation approach in the 1980s. Villers, for example, mentions that between 1983 and 1996 the term 'true nature' disappeared from the United Kingdom Institute for Conservation of Historic and Artistic Works' (UKIC) guideline for conservation practices. In the above it was also argued, however, that many of the ideas still alive in conservation practice and theory today can be traced back to notions developed in this so-called 'conventional conservation theory' or 'freeze-frame paradigm'. It seems inappropriate, therefore, simply to state that the traditional has been replaced by a contemporary theory of conservation. Instead, we seem to catch conservation theory in a state of transformation.

From the above we have seen that the absence of open discussion on conservation of installation art (or in any field of art for that matter) can be explained by looking at the historical roots of conservation practice. Conservation, as a relatively young, developing profession has been fighting a disciplinary struggle, leaving little room for reflection and criticism. Another characteristic addressed is the individual character of the profession; conservation is said to be less collaborative than many other disciplines. Notwithstanding its increasingly interdisciplinary character, conservation is still very much a one-person operation with few shared responsibilities in decision-making and treatment. Despite notable emancipation, the field of conservation is burdened with some persistent stereotypes and a low esteem in the hierarchy of museums. Generally speaking, conservation training has been insistently material and scientifically oriented, even though recently other capacities such as negotiation and coordination skills have come increasingly into focus.

The predominance of science, so I argued, has allowed conservators to hide behind supposedly objective and impartial methodologies. New developments in methods and techniques of examination and treatment are implemented with hesitation since recognising new standards would imply acknowledging that previously employed methods have caused damage to objects treated earlier – and thus undermine the conservator's authority. Last but not least we have seen that fear of scandals, controversies, claims and lawsuits stimulates a culture of confidentiality and renders conservation practices opaque.

In terms of the key concepts in conservation, we have seen that like the concept of authenticity, the notion of intention is traditionally understood in terms of freezing the object at a certain moment in time. Both concepts are strongly linked to the idea that artworks have an ideal single state (generally coinciding with the supposed original state). In conservation theory and ethics, artist's intent and authenticity commonly refer to a single, past, frozen moment in time and in this respect they are concepts of timelessness (Albano 1996, 183). As applied in conventional conservation theory, they thus presuppose a static object. All change is measured against this moment of wholeness, the preferred, original state of the object and therefore logically valued as loss. Or as Pip Laurenson describes, within the traditional conservation framework, 'change is understood in reference to the state of the object, and change which is irreversible and undesirable is defined as damage or loss' (2006).[36]

In the following chapters I will explore how the notions of authenticity and artist's intent figure in museum practices. In the first case study chapter, we will see how the current understanding of authenticity insists on a material understanding of the object and how it encourages documentation of the physical object. The second case study demonstrates that 'intention' is associated with a more conceptual understanding of the artwork, displayed in the practice of engaging the artist in conservation practices. By exploring the processes that shape the artwork in the museum context, I intend to demonstrate that authenticity and artist's intentions are not necessarily located with the artwork or the artist, though this view is still prevalent in conservation theory and practice. Instead, I offer an alternative view on these concepts by analysing how

36 On changing values towards decay and aging in the context of cultural heritage, see, for example, Lowenthal (1994), on evaluating change, see Ashley-Smith (1999) and Appelbaum (2007).

authenticity (chapter 2) and intent (chapter 3) are 'being done'; how they are constructed through documentation, artist interviews, negotiations and so forth. As authenticity and artist's intent can only be known in reconstruction, they *become* tangible in museum practices. Rather than fixed and ontological, they are *process-oriented* and *performed* and can be studied as such. Therefore, I focus on these concepts not as problems that need to be solved, but as solutions to problems that emerge from the desire to preserve and present what is valued. With respect to the following chapters in which I will empirically investigate the key notions of 'authenticity' and 'artist's intention' in practices of contemporary art conservation, I aim to follow Clifford Geertz's oft-quoted comment:

> The important thing about the anthropologist's findings is their complex specificness, their circumstantiality. It is with the kind of material produced by long-term, mainly (though not exclusively) qualitative, highly participative, and almost obsessively fine-comb field study in confined contexts that the mega-concepts with which contemporary social science is afflicted – legitimacy, modernization, integration, conflict, charisma, structure,...meaning – can be given the sort of sensible actuality that makes it possible to think not only realistically and concretely *about* them, but, what is more important, creatively and imaginatively *with* them. (1993, 23)

From Singularity to Multiplicity: Authenticity in Practice

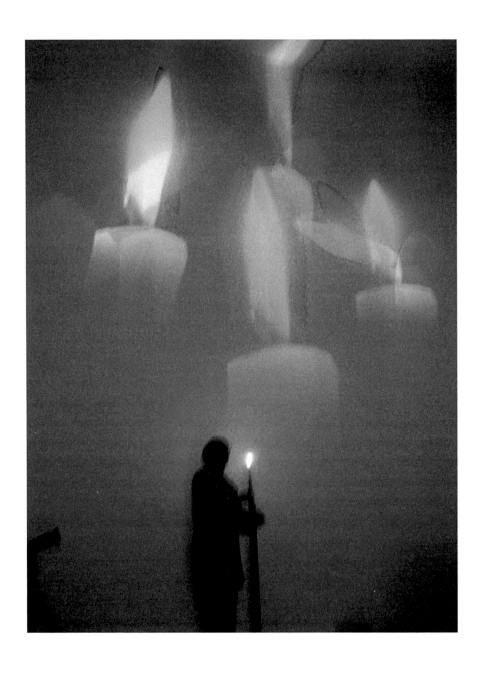

FIG. 4 – Every morning, before the museum opens its doors, the candle of *One Candle* is lit by a museum guard. MMK Frankfurt am Main, November 2006.

On a regular morning, at quarter to ten, a museum guard arrives at the second floor of the Museum für Moderne Kunst in Frankfurt am Main, Germany. She leaves her small bag on the chair facing the exhibition room and walks into the space of One Candle. *The room is dark. From underneath one of the projectors, she takes the matches and turns to the candle at the farthest end of the small triangular room. In one movement she lights the candle. The room is suddenly illuminated by images of a single burning candle; the flickering flame being projected by a video camera onto the walls in three different colours. The guard looks at the projections on the walls; she inspects the position of the video camera and lowers the candle in its tripod. Then she wipes some candle wax off the floor. And after deciding that all looks well, she takes her seat to await the first museum visitor.* [figure 4]

This small routine is repeated every morning at the Museum für Moderne Kunst in Frankfurt am Main (hereafter referred to as MMK). Before visitors enter the museum, *One Candle* is prepared for its display. The cathode ray projectors are turned on and the candle is lit. *One Candle* by Korean artist Nam June Paik (1932–2006) is a closed-circuit installation consisting of a burning candle filmed by a video camera and projected on the walls by several divergent cathode ray projectors. The work was first installed in 1988 at Portikus, a gallery space devoted to contemporary art in Frankfurt. In 1991, the year that the museum opened its doors, the work entered the collection of the MMK.[1] [figure 5]

Since its acquisition, *One Candle* has been on display almost permanently in the same triangular room. Right from the start, however, the MMK was challenged by the obsolescence and malfunctioning of the cathode ray tube projectors used in this work. In fact, after five years – in 1996 – the entire set of projectors was replaced by a new set of contempo-

1 The MMK, a middle-sized museum, founded in 1981, opened its doors in 1991. The triangular museum building, baptised by locals as 'the slice of cake', was designed by the Viennese architect Hans Hollein and covers approximately 4,150 square meters. Its starting point was determined by the City of Frankfurt's acquisition of around 89 artworks from a major private collection, 'The Ströher Collection', with a focus on Minimalism and Pop Art of the 1960s. The museum counts around 20 staff members. Successive directors: founding director Jean-Christophe Ammann (until 2001), Udo Kittelmann (until 2008), Susanne Gaensheimer. The MMK has been described as a 'postmodern museum'. See Grunenberg (1999) for an expanded discussion on typology of contemporary art museums. For more information about the MMK: www.mmk-frankfurt.de/.

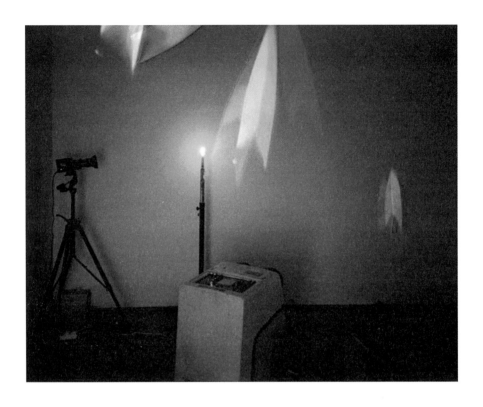

FIG. 5 – *One Candle* installation view in the MMK, Frankfurt am Main, before equipment change, November 1991. The photo shows one of the large CRT projectors, currently no longer present in the room. The image does not show whether visitors could enter the space or whether the projectors were protected by a cord separating the visitor from the work as is currently the case.

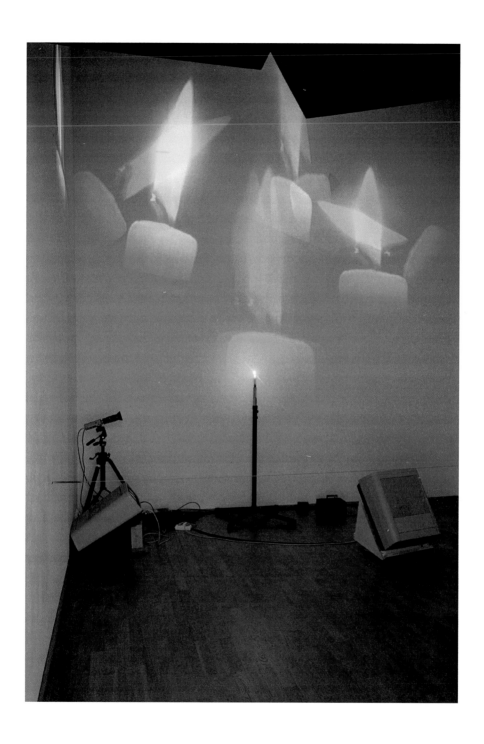

FIG. 6 – *One Candle* installation view at MMK in 2007, after the larger CRT projectors of previous years had been replaced by modern Sony versions.

rary cathode ray projectors. [figure 6] Over the last few years these new projectors have also required maintenance: tubes have been replaced and several other repairs have been carried out.[2] Despite these efforts, the current technological equipment is now also obsolete and decisions have to be made whether and how to update the current projectors.

In 2004, the conservator of the MMK selected *One Candle* as a case study for the research project Inside Installations: Preservation and Presentation of Installation Art.[3] The project, supported by the European Commission, provided an opportunity to further investigate the conservation problems of *One Candle* in relation to its technical equipment. One of the central questions raised by the conservator was: 'What is the significance of the projectors and what are possible solutions for carrying this work into the future?'[4] The research aimed, in the words of the conservator, 'to investigate whether it is possible or necessary to go back to the original projectors used in the display of 1988.'[5] By replacing the equipment in 1996 with more sophisticated cathode ray tube (CRT) projectors, the physical appearance and other technical specifications of the projectors as well as the quality of light they produced changed. And since these particular 'original' cathode ray projectors are no longer in production, the research consisted of an investigation into the possibilities of repairing the initially used equipment, an exploration of the availability of similar equipment and an investigation into the possibilities of upgrading the equipment to a more contemporary standard.[6] How then would replacement affect the meaning and value of the work? The initial description of *One Candle* as a research object in the project Inside Installations states:

> The cathode ray projectors that Paik originally used are no longer produced (only a few are still available), and an LCD projector

2 Conservation of electronic and digital components depends on a continuing proactive involvement of museum staff. Reformatting, small repairs, and 'fixing things' with regard to technical equipment are generally accepted as maintenance and not considered a restoration treatment (Keene 2002).

3 See the introductory chapter for further information on the research project Inside Installations: Preservation and Presentation of Installation Art.

4 Case study description for Inside Installations, written by Ulrich Lang, conservator MMK, November 2004, unpublished. The position that I refer to as 'conservator' is at the MMK referred to as 'restorer'. In accordance with vocabulary used during Inside Installations and to avoid confusion, I will remain using the term conservator.

5 Interview with Ulrich Lang, conservator, MMK, 03.06.2005.

6 See the research report of Tina Weidner (2004).

with only one tube could not project three different images of a burning candle. Because it is important to have the overlap on the wall (the overlap produces a whole colour range and a white image in the centre), one option would be to put three small LCD projectors in one old body, one each for red, green, and blue. But this solution would have enormous costs, would destroy the interior of the old projectors, and would reduce the possibilities of future reconstruction. And the image would still be different, even if filters were used to match the light temperature.[7]

In this problem description, formulated by the conservator, several value claims are made about the importance of the archaic cathode ray tubes for the identity and functionality of *One Candle*. First of all, the aesthetic qualities of the technological characteristics of cathode ray projectors in general are valued ('because it is important to have the overlap on the wall' and, in case of replacement, 'the image would be different'). The conservator here refers to the so-called 'aesthetic authenticity' of the work. Also, special value is attributed to historical authenticity of the current set of projectors.[8] The conservator describes replacement of the cathode ray tubes by contemporary liquid crystal display (LCD) projectors in terms of value loss. The projectors, in his view, are to be considered a vital part of the work's authenticity.

Of particular interest to the conservator was an investigation into the documentation of light so as to be able to distinguish between the differing light qualities of the successive projectors. How were the colours of the projections in those days? What did *One Candle* look like before the replacement of equipment? Are the projectors interchangeable or should they be considered essential for maintaining *One Candle's* authenticity? The underlying question that emerged from the obsolescence of the projectors was: what is *One Candle* and what does it mean for *One Candle* to change?

7 Case study description for Inside Installations, November 2004, unpublished.

8 See the previous chapter for an exploration of the notion of 'authenticity' in relation to art conservation, and the different kinds and definitions of authenticity. In this chapter authenticity refers to the category of authenticity defined as 'authentic as original' (as opposed to other definitions such as 'authentic as true to oneself' and 'authentic as trustworthy statement of fact'. According to this definition of authenticity, an artwork is authentic when the object is true to its origins (see also MacNeil and Mak 2007, 27).

Of course, *One Candle* is not unique in its conservation problems. Other museums with works by Paik in their collections are dealing with comparable problems concerning breakdowns and obsolete video equipment. In fact, the legacy of Nam June Paik (who is recognised as the godfather of video art and one of the most influential video artists of our time) has in the past functioned as a springboard for discussions on the preservation of technology-based art in general and time-based art in particular. The symposium 'Wie haltbar ist Videokunst?/How Durable is Video Art?' (November 25, 1995) at the Kunstmuseum Wolfsburg in Germany was, for instance, held on the occasion of the Paik exhibition 'High-Tech-Allergy' and discussed similar questions in relation to other video artists (Otterbeck and Scheidemann 1995).[9]

By the end of the 1990s, artworks using technological components had received considerable attention in conservation research and literature. Although the development of strategies of how to deal with obsolete technological equipment is still very much subject to research and discussion, two extreme approaches can be distinguished: the 'purist, original-technology-at-all-costs approach' and the 'adapted/updated technology approach' (Viola 1999, 279–294; Laurenson 2004, 51).[10] The first approach represents those artists, conservators and curators attaching a high level of importance to the maintenance of original equipment. An example is the exhibition of Swiss video installations from the 1970s and 1980s at the Kunstmuseum Luzern. For this event a lot of effort was put into displaying the works in their 'original' state, thus using the technologies from the time of the works' conception.[11] The other approach, replacing out-dat-

9 For other articles on the conservation of Paik's works, see Bors (2000); Hanhardt (2003); Lacerte (2007); Jones and Stringari (2008); and Shirley (2008). Shortly after Paik's death in 2006, on February 16, 2007 a panel discussion on the preservation of Paik's time-based work was organised by the International Network for the Conservation of Contemporary Art – North America (INCCA-NA), together with the Museum of Modern Art, New York (MOMA), the American Institute of Conservation (AIC), and the Getty Conservation Institute (GCI), titled 'Preserving Nam June Paik's Video Installations: the Importance of the Artist's Voice.' In October 2007, the Total Museum of Contemporary Art (Seoul, Korea) organised an international symposium on the work of Nam June Paik.

10 Needless to say that the same conservator may adopt different approaches in identical material situations, given the direction provided by the artist. See also the next chapter for an elaborate discussion on the weight given to the artist's voice when devising a conservation decision.

11 The exhibition 'Swiss Video Art from the 1970s and 1980s: A Reconstruction', curated by Johannes Gfeller and Irene Schubiger, was on show from March 15 to May 2008, and was organised in collaboration with AktiveArchive (HKB Bern, SIK Zurich, BAK). For more information on AktiveArchive and the reasoning behind this exhibition, see Phillips (2007) and Schubiger (2009).

ed technology by more sophisticated technologies, has become known as 'emulation' (creating a facsimile in a different medium) or 'migration' (upgrading the technology to a more contemporary standard).[12]

Although there is no single solution to the problem of obsolete technologies used in Paik's work, there is currently a general tendency to refrain from replacing original (or what is thought to be original) equipment for as long as possible, or – if necessary – to place new technologies in the original casings so as to preserve the *look* of the original equipment.[13] In an interview with a Dutch magazine, Wulf Herzogenrath, director of Kunsthalle Bremen (Germany), for instance, strongly argues for the preservation of the original television sets used in Paik's work: 'We, as museum, will always pursue the same effort as with a restoration of Rembrandt's *Nightwatch*. It will always cost money, but in the case of an important work, we will find a way to restore even the most complicated technology.'[14] A similar statement was made at 'Preserving the Immaterial: A Conference on Variable Media', which took place at the Solomon R. Guggenheim Museum, New York, in 2001 and during which Paik's work *TV Garden* (1974) was discussed extensively. In light of the conservation problems of *One Candle*, it is interesting to cite particular excerpts from this conference at length.[15] On discussing *TV Garden* in the collection of the Guggenheim, Stephen Vitiello, sound artist and one of Paik's former assistants, says:

> *TV Garden* is a conceptual work. He [Nam June Paik] may never have written it down, but there is an implied score: play Global Groove with sound on multiple monitors in a room; monitors face up and surrounded by plants.

12 Both strategies have been explored and further developed by, for instance, the 'Variable Media Approach', an initiative of the Guggenheim Museum in New York (Depocas et al. 2003). The Variable Media Approach as well as the DOCAM project suggests a 'media-independent' preservation approach which allows for migration of obsolete formats to more contemporary technologies.

13 It is said that nowadays even Paik's assistants are acting in a more conservational fashion towards the technical equipment used in Paik's work.

14 Herzogenrath quoted by Bors (2000, 18). Original text in Dutch: 'Wij, als museum, zullen dezelfde moeite betrachten als bij een restauratie van Rembrandts *Nachtwacht*. Het kost altijd geld, maar als het een belangrijk werk betreft, vinden we een manier om zelfs de ingewikkeldste technologie te restaureren.'

15 All are excerpts from 'Preserving the Immaterial: A Conference on Variable Media', which took place at the Solomon R. Guggenheim Museum, New York, on March 30–31, 2001 (published in: Depocas et al. 2003, 74–77).

And that is what's key. Beyond that, he would be fairly flexible. Flat screens inside casings would be fine. The piece doesn't require the same casings that were installed at the Everson Museum of Art in 1974 or the same casings that were at the Whitney in 1982, but it is important for the Guggenheim to trace the history of the work. When presented, viewers should understand that *TV Garden* was originally conceived of in 1974 and has a history of different ways of being presented. (Vitiello quoted in Hanhardt 2003, 76)

In his reply to Vitiello, senior curator of film and media arts at the Solomon R. Guggenheim Museum and renowned specialist in Paik's work, John Hanhardt, places more emphasis on historical awareness:

You've raised a complex set of points. As a conceptual work, *TV Garden* can respond to the changes in the medium over time. There's also flexibility in terms of location and the differing aesthetics of various televisions and types of plants in different locales. Yet it's important to have historic examples of the various *TV Garden* installations.

Let's say we were doing an historical exhibition of video from 1970 to 1975. If we wanted to represent *TV Garden* as it was then, it would be very important to have those particular televisions as a resource. For this reason, the storage of television casings is something we should pursue. When we do a show in a contemporary way, we should also display photographic documentation of a variety of previous installations. (Hanhardt 2003, 76–77)

Thus, although Hanhardt agrees that *TV Garden* should not be presented in one single fixed form and that a certain degree of flexibility is part of the work, he also feels the need to keep historic examples of the different *TV Garden* installations. The curator therefore suggests keeping open the option of having an historical installation as well as a contemporary installation. To this, Vitiello adds: 'The piece has been flexible and will probably continue to be flexible. Nam June Paik would be happy with the piece as long as we're aware of those key points that he set in stone' (Vitiello quoted in Hanhardt 2003, 77). Paik was known for his active participation with curators and technicians in reinstalling and technically

upgrading his works which would seem to argue in favour of a flexible attitude towards replacement of obsolete technologies. Yet, he was also known to be rather reluctant in providing installation instructions and ambiguous about what should happen if he was no longer around.[16] It is therefore not easy to reconstruct his ideas about conservation from his statements and practices. During the conference in New York, Stephen Vitiello recalled an earlier conversation with Paik:

> In 1996, I introduced Nam June Paik to two curators from Brazil, who were asking him to do this first major exhibition in Brazil. He exhibited *TV Garden*, *TV Fish*, and *TV Buddha* and explained to me that these pieces could be done working from a distance – the curators could get their own plants, their own fish, and their own Brazilian Buddha. When I started to pin him down on how to construct these pieces, his favourite thing to say was, 'Use your judgement.' (Vitiello quoted in Hanhardt 2003, 74–75)

Other artists have been more outspoken about preservation strategies in case of obsolescence. American artist Bill Viola (1951), for example, is very specific about the display equipment used in his works. In the case of *Nantes Triptych* (1992), a video installation in the collection of London's Tate Modern (Great Britain), Bill Viola stated a preference for the original set of cathode ray tube projectors to 'stand as it is, as a piece made at a particular time, reflecting the technology available at that time' (Laurenson 2001b, 115). But, as Pip Laurenson acknowledges: 'Keeping things as they are is harder than one might think, especially in relation to display equipment such as projectors' (Laurenson 2001b, 115).

In the case of *One Candle*, even finding one unanimous answer to the question of what is 'set in stone' and what thus needs to be preserved wasn't easy. During the research it turned out that several staff members within the MMK held different opinions about what should be considered vital to *One Candle*'s authenticity. This issue of multi-actor perspectives is the subject of sections 2.3 and 2.4. In section 2.5, I will show how (despite these different perspectives) singularity is accomplished: how

16 See also 'Preserving Nam June Paik's Video Installations: the Importance of the Artist's Voice', a panel discussion hosted by MOMA New York, February 16, 2007. A video recording of the event was kindly made available to me by INCCA.

the *One Candle* at the MMK in Frankfurt gained the status of a single and unique artwork in need of conservation. In section 2.6 and thereafter, the focus will shift from perspectives to practices and I will explain how, in the search for *One Candle*, its solidness crumbles and how it is also more than one. From singularity to multiplicity, that is what this chapter is about.

But first, let me introduce another *One Candle*, because although the MMK's *One Candle* in Frankfurt was treated as a single and unique work, my initial interest in the work was raised by a *One Candle* I experienced in Berlin. [figure 7]

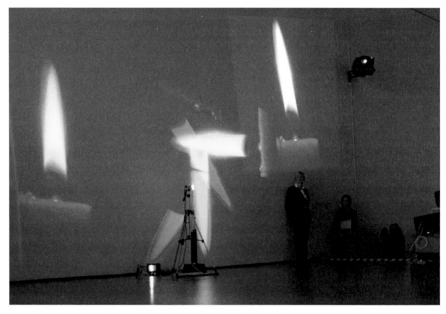

FIG. 7 – Installation view of *One Candle* at 'Global Groove 2004', Deutsche Guggenheim Berlin, October 2004. The candle flame is projected on the two sides of the gallery space as well as the ceiling. A set of large three-colour projectors is installed in the middle of the space opposite of the camera (not visible on this photo). The candle is watched over by a guard (on the photo next to the tripod on the right).

The first time I saw the work *One Candle* by Nam June Paik was in 2004, during the temporary exhibition 'Global Groove 2004' at the Deutsche Guggenheim in Berlin.[17] It was not until a year later, during one of the first meetings of Inside Installations, that I learned *One Candle* belonged to the Frankfurt collection. I was at the time surprised to see images of the work in the collection of the MMK. In fact, I doubted whether what I saw in Berlin was the same *One Candle* as the one in the collection of MMK. Despite the many similarities, there were also striking differences in appearance and the way I experienced it: I remembered the *One Candle* in Berlin as a dramatic piece, providing the gallery walls and ceiling with a stunning and vibrant background of candle light. The *One Candle* in Frankfurt, however, seemed to be very modest and intimate – almost like a chapel. Did my memory deceive me? Was it not *One Candle* that I'd seen in Berlin after all? How could it be that two seemingly different installations go by the same title, artist and date of creation? In Berlin, there was no reference to the *One Candle* in Frankfurt. How then does the *One Candle* I saw in Berlin relate to the one in Frankfurt? Might there be more than one *One Candle*? Actually...how many *One Candle*s exist and by whom, and how is it decided which is the authentic artwork: the first *One Candle* as installed at Portikus, the *One Candle* as it entered the MMK collection in 1991, the *One Candle* at MMK from 1996 onwards when the set of equipment was replaced by a new set, or the *One Candle* that I experienced in Berlin? Could all these different *One Candle*s be equally authentic?

Still a bit puzzled but even more curious about this work in particular and issues of uniqueness, authenticity and authority in general, I decided to look into the histories of *One Candle,* and with them into the working practices of the MMK. Not in order to judge their procedures and decisions, but to explore how *One Candle* and the problem of authenticity is performed or enacted in the museum practices at hand.[18] To avoid

17 The Deutsche Guggenheim in Berlin is a partnership between the Solomon R. Guggenheim Foundation and the Deutsche Bank. The gallery space covers about 510 square metres and is located on the ground floor of the bank's premises. It hosts around three to four exhibitions a year. 'Global Groove 2004' ran from April 17 to July 9, 2004.

18 The term 'performance' was recently introduced in discussions about conservation research and treatment in order to indicate the active role and agency of conservators within activities of problem definition and value creation. 'Performance' in this context, is used to indicate that conservators are not 'just' neutral custodians, but that their behaviour and activities have a formatting effect. The word

confusion, it should be clear that I myself was not involved in the actual research on conservation of *One Candle* within the project Inside Installations. This was done by people far better equipped for this job than I am. My role and engagement was that of a participant-observer, studying the day-to-day working practices of the museum in terms of conservation and presentation by employing methods of ethnographical research.[19] After arranging several interviews with museum staff members, I booked a train ticket to Frankfurt and set out to explore what appeared to me to be the coexistence of more than one *One Candle*.[20]

2.3 AUTHENTICITY AS A MATTER OF PERSPECTIVE

As we have seen in the previous chapter, museums (including museums for modern and contemporary art) are traditionally concerned with the conservation of rare and unique objects. The traditional museum attaches a high value to objects that are considered to be authentic. Indeed, authenticity, uniqueness and originality constitute the foundation of today's museum collections. Generally speaking, when we speak of an authentic artwork, we presume a single, unique artwork, preferably signed by an artist, whose 'original' material condition reveals the original artist's intent and the *true* identity of the artwork. This understanding of authenticity fits well with the single-genius, single-date conception traditionally favoured by art history and the art market.

'performance' here is restricted to the domain of humans only. To expand the capacity of agency to objects and to avoid confusion with 'performance' as referring to a particular art form, I will further use the less-loaded term 'enactment' (see also Mol 2002, 32–33, 41–42 on her choice for attributing 'enact' instead of 'perform').

19 See the introductory chapter on ethnographic methods of doing research.

20 Many of the materials presented here were produced during several trips to the MMK. Fieldwork was conducted between January 2005 and October 2007 and included observations, documentation research and interviews with museum staff. I am grateful to the staff of Portikus and the MMK for allowing me to shower them with questions and for making me feel welcome. Throughout this book, the English translations of citations from interviews originally in German or Dutch are my own. These as well as the citations in English may have been adjusted slightly in order to improve legibility. The respondent's position mentioned (director, conservator, curator of collections etc.) is the position this person held at the time of the interview. For their constructive comments on earlier versions of this text, I thank Tatja Scholte, Glenn Wharton, Annemarie Mol, Sally Wyatt and the participants of the research colloquium AMC, as well as the organisers and participants of the conference 'Art, Conservation, and Authenticities/Material, Concept, Context' (University of Glasgow, Scotland, September 12–14, 2007).

Authenticity, in the context of art conservation, traditionally refers to the category of authenticity defined as originality.[21] An authentic object is true to its origins, first-hand, genuine, as opposed to copies. In the scientific model of conservation, asserting to the object's 'true nature' is considered the primary means to secure the connection to the artist, in whom authenticity is grounded. In other words: authentic art objects provide us with a direct link to a particular past and a particular artist.

Underlying conservation theory and practice is thus the assumption that an object has (or had) a true nature or true state or condition that should be maintained by means of conservation or to which one can return by means of scientific research and restoration. Illustrative are the definitions used by professional conservation bodies: 'Conservation is the means by which the original and true nature of an object is maintained',[22] and 'Conservation is the means by which the true nature of an object is preserved'.[23] It will come as no surprise that after the act of restoration people often claim that the true nature of the object is once again *revealed*.

Yet around the 1980s critical thoughts were developed opposing this so-called 'objective' and 'truth-enforcing' approach to conservation. These critiques led to what Spanish conservator Salvador Muñoz Viñas calls 'the communicative turn in conservation' creating 'a contemporary theory of conservation': a new way of understanding conservation and restoration activities (Muñoz Viñas 2005, 91–113, 147–170). Conservation was no longer considered as the objective acts of an impartial conservator engaged in truth-enforcing activity, but rather as a social process (Avrami, Mason and de la Torre 2000; Clavir 2002; Laurenson 2006). The most significant difference between the so-called classical and contemporary theory of conservation is that the latter shows a keen awareness of historic and cultural variations in preferences. Thus what is labelled 'the true state' in classical theory is according to contemporary theory no truer than the existing state; it is simply a more preferred state. This shift of thoughts, according to Muñoz Viñas, has far-reaching consequences for conservation theory and practice:

21 Other definitions of authenticity are, for example, 'authentic as true to oneself' and 'authentic as original'. See: MacNeil and Mak (2007) for a close exploration of these different definitions.

22 United Kingdom Institute for Conservation of Historic and Artistic Works, Guidance for Conservation Practice, London 1981, cited by Laurenson 2006.

23 New Zealand Professional Conservators Group, The Code of Ethics, Wellington and Auckland, New Zealand 1991, amended, p. 6, cited by Laurenson (2006).

The communicative turn in conservation has important conse-
quences upon the entire logic of conservation. Communication
is not a physical or chemical phenomenon, nor is it an intrinsic
feature of the object; rather, it depends on the subject's ability to
derive a message from the object. In contemporary conservation
theory, the primary interest is therefore no longer on the objects,
but rather on the subjects. Objectivism in conservation is thus
replaced by certain forms of subjectivism. (2005, 147)

Muñoz Viñas further argues that the criticisms of objectivity in conserva-
tion have also led to a redefinition of the complex notion of authenticity.
Due to the communicative turn in conservation, he argues, authenticity
is not necessarily contained in the artwork (and its materiality), nor does
it rest with the artist, a thought that long predominated in conservation
practice. Instead, claims for authenticity entered the realm of interpreta-
tion and subjectivity, and became a matter of perspectives. Put otherwise:
preoccupation with materiality, shifted to a preoccupation with the inter-
pretative value of objects. Rather than considering 'the objective truth' as
a primary goal, contemporary theory of conservation acknowledges the
subjectivity of decisions and attribution of values. In this view contempo-
rary theory of conservation is based on *negotiation* (Avrami, Mason, and
de la Torre 2000; Staniforth 2000), on *equilibrium* (Jaeschke 1996; Ber-
geon 1997), on *discussion* (Molina and Pincemin 1994), and on *consensus*
(Jimenez 1998; Cameron et al. 2001).[24] Thus, instead of an absolute value
or an objective 'given', authenticity was understood to lie in the eye of
the beholder, depending on by whom, from which perspective and when
authenticity is assessed (Muñoz Viñas 2005).

This insight has introduced a new problem, however, namely the dis-
tribution of involvement and authority in matters regarding presenta-
tion and conservation.[25] If authenticity is 'just a matter of perspective',
whose perspective then will be the leading one in situations of disagree-
ment? Who, in other words, is the final decision-maker? How significant
and decisive are, for example, values attributed by a museum when these
oppose the values presented by the artist, or his or her representatives?[26]

24 See Muñoz Viñas (2005, 163).

25 On the issue of authority and control in relation to conservation, see, for instance, Real (2001,
223–224); Laurenson (2004, 49–53); Fyfe (2004).

26 See chapter 3 for a discussion on the weight given to the artist's voice in decision-making.

Also, problems may arise *within* the museum between differing value-sets and perspectives held by different parties. Museum professionals will share the assumption that a work of art in the collection is in need of conservation and should be preserved for future generations. However, different parties within the museum interpret and value artworks and their components differently due to their differing professions and positions. Different museum professionals have different concerns and do not always share the same authenticity claims.

As Clavir (2002, 35) pointed out: 'Although conservation values are embedded in museum values, conservators consider themselves to be different from other museum professionals, and this belief is returned (e.g., by museum curators and directors)'. It has been argued that conservators and curators, for example, attribute a different set of values to material authenticity.[27] Generally speaking, the conservator will consider the long lifespan of the work and will act conservatively in order to maintain the work in its established form, while the curator envisages the work more as a product of the present and might consider the historical value of the piece less important than the artistic values.[28]

In the case of *One Candle* at the MMK, the problem of the obsolete cathode ray projectors is widely acknowledged. Still, during the interviews it became clear that the gravity of the problem was weighed differently. Moreover, what was considered to be the core of the work varied from one person to the next. The conservator, for example, placed high value on the specific light quality of the projectors. The driving force behind his conservation research was to explore the role and effect of the projectors used in 1991 when the work was first installed at the MMK. The curator of collections, however, stressed the anarchic, variable character of the work by placing it in an art historical context and by referring to Paik's particular artistic practice:

> This goes back to the Fluxus years, to the sixties; to keep it [the work] as free as possible and to see it as a performance. It is a kind of performance if you like. Nothing is fixed. You have to change the candle. You have to lift the candle three times a day. You have to take care of it because the candle is burning down in a few

27 See, for example, Clavir (2002); Macedo (2006); Barker and Bracker (2005).

28 See, for instance, Macedo (2006); Laurenson (2004).

hours and if you don't take care, the camera can not catch the light anymore because the candle is lower than the focus of the camera. So it is a kind of performance. It is a live performance.[29]

Here two different takes on the same work come to the fore. The conservator seems to envisage a work with a specific aesthetic effect in which the type of projectors plays an import role. The curator of collections, however, speaks of a performance and refers to the work as a fairly flexible work where little is fixed. In both cases, a particular interpretation of the work is articulated.

In the case of *One Candle*, the conservator, taking into account the views of both fellow museum workers and future generations of visitors, is very much aware of the fact that the values he attributes to the work and the related conservation strategy are not necessarily shared by others. In fact, deciding on restoration treatment and conservation strategies is perceived as a rather uncertain and sometimes stressful affair:

> [T]his is my point of view and I know it is a very personal point of view; the argument that I have to preserve that *One Candle* as much as possible in that room and to try to keep the earlier projectors. It is just one attempt or my attempt to somehow capture and retain this piece. I know that others might think differently.[30]

> With all conservation topics or treatments, I know that whatever I do, whether it involves a retouch of a painting or an attempt to do the best with Paik's *One Candle*, it is merely what I can do now and it might change in the next generation. People will have other ideas and the next generation will have different questions. I am just trying to get as much as I can to be prepared or to prepare the next generation for questions.[31]

The conservator stresses that this is his own interpretation and places his decisions in a larger context by referring to a next generation. Calling upon scientific objectivity as a way to justify decisions is replaced

29 Interview with Mario Kramer, curator of collections, MMK, 06.11.2006.
30 Interview with Ulrich Lang, conservator, MMK, 09.05.2007.
31 Interview with Ulrich Lang, conservator, MMK, 09.05.2007.

by surrendering to inevitable subjectivity. The insight that deciding on authenticity and conservation strategies is subject to interpretation and negotiation has led to the development of several valuable decision-making instruments for both traditional and contemporary art conservation. These models have been developed to acknowledge different stakeholders and to provide structure and insight in complex deliberation and decision-making processes.[32]

The problem with a conservation theory that attends to different perspectives only, however, is that the art object and the practices in which it is handled and cared for are left aside. The artwork, in other words, is no longer considered an actant in its own making. In the case of *One Candle*, for example, the curator and conservator have a different 'image' (for want of a better word) of the artwork. In line with a conservation theory that adopts the communicative model, both 'images' could be reconstructed without taking into account what was already there and what has been done in terms of the tangible *One Candle* at the MMK. In other words: in the case of *One Candle*, each of the stakeholders may have their own particular ideas *about* the work and the problem of the obsolete projectors, but if only these *interpretations* are addressed, the material history of the artwork – all the work done to preserve it and all the changes that *One Candle* has gone through – stays out of view. Then the artwork's career – what happened to it over the years and how it became what it is today – hardly plays a part in the discussion about the work's conservation. According to a conservation theory that follows the communicative model, conservation is thus understood to be a disembodied practice: rather than by accounting for the materiality of the work and its history, decisions about a work's conservation could be made with reference only to what different stakeholders consider to be the work's most important values. On a positive side, such a conservation theory would give a voice to the conservator and other stakeholders involved; but, on a more negative side, if conservation theory is all about interpretations of the object then where does this leave the work itself?

32 See, for instance, the decision-making model for contemporary art (www.incca.org), Barbara Appelbaum's decision-making model for cultural heritage objects (2007), and risk assessment tools for object conservation discussed by Jonathan Ashley-Smith (1999). The models discern between different values related to a work of art and provide insight into the successive steps that need to be taken leading towards an informed decision in conservation.

79

Theorising conservation as merely 'interpretative' has the risk of moving too far from materiality. And although the 'communicative turn' in conservation theory and its move away from an essentialist approach has proven to be insightful in many ways (such as in acknowledging stakeholdership and in the development of decision-making models), there is a risk that people will turn away from the materiality of the work and focus on interpretative matters that are not so much related to the physical object, since materiality is an unmarked category in this model.

In this section, I will consider the downsides of conservation theory putting too much emphasis on these so-called 'perspectival tales' and I will suggest an alternative way of thinking that does include materiality in its framework. As theoretical guidance, I will turn to recent studies in medical practices and build on the work of philosopher Annemarie Mol as presented in her book *The Body Multiple: Ontology in Medical Practice* (2002). Although perhaps unexpected, insights in these – in various ways – very distinct practices are of help to this inquiry into museum practices.[33] In her work Mol takes us by the hand through the hospital wards in order to explore the ways medicine '*enacts* the objects of its concern and treatment' (2002, i). The focus of Mol's attention is the disease of atherosclerosis, but rather than studying it as a fixed and single entity, Mol observes and analyses the *practices* in which 'some entity is being sliced, colored, probed, talked about, measured, counted, cut out, countered by walking, or prevented' (Mol 2002, i). In *The Body Multiple* she sets out to demonstrate that objects handled in practice tend to differ from one practice to another; they are not singular by nature. Rather, their singularity is an achievement. In the words of Mol: '*Ontology* is not given in the order of things, but that, instead, *ontologies* are brought into being, sustained, or allowed to wither away in common, day-to-day, sociomaterial practices' (2002, 6).

Mol undertakes what she calls 'an empirical philosophical exploration' by observing the *doing* of atherosclerosis in the different hospital

33 In conservation literature, scholars have drawn analogies between medical practices and conservation practices, such as dealing with a 'sick body', diagnosing, and curing and caring. Despite certain parallels, hospital practices and museum practices are in many ways very different practices, of course. An exploration of such parallels and differences is beyond the scope of this chapter, however. I use Mol's approach and vocabulary as heuristic instruments. Without losing sight of the differences, particular insights gained from ethnographic work in hospital practices are here made productive in theorising conservation.

departments to find out that the objects handled in practice are not the same from one site to another: under the microscope, atherosclerosis, for instance, is a thick vessel wall, in the consulting room it is pain when walking, and in the computers of the epidemiology department, atherosclerosis is an important cause of death among the Dutch population. When attending to the practices in which atherosclerosis is enacted, reality, according to Mol, is varied and multiple (Mol 2002, 164). Mol's main focus then is on the question of coordination. Because if these different objects that go under a single name exist, why are they not fragmented into many?

In her book, Mol builds upon earlier social studies that have argued against what we have come to know as essentialism: a line of thought that treats the 'true nature' of the object as a fixed entity that can be revealed. In the hermeneutic tradition, the idea that an object has a true or essential nature that can be known is replaced by foregrounding interpretations of the object. In this view, an object has no true nature, but is the result of different perspectives on the object. Against the hermeneutic tradition, Mol argues that by attending solely to perspectives, the object of matter easily drifts out of focus since what we can say about the object of knowledge is 'just talk'. To quote Mol in her critique on attending only to perspectives, in the context of disease:

> In a world of meaning, nobody is in touch with the reality of diseases, everybody 'merely' interprets them. There are different interpretations around, and 'the disease' – forever unknown – is nowhere to be found. The disease *recedes* behind the interpretations. In a world of meaning alone, words are related to the places from where they are spoken. Whatever it is they are spoken about fades away. (2002, 11–12)

There is yet another effect of this hermeneutic perspectivalism because, as Mol argues, the idea of multiple interpretations reinforces essentialism rather than undermines it. With perspectivalism, there is still one single object on which people cast different views. The perspectives and interpretations may differ, but the object remains the same. The observers are multiplied, while the physical body is only observed from a distance. The physical entity is thus looked at by many people and from many angles, but the object is left untouched, mute and passive. Instead of fading away, this is what makes the object fixed and solid: a single entity that is intan-

gibly strong but has no part in the configuration of reality (Mol 2002, 12).[34]

In Mol's reasoning, perspectivalism has the paradoxical effect of both taking the object out of focus, *and* reifying it, since it needs to be assumed to be unified and coherent in order to unite the divers perspectives. The unwanted consequence of shifting away from focusing on the object to focusing on perspectives related to that object, is that the materiality of the object is lost. To overcome the problems of both essentialism and perspectivalism, Mol reintroduces material reality by studying the *practices* in which – in her case – atherosclerosis is *done*. By attending to enactment and focusing on stories about 'events-in-practice' (2002, 21) the downsides of both essentialism *and* perspectivalism are avoided and it is shown that material reality produced in practices is not singular but multiple. Here, with Mol's approach as a heuristic instrument in mind, it seems a relatively small step from atherosclerosis to *One Candle*, from medical practices to conservation practices, and from the hospital to the museum.

In the previous paragraph, we have seen that in conservation theory a similar line of thought has developed. The so-called 'communicative turn' in conservation replaces essentialist thinking about the true, original material condition of an object with a more hermeneutic approach in which interpretations and perspectives about the object become foregrounded at the risk of moving too far from materiality. Yet, if we do not consider the artwork as a fixed and untouched object that can be viewed from different angles, then different *One Candle*s appear and authenticity can be explored as being done in practice. In other words: by focusing on the ways in which *One Candle* is manufactured in practice over and over again, authenticity becomes part of what is *done* in practice rather than of what is already there and is waiting to be discovered. Attending to *enactment* rather than to *knowledge production* in this sense has an important effect: what is thought of as a single object may indeed appear to be more than one.

In the following, I will focus on the apparent tension between singular and multiple and I will explore how both repertoires can exist in museum practice simultaneously.[35] Drawing from the talks and interviews

34 In accordance with Mol's line of thought, I should here refrain from using the notion 'object'. Yet, to avoid confusion, I will continue to use the term 'object' when I refer to an art object.

35 The term 'repertoire' here is used in the same way that Mesman described it: 'A repertoire involves a particular style of reasoning; as such it functions as a guiding principle that orders our ideas about what the world is and how it works. This guiding aspect should not be viewed too strictly, though. Rather than

conducted with museum staff, I realised that my initial excitement and puzzlement about the coexistence of more than one *One Candle* was not really shared by the respondents at the MMK. Within the museum, *One Candle* installed at the MMK was clearly considered to be the one and only authentic one – a unique work of art produced and signed by the artist, then purchased and preserved by the museum. As we shall see, like atherosclerosis, *One Candle,* however, is not singular by nature.

2.5 *ONE CANDLE* AS SINGULAR

In the museum, several mechanisms and arguments bring the repertoire of singularity into play. There is the narrative of the artist, Nam June Paik, coming to the museum in 1991, choosing that particular triangle room and authenticating the work as installed by his assistant. Although this story is confirmed by all museum staff members, there is no actual documentation on the event of Paik coming to the museum and authenticating *One Candle.* Recollections of how Paik co-installed the piece and how he made his decisions are vague or nonexistent. How can the museum then be so sure about this event, which seems so important in terms of authenticating the *One Candle* at the MMK?

I am sitting opposite to the deputy director of the MMK. We are in the library of the museum talking about his experiences with One Candle. *From an earlier conversation with the conservator, I learned that Nam June Paik visited the MMK when* One Candle *was first installed by his assistant in 1991. With his presence and approval, the artist authenticated the work and made it his. Curious about Paik's involvement in the installation process and wanting to know more about this, I ask the deputy director about his recollections. From one of the book shelves, he picks up a catalogue of the MKK, flips through the pages and then shows me a picture. 'Here', he says, 'this proves that Nam June Paik was here at the opening reception of the museum when* One Candle *was on display'. Later, the storage manager shows me a piece of paper that he dug up from one of the print cabinets in the storage room. 'This is a drawing*

exactly fixing what will be said or done, a repertoire determines what those involved view as relevant, which arguments or strategies, they feel, matter. It outlines what is central or peripheral in a particular situation or condition. It provides a frame for legitimizing decisions' (Mesman 2008, 36). See also Mol (2002).

by Paik of our One Candle *in the triangle room', he says. The drawing was made at the time of installing the work.* [figure 8]

To establish the connection between Paik and *One Candle* at the MMK, things need to be kept together. The image of Paik at the opening event demonstrating his presence at the museum and the artist's sketch of *One Candle* in the triangle room achieve the necessary connection between the artist, the work and the museum. Keeping these elements together ensures the originality of the *One Candle* at the MMK.

It is said that Paik, after installing the work together with his assistant, meaningfully signed one of the CRT projectors (which is currently no longer present in the gallery space because it was not functioning) to make it his and confer uniqueness.[36] *One Candle* at the MMK has been on display in that same chapel-like room for nearly sixteen years now and over time it has gained an iconic character, serving as a monument for and by Paik, who passed away in 2006. Despite alterations in technical equipment, *One Candle* at the MMK is considered to be one of the last untouched installations by Paik. In answer to my question why this work (like some other installations at the MMK) has never been dismantled, the director answered:

> Simply because it is such a good work. And especially because the artist did it on his own. And especially with *One Candle* I am not sure whether you could ever create it the same way. I am not so sure. The bedroom of Claes Oldenburg: how you can take this away? You will never, never succeed doing it the same way. It was done by Claes Oldenburg. The same in a way with Gregor Schnei-

36 From the interviews it becomes clear that there is no certainty as to when and why the projector was signed. According to one of Paik's assistants who has cared for *One Candle* at the MMK over the years, Jochen Saueracker, Paik only signed his works when they were sold. He suggests that the projector might have been signed at Portikus once it became clear that the work was being acquired by the MMK (Interview with Jochen Saueracker, assistant to Paik, 12.12.2007).

der. I have to say I am really afraid of taking those works away. Because I can't guarantee if they would ever, ever look the same as in the past when the artist did it.[37]

The installation at the MMK has not only gained increasing importance within Paik's legacy; it has also gained value for the MMK and its collection. Over the years, the connection between *One Candle* in that specific space and the museum has become stronger and tighter. The sturdy bond between the work and the museum in Frankfurt is brought forward by the conservator:

It is the idea of *One Candle*. On the other hand, I don't know how many Paik installations are really untouched ever since he made them. But it is probably one of the last and because most people, if they talk about *One Candle*, talk about the *One Candle* at MMK and they have probably seen it like it is here and in most publications it is the image of the piece in Frankfurt and it is after sixteen years..., I would say...this way of installing this piece is part of the history of that piece.[38]

Of course, the fact that *One Candle* was first installed at Portikus has not been forgotten, but the lifespan and impact of the MMK *One Candle* in its triangle room seems so much bigger. The museum professionals, who had seen *One Candle* at Portikus, appreciated the work there but no longer regard it as being part of the reality of the MMK's *One Candle*. The particular installation at Portikus is part of the work's history, but not used as a reference for the MMK *One Candle*. The MMK's *One Candle* has become part of the MMK itself. It has been there as long as the museum has existed and might still be there for another long period of time. A MMK without *One Candle* is hardly imaginable, according to several of the respondents. Even taking it away or replacing it seems inconceivable. As the deputy director puts it:

I like the small room very much because you can't go in there with a group of people so you have to find it yourself. If you have more

37 Interview with Udo Kittelmann, director, MMK, 10.05.2007.
38 Interview with Ulrich Lang, conservator, MMK, 06.11.2007.

than four or five people to guide through the museum, you can't go to Nam June Paik. It's like a hidden room. [...] I like the atmosphere; it is a bit like a chapel, a holy room. I think nobody can see a candle without a religious connotation; you don't need to be religious to see that. For everybody, a candle is something about life and time. [...] We will never change Nam June Paik because it was his decision to put it in this room. Maybe one day we will put it away, but I can't imagine bringing it to a new room. I think that is impossible. Well, maybe not impossible but we would never do it here in the museum.[39]

Most of the respondents could not imagine that *One Candle* would be installed elsewhere at the MMK. Only the curator of collections explicitly showed a curiosity about experiencing it differently. According to him, the museum has the freedom to show it in a different space in the museum. One of the questions raised was whether a more transportable and explorative approach of reinstallation would have been more in line with the performance character of the work and with Paik's own anarchic artistic practice. The curator of collections:

Well, to date we have not discussed it, but I can imagine we do so in the context of a special show or in the context of a new presentation of the collection. It is so perfect in this little chapel. We cannot change the Beuys work because you can not transfer these enormous bronze sculptures to another space. So we don't have the question with Beuys. We never changed On Kawara's piece; his date-paintings have also been permanent for sixteen years. It would be very easy to change because these are just small paintings, but the installation is so beautiful and so perfect as done by On Kawara, and the whole context of his work is so important for our collection that we have never changed anything. But of course, we did change most of the other works of the collection. We have many original installations by artists but we changed them over the years. Yet, we never changed the Paik.[40]

39 Interview with Andreas Bee, deputy director and curator, MMK, 10.05.2007.
40 Interview with Mario Kramer, curator of collections, MMK, 06.11.2006.

The curator of collections is silent for a little while. I ask him: 'So, you would be interested in changing it?' After deliberation, he replies:

> Yes, I mean you can always reconstruct the so-called original little chapel. That is very easy to do, I would say. But to show it in a much bigger space might be interesting for a special reason. Yet I know that Paik was always very pleased that it is permanent here and everyone told him that they saw the piece in Frankfurt. That was also very unusual for him because most of his other works just appear for an exhibition and there are very few works by Paik on show permanently.[41]

Only time will tell if *One Candle* will, in the future, be disconnected from its specific site to be reinstalled elsewhere in the museum. By displaying *One Candle* as a permanent work rather than a portable work, its context has become part of the identity of the work which is now thought to be in need of preservation. Over the years, *One Candle* displayed in its particular space has gained contextual authenticity. Replacing the work is associated with a sense of loss. In the words of the conservator: '[...] it is this part of the museum that belongs to the piece or the piece belongs to that part of the museum'.[42]

This sense of belonging, as we have seen, is a result of the act of long-term presentation by the museum. Over time, *One Candle* in its characteristic triangle room at the MMK has become the one and only authentic *One Candle* it is considered to be today. The site thus is an important actor in the manufacturing of the work as singular.

Interestingly, one of the guards at the MMK has been taking care of the work since it was first installed at the museum. Every morning, before the museum opens, she lights the candle and takes her place just outside of the triangle room to watch over the work. She has done this for sixteen years now and has developed a caring relationship with the work and her own method of changing the candle three times a day:

> I have my own lighter. I take the candle in my hand and light the bottom to make it soft. I place the candle in its holder and light it.

41 Interview with Mario Kramer, curator of collections, MMK, 06.11.2006.
42 Interview with Ulrich Lang, conservator, MMK, 09.05.2007.

Next I adjust the tripod and look at it carefully to see when it is right. I have my own method and when somebody else does it while I have a day off, it doesn't seem to have the right feeling. I get annoyed because candle wax is all over the place.[43]

She likes it when the candle flame flickers gently and when the projections on the wall move slightly. But she dislikes it when the candle flame moves restlessly. And when visitors blew out the candle twice, she told them off and asked them if they do that at home as well. 'It is a ritual', she explains. 'For me it is like a chapel. People often first walk past it to see the Beuys work. But on the way back they enter the small room and stay there for quite some time in silence. Sometimes people haven't been here for a while and say fondly: "*Ach dieser ist auch nog hier*" [Ah, this one is still here too].'[44]

The repertoire of singularity is accomplished by keeping things connected, by the work's long-term display in the triangle room, by the space itself and by the rituals performed. All these things are done by the museum. Yet *One Candle* is also made one by *not* doing something, namely: by not emphasising certain aspects of its histories. Within the existing theoretical framework, practicalities such as tinkering, repairing, replacing, reinstalling are easily left out of focus. In contrast, paying attention to all those practicalities and details, as I have done above, demonstrates that *One Candle* is perceived as a solid work, frozen in its original state *despite* all changes in materiality.

2.6 DISRUPTIONS AND DISPERSION

In the previous section we have seen how *One Candle* at the MMK has gained its status and urgency to the extent that it is now perceived as *the* single and unique *One Candle*. We have also seen that *One Candle*'s status as an authentic and precious artwork is not a given, but the result of particular practices, with the long-term presentation of *One Candle* resulting in the wish to preserve the artwork. This repertoire of singularity is

43 Interview with Mrs Gruenning, museum guard, MMK, 09.05.2007.
44 Interview with Mrs Gruenning, 09.05.2007.

strong and persistent as long as certain practices, to speak with Mol, are bracketed (Mol 2002, 163). If, however, we look into the histories of *One Candle* and make visible the practicalities of enacting *One Candle*, then a different repertoire appears: one that shows disruptions and leaves room for questions about its solidness.

With contemporary art, as the physical work itself is no longer the primary source of information nor of authentification, other sources of information become more important in the conservation practice of contemporary artworks. The quest for information on the histories of particular artworks has become a large part of conservation activities. For the conservator, finding relevant information and learning about the history of *One Candle* was an important part of his research into the work. And because not much was documented about what had happened with the work over the years, he was depending on people's memory and oral history. Shadows of doubt were thrown on the trustworthiness of the information: 'The records are not detailed enough. I am trying to get the facts right.'[45]

Similar to the conservator at the MMK, I was looking for information on *One Candle*. And in an analogous fashion, the information on which *I* based my knowledge of the history of *One Candle* changed according to the narratives of my conversation partners. The stories changed and what was first considered a solid fact became debatable because of different stories or new evidence.

Through the interviews with the museum workers and documentation research, new details and scraps of information surfaced. The museum guards had noticed my presence and informed me about their experiences with *One Candle* and its audiences. I was pleasantly surprised when, after a couple of months, during my second visit to the museum, one of the guards came up to me to ask how my research was going. Documentation on the work, which had been forgotten, was retrieved from drawers and shelves and was brought to my desk in the library. People started talking together about *One Candle* again and the information that I brought back from the Portikus archive was met with enthusiasm by the conservator and was added to his documentation file. In short: during my stays at the museum, *One Candle* gained a certain momentum. Its relative importance increased and fragments of *One Candle* appeared to be in many places

45 Interview with Ulrich Lang, conservator, MMK, 03.06.2005.

within the museum. After several days of talking, walking and observing in the museum I too was connected with *One Candle.*

Much of the documentation was scattered over many cabinets, folders and computers in several offices. As a consequence, I had to move around the museum and became acquainted with the conservator and his assistant, the curator of collections and his assistant, the librarian, the technical staff, the janitor, the deputy director and his assistant, the photographer, the museum guards, the director and his assistant, and the storage manager. Each of these (as well as former) staff members, it appeared, had a connection with *One Candle* in one way or another and all had collected their own materials, memories and stories on the artwork. It soon became clear that many of these staff members were (or had been) involved with *One Candle* and their involvement and actions had affected the course of *One Candle* in different ways.

After starting off with having first one, then two or perhaps even more *One Candle*s, I now had an artwork that seemed to be everywhere in the building, fragmented into little bits and pieces in different departments, offices and minds. How to make a consistent story out of these bits and pieces of *One Candle* that I gathered during my fieldwork? Of course, I could visit the work in the triangle space, but from documentation research and interviews I learned that also the physical work on display at the MMK was less solid and untouched than the singular repertoire accounts for. In light of all the material changes that *One Candle* had undergone, I found it hard to locate the work's authenticity in one single condition and moment in time.

The permanent character of *One Candle* in the triangle room, for example, came into question after I spoke to one of the guards in the museum. She recalled that under the former director *One Candle* was once taken out of its space and replaced by a different work. After inquiring about this change of information, a copy of the exhibition plans, retrieved from a folder by the deputy director's assistant, indeed showed that during a short period of time another work was on show in that particular space. This clearly did not coincide with the image of *One Candle* as a permanent work installed by Paik. In fact, none of the people I had spoken to before had told me about this. It seemed as if this little crack in *One Candle*'s permanent character was simply erased from institutional memory. Confronted with this new information, some of them acknowledged that they had completely forgotten about it. The enduring presence of *One*

Candle in the triangular space clearly was far more vivid than the remembrance of that other work that had once, even though only for a short period of time, taken up its space. This implies that *One Candle* was taken out only to be reinstalled again later. But by whom? Was this reinstallation authenticated by the artist? And if not, would it make a difference in favour of preserving *One Candle* in its supposed 'original' state? The conservator answers:

> Maybe, because of what you just found out: that it could have been out of the room and nobody told me before and I couldn't find it in the documentation here. As regards to this question you just asked about whether it makes a difference if it was out of its room for half a year: probably not, but *One Candle* has been shown here for 16 years now and those images make up our frame of reference. On the other hand...this is my point of view and I know it is a very personal point of view; the argument that I have to preserve that *One Candle* as much as possible in that room and to try to keep the earlier projectors. It is just one attempt or my attempt to somehow capture and retain this piece. I know that others might think differently.[46]

Other alterations and uncertainties about *One Candle*'s material history, too, became apparent when the storage manager, who at the time was responsible for the audiovisual equipment at the MMK, recalled how the work, after the exhibition at Portikus, was packed and unpacked to be stored at the MMK which was due to open in 1991:

> The first time I came into contact with *One Candle* was in 1989 or so. I checked the projectors and I think there were six or seven, this should be in the file, just a handwritten note about the condition of the projectors at that time. I think there were only two or three that worked. Not all the tubes worked. I think there were only one or two projectors with three working tubes. [...] I think already at that time Paik had decided to add new projectors; they weren't new but he bought them in New York second-hand.[47]

46 Interview with Ulrich Lang, conservator, MMK, 09.05.2007.
47 Interview with Uwe Glaser, storage manager, MMK, 08.11.06.

The storage manager was also involved when these projectors, 'after breaking down one after the other', were replaced by Sony models.[48] The problem with these Sony's, explains the storage manager, was that they were much smaller than the previous projectors: 'What could be done with the other projectors and what could not be done with these Sony's was creating extreme divergence of the projected images.' In order to adjust the tubes in the original projectors, placing them deliberately out of focus, Paik took out the three tubes and realigned them slightly differently by putting something underneath them. 'He really made a mechanical transformation', says the storage manager who at that time was taking care of the audiovisual artworks in the museum. The Sony projectors did not have a cooling system in them, with the result that they were much smaller; the tubes therefore could not be taken out and tweaked as Paik had done with the older projectors. The storage manager confides:

> Jochen Saueracker, Paik's assistant, did not have any time to come to Frankfurt and so I did it myself. I tried to have things the same as before with these divergent colours, by turning the magnetic rings in the projector. [...] I tried it out in this triangle room and compared the projections with those from the older projections. The effect is similar, but it is reached electronically instead of mechanically. [...] Afterwards, I phoned Jochen Saueracker and explained what I had done. One day, he came by, looked at it and phoned with Paik. Then he said it was okay. Yes, I think it went like that. It was a long time ago. I think Paik verbally authenticated it through the eyes of Jochen Saueracker and said: yes, it is fine.[49]

This bit of information about one of the museum workers adjusting the Sony projectors was also new to me. None of the other respondents had mentioned it before. Maybe they weren't aware of this, or perhaps the intervention was considered too bold to admit. Indeed, in view of current conservation ethics, such an intrusive treatment now may seem unethical, but at the time it was not uncommon to replace and repair technical

48 There is a sponsor letter by Sony in the archive of the curator of collections which underscores the replacement of projectors and from which the date of this replacement can be derived.

49 Interview with Uwe Glaser, storage manager, MMK, 08.11.2006.

equipment and hardware used in artworks as this equipment was often not thought to be an essential part of the work. When a video-installation was sold to a museum, the technological equipment was often not included in the price and had to be acquired separately. Judging by the invoice, this was also the case with *One Candle*. At the time of the acquisition, it seems, the hardware was not included in the sale. The remaining documentation does not clarify where the projectors used at Portikus came from. Were these projectors also used in 1991 when *One Candle* was installed at the MMK or did Paik or the museum acquire other ones?

It is almost ten o'clock, the opening hour of the museum, when I enter the third floor of the museum to get my things that I left at the conservation studio. Conveniently, the conservation studio and One Candle *are both on the same floor and I decide to have another look at the work first. The triangle room is still dark and three guards are anxiously standing outside of the space, talking to each other. I can tell that something is wrong. One of the guards leaves to fetch her superior. 'Did you touch any buttons?' he asks. 'No, no', she replies. After some research it becomes clear that one of the upper projectors is out of order. The conservator is away for business and so the technicians replace the projector with one of the projectors in stock. The work is repaired by the time the first visitor comes in.*

Within the museum, *One Candle* is considered to be a single, coherent and nearly untouched art object. However, upon closer consideration and when taking into account the various practices and practicalities involved over time, the opposite appears to be the case. Over the years, *One Candle* has been changed and affected in many ways as the result of a number of caring hands and minds. Only when the spotlight is aimed at the practices in which *One Candle* is lit, turned on and off, repaired, stored, replaced, reinstalled, only then its solidness appears as a construct rather than a given. At such moments the repertoire of *One Candle*'s oneness and singularity is replaced by a repertoire that leaves room for doubt and fragmentation.

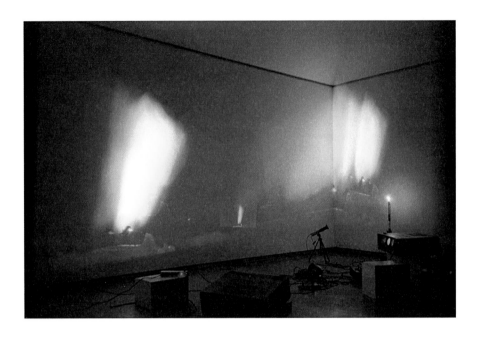

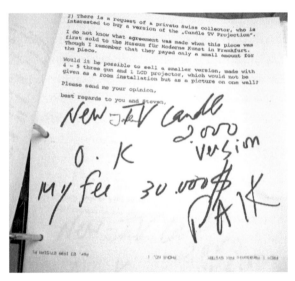

FIG. 9 – *One Candle* installation view at the National Museum of Modern Art, Seoul, South Korea in 1992.

FIG. 10 – Fax from Jochen Saueracker to Nam June Paik. Archive Jochen Saueracker. In the letter Paik is consulted about the possibility to sell a smaller version of the MMK *One Candle*: 'I do not know what agreement was made when the piece was first sold to the MMK. Though I remember that they payed [sic.] only a small amount for the piece. Would it be possible to sell a smaller version, made with 4–5 three gun and 1 LCD projector, which could not be a room installation but as a picture on one wall? Please send me your opinion'. On the same sheet of paper Paik simply responded to the request by stating his fee and signing: 'New TV Candle 2000 version, O.K'.

We have seen that *One Candle* at the MMK has dispersed and is not as coherent as people often think of it as being, but where does this leave the *One Candle* that I saw in Berlin? After consulting the registrar of the museum and doing research in the archives of Portikus, I learned that besides Berlin, *One Candle* had been on display elsewhere as well. In fact, *One Candle* has (at times simultaneously) been on display during temporary exhibitions at several other locations, including Bremen Kunsthalle, New York, Seoul [figure 9], Bilbao, Iowa, Paris, Italy and the Hamburger Bahnhof in Berlin.

Instead of dismantling the MMK piece and shipping the equipment to the institute that requested the work, the approach of the MMK is to contact Paik's assistant in Germany to ask for his availability and to subsequently send a contract that allows for a one-time installation of the work. The curator of collections, who is responsible for the loans, explains: 'We always make an exhibition copy. We just send a loan form to make it official. Everybody has to sign this loan form but not a single real projector, candle or camera is leaving this museum.'[50] Except for the loan form, a copy of which is filed in the archive, nothing leaves the building. Besides the paperwork, the MMK itself has little to do with such installations. In the past, in most cases, Paik's assistant took care of installing the work at the other venue. The authenticity of these works is thus assured by the engagement of Paik's assistant who is considered, by the museum, a valid and reliable representative of the artist.

To indicate the separate status of these temporary *One Candles*, the term used by the museum staff is 'exhibition copies'. Not 'versions' or 'variations', but exhibition copies. The accompanying wall label of the Hamburger Bahnhof, for example, mentions a single date and refers to the collection of the MMK and as such commends the unique status of the MMK *One Candle*.[51] According to Paik's assistant, Paik was fairly flexible

50 Interview with Mario Kramer, curator of collections, MMK, 06.11.06.

51 The market-informed practice of one-time exhibition copies is not uncommon to the art world although generally such copies are governed by the artist, or his estate or gallery. In respect to the MMK, the practice of such loans with Saueracker as conduit commenced when Paik was still alive and continued after his death in 2006. Usually, exhibition copies are considered to be of lesser value, and are not to be sold or exhibited elsewhere (Kwon 2002). At Tate London a similar practice is called 'virtual copies' as the works do not physically leave the museum (conversation Derek Pullen, head of sculpture conservation at Tate London, September 14, 2007). On the role of the artist's estate in conservation issues, see Learner

about installing his work at different venues. Yet when Paik was consulted by a private collector about the possibility of acquiring a work similar to the *One Candle* in the collection of the MMK, the work was titled differently (*New TV Candle Version 2000*). The acquisition by this private collector fell through, but the correspondence [figure 10] is meaningful because it may inform us about Paik's thoughts and practices in relation to versions.

According to Paik's assistant, Paik had the policy of distributing his work to every continent and limiting the number of editions to the number of continents. Thus, although each installation piece could have been sold in a theoretically infinite number of editions, each equally authentic, the number of editions would have been limited. Yet this attitude can be explained in different ways as Paik is known for his ambiguous notion of originality. Illustrative is Paik's reply to the question 'How will it be possible to clarify the question of the originality of a piece, if you can't help with the answer anymore?', with reference to one of his works. Paik answered: 'Everybody can make this piece but I sign. When I die, it is your problem to find out which is original. You have two originals: one piece and a better quality copy'.[52] In hindsight, Paik's words almost seem prophetical.

Here it is important to note the shift in time-based media art production in the 1990s to creating multiples of the same work and selling limited numbers of copies. Over the years, artists (and their galleries) have employed several strategies, such as, for instance, the signing of DVDs, to ensure a certain level of exclusivity and monetary value. The question is: to what extent did Paik employ such practices? Did he engage in the production of editioned works? Was *One Candle* perhaps intended to be one of several multiples? And if so what does this mean for *One Candle* at the MMK?

In these days, with museums used to collecting unique one-of-a-kinds or limited editions, it is not uncommon practice for an institution to secure a contractual agreement of exclusivity upon acquisition, but noth-

(2008) (on cooperation with the estates of Roy Lichtenstein and Eva Hesse), Appelbaum (2007, 79) (on artists' heirs as third-party stakeholders), and Lacerte (2007) (in relation to Nam June Paik's estate). Interestingly, the MMK considered Saueracker the logical custodian of *One Candle* and is not so much in touch with Paik's estate.

52 Nam June Paik in an interview with Wulf Herzogenrath, Bärbel Otterbeck and Christian Scheidemann, November 25, 1995, quoted in Otterbeck and Scheidemann (2005, 107).

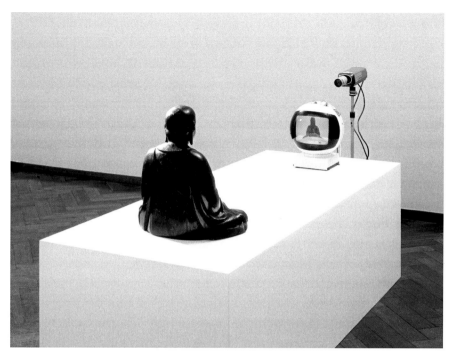

FIG. 11 – *TV Buddha* (1974) by Nam June Paik, Collection Stedelijk Museum, Amsterdam, the Netherlands.

ing of this kind was found in the museum archives of the MMK. The problem, it seems, is that little is known about Nam June Paik's own thoughts about fixity and change through reinstallation and technical replacement once a work has been purchased. Many of his works, like the many variations of *TV Buddha*, have been said to develop like 'variations to a theme' (Belting 2002, 410). [figure 11]

Not surprisingly, the Stedelijk Museum is also challenged by questions regarding the conservation of *TV Buddha*. And interestingly, as in the case of *One Candle*, here also it is emphasised that the work contains many of its original materials and as such can be regarded as one of the few authentic works in terms of audiovisual material, all of which have been authorised by Paik.[53] At the Stedelijk Museum local practices have been developed to ensure the work's perpetuation. These are in many ways quite different from the ones employed by the MMK. Unlike *One Candle*, *TV Buddha*, for example, has been dismantled and reinstalled on

53 Interview with Gert Hoogeveen, Audiovisuals Department, Stedelijk Museum, Amsterdam, 19.11.2008. Hoogeveen explains that this might be the case because both works are closed-circuit and thus, unlike most works by Paik, do not contain videotapes and hardware that rapidly becomes obsolete.

several occasions. Also, it has (physically) been sent on loan quite often. In a letter to Edy de Wilde, the then-director of the Stedelijk Museum, on the occasion of the acquisition of TV *Buddha,* Paik wrote: 'As for the installation, I think Ms Mignot [then curator] did a marvelous job and I completely trust her.'[54]

Over time the task of reinstalling TV *Buddha* has been passed on to a staff member of the audiovisual department. He observes that there is not much documentation about the work, nor are the parameters stipulated clearly. Rather, a reinstallation practice (tradition) has emerged based on experience and knowledge, and using an image of a previous reinstallation of the work as reference.[55] With respect to the aspect of variations, it is worthwhile to quote a few more lines from Paik's letter:

> TV Buddha is currently at MOMA, N.Y. and saying goodbye to New Yorkers, where I bet he must have lived since the end of World War II...Needless to say, I will not make a multiple or something like that...I have too many new ideas to devote my time for the repetition of old work.[56].

Some argue that repetition and seriality was employed by Paik as a playful artistic strategy to counteract the art world's model of uniqueness. Yet, although Paik is known for his signature and ambiguous notion of 'originality', as an artist practising in the museum and gallery circuit, he also worked within existing economic models employed by the art market. Considering the complexity of the versioning, it will come as no surprise that (especially after Paik's death) many 'original' Paik works entered the art market. Perhaps as a deterrent, the front page of the Paik estate website (www.paikstudios.com) for a while opened with full reports on several lawsuits.[57]

54 Quote taken from a letter from Paik to Edy de Wilde, September 25, 1977. Archive Stedeljk Museum, Amsterdam.

55 Interview with Gert Hoogeveen, Audiovisuals Department, Stedelijk Museum, Amsterdam, 19.11.2008.

56 Quote taken from a letter from Paik to Edy de Wilde, September 25, 1977, Archive, Stedelijk Museum, Amsterdam

57 In a press-release of May 1, 2009, the Smithsonian American Art Museum announced that the Nam June Paik Archive was gifted to the museum by the Nam June Paik Estate, via Ken Hakuta, the artist's nephew and executor, and with the consent of Shigeko Kubota, the artist's widow. The archive is said to include early writings on art, history and technology as well as correspondence, videotapes, production

Interestingly, the temporary display of *One Candle* that I saw in the Deutsche Guggenheim in Berlin was not known or registered at the MMK. But after consulting with one of the curators of the exhibition at the Deutsche Guggenheim, I learned that at the time Nam June Paik and Paik's Studio had been involved with the set-up of the show in Berlin in 2004.[58] All works on display had been arranged directly with Paik or via Paik's Studio instead of through official loan requests from museums. Because of this, the institutions who owned works by Paik were, so to say, overruled by the authorisation of the artist. The *Global Groove 2004* catalogue reads: 'Paik has included a modified version of his *One Candle* (Candle Projection) (1988).' (Krens 2004, 7). For the conservator of the MMK as well as Paik's assistant the candle work in the Berlin Guggenheim was not the same as the MMK's *One Candle* because Paik had titled his Berlin work slightly differently, namely: *Candle Project*. The former assistant curator of the New York Guggenheim recalls that in 2000, a *One Candle* had been on display during the travelling retrospective *The Worlds of Nam June Paik*, organised by Guggenheim NY.[59] The work, then installed by Paik and his assistant, was known at the MMK and agreed upon as a one-time production as the artist himself was involved.

The coexistence of the many different configurations of *One Candle*, of course, again problematises the understanding of *One Candle* as a single, unique, physical artwork with one date of creation, and commends it as a movable, flexible work. The existence (although temporary) of the many different *One Candle*s in fact emphasises the conceptual character of the work *One Candle* at the MMK, which undermines the equation of *One Candle*'s authenticity with one single condition – and with it, perhaps, the necessity of going back to the 'authentic' projectors. Rather than freezing *One Candle* in a certain state as is suggested by the repertoire of singularity, through loan agreements the museum allows for flexibility in terms of location, site, and aesthetics. On the one hand we have the singularity of the art object and the emphasis on the original material condition of *One*

notes, sketches, notebooks and plans for video works. John Hanhardt has been appointed to lead the organisation of the archive and to create a Paik study centre at the museum. See www.americanart.si.edu/pr/library/2009/paik_archive_release.pdf and http://americanart.si.edu/collections/search/artwork/?id=77502.

58 Interview with Jon Ippolito, assistant curator Guggenheim New York, 18.05.2007. Meaningfully in 2009, in the online exhibition archive of the Deutsche Museum, the work is now referred to as: 'One Candle (1988), 2004 Version.' (www.deutsche-guggenheim.de/d/ausstellungen-paik01.php)

59 On show from February 11 to April 26, 2000.

Candle at the MMK, while at the same time we have these more flexible and variable *One Candle*s on loan. How is this possible?

To answer this question, it is again useful to turn to Annemarie Mol's account of how singularity is accomplished by coordination and distribution:

> The relative scarcity of controversy in daily practices, where so many different objects go under a single name, is likewise a remarkable achievement. It is a result of *distribution*. It comes about by keeping diverging objects apart if bringing them together might lead to too much friction. As long as incompatible atherosclerosis do not meet, they are in no position to confront each other. (Mol 2002, 119; italics added)

Following the rationale and practices of the museum, it becomes apparent that these two contrasting practices can coexist because they are *not* coordinated. Both lines of practice simply exist next to each other and by virtue of this they do not necessarily affect each other. It is only in my story here that they are brought together: I am establishing the connection. In the museum there is no clash because through work division, the stories can be kept apart; the curator of collections, the registrar and Paik's assistant take care of the loans, while the conservator's main task is to take care of the *One Candle* at the MMK. This is what happens when incompatible *One Candle*s are brought together:

During a conversation with the director in his office at the MMK, he tells me that he is not very interested in the loans, because they are just exhibition copies and as such the museum is not responsible for them. In the course of the interview and after hearing about the work in Berlin, the director, however, shows more interest in the different installations and impatiently asks me: 'So, is it now a unique piece or not?' I chuckle and reply: 'Well, that is the question I had for you actually.' The director, now laughing as well: 'Yes, I understand your question but I can't tell you at this moment. I am a little bit surprised as you see. I don't know. But what does the contract say?' The contract with Paik, however, says nothing about this and after explaining that I am trying to compose a list of where the One Candle*s have been displayed, the director asks me: 'Yes...so how many are there?' 'Quite a lot actually', I answer, 'you would be surprised.' The director is eager to know: 'How many? How many?' By this time we*

are both laughing about the absurdity of our conversation as I answer: 'Ten to fifteen or so....' The museum director frowns and replies: 'Really? Well that is good to know...that is good to know....' The director now shows his interest in the subject and states that he is not very interested in the idea of a unique work: 'Not at all. It should not be this big thing in the art world anymore. Unique or not unique, hey, come on!' Still, when I ask him if all this changes his ideas about One Candle *here at the* MMK, *he replies: 'No, that one is ours. It is here and bound to stay here.'*[60]

Bringing the two practices together leads to confusion. Yet in the museum, the repertoire of one single *One Candle* is stronger than that of incompatible *One Candle*s. For the director as well as the conservator, the *One Candle* versions and the in-house *One Candle* remain two separate things. The conservator explains:

> Do I consider *One Candle* a unique work? Yes and no. Very clearly. I can just repeat: yes because it is a unique artwork. Yes, because we have had it on display for sixteen years and it came into the collective memory as such. And no, because you can show other versions in other places.[61]

Later, when I ask whether it would be conceivable to end or change the loan procedures, the conservator replies:

> It could be part of a discussion if we would say: Now, this is the *One Candle* and this is the only one that can be shown and if you want to display it, you have to build a triangle room like ours. But I don't think it will happen. It is an option, theoretically, but I think it doesn't make sense. It is definitely at odds with Paik's concept! Because he does have video-sculptures which have a precise size. *One Candle,* though, is an installation, and in our database it says: 'dimensions variable'. I think that is part of the piece; that it does vary. But still the reference is important.[62]

60 All excerpts are taken from an interview with Udo Kittelmann, director, MMK, 10.05.2007.

61 Interview with Ulrich Lang, conservator, MMK, 06.11.2006.

62 Interview with Ulrich Lang, conservator, MMK, 09.05.2007.

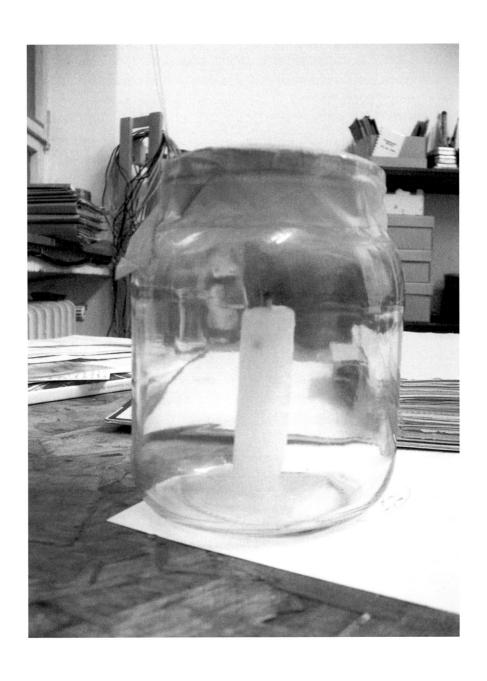

FIG. 12 – One candle in a jar with Paik's autograph scratched into the candle wax.

By referring to *One Candle* at the MMK as a *reference*, the conservator touches upon yet another mechanism at issue here: this distribution of the *One Candles* also reinforces the value and solidness of the semi-permanent *One Candle* 'at home' at the MMK in which the wall labels play an important role. Interestingly enough, when I tried to gather images of the several *One Candles* abroad by collecting the catalogues, time and again I was confronted with the same image – that of the *One Candle* at the MMK. Apparently, one single press image from the MMK is used because the catalogues of the temporary exhibitions are usually printed prior to the actual installation process of the loan. This again contributes to the construction of *One Candle* at the MMK as *the* one and only authentic installation. The image, like the wall label, plays an important mediation role; in a very active way it contributes to making *One Candle* singular.

2.8 *ONE CANDLE*: MORE THAN ONE, LESS THAN MANY

Besides many hours spent in Frankfurt, the research on One Candle *also brought me to Düsseldorf to meet and talk with one of Paik's former assistants, Jochen Saueracker, who is still taking care of many of Paik's works in German collections. Saueracker has been working on a website on Paik and is by many considered to be an authority on Paik's legacy. In addition to being a custodian of Paik's works, he also works as an artist. I visited him in his studio, only a short walk away from the Düsseldorf train station. When we sat down for a coffee and after talking for a bit, Saueracker turned around and enthusiastically declared: 'I have something to show you.' From one of his shelves in his orderly looking studio, he picked up a small jar and handed it over to me. I couldn't believe my eyes: there it was, in my own hand, a single candle, placed in a jar and signed by Paik.* [figure 12]

With this one candle in a jar right in front of me, Paik's assistant took me back to 1988: to Portikus where *One Candle* began. The assistant explained that Paik at the time did not think that *One Candle* would remain and therefore, instead, the candle stub of the first burnt candle at Portikus was put into a jar to be preserved. Since then, the candle has been kept by Paik's assistant because he, like the artist, never imagined that such a fragile, technological room-filling installation could and would be acquired and conserved in a museum collection. Perhaps, at the

time, the saving of the first burnt candle did not carry much weight for the artist. Or, considering the stories I had come to hear about the artist, perhaps it had been one of his many practical jokes? At any event, here in the studio of Paik's assistant, with us talking about issues of conservation and authenticity, the candle in the jar seemed quite meaningful. The confrontation with this seemingly untouched relic from the early days of *One Candle*, startled me in a positive way. After months of talking to people who had known Paik, after looking at his works, visiting archives and storages, my research brought me to this one candle from 1988 that was still intact and had been left untouched over the years. In this particular setting, with all that I had come to learn about *One Candle*, I was touched by the artefact I had in my hands.

The confrontation with the candle in the jar made me realise that the kind of affectivity I was feeling towards the object is also very much part of how we respond to artworks and other objects from the past. Such feelings are an important drive for conservators in their daily care for these works, and as such are of considerable importance to the practices that I study. It also, however, reminded me of the words Stanley N. Katz uttered in a discussion about what social sciences could bring to existing studies of art: 'I think the social sciences can remind scholars of the need to react to beauty but not to be captured by it' (Katz 2006, xi).

In this chapter I have looked into the practices of *One Candle*, and with it into the working practices of the MMK. When evaluating installation art and time-based media art, one could argue that the concept of originality and authenticity as singular has become obsolete. In respect to new media artworks, it has been argued that a new museological paradigm shift is needed to account for the variable, multiple or flexible character of such works (Laurenson 2006; Ippolito 2008). This case study demonstrates that within the museum, the repertoire of singularity is persistent. *One Candle* is considered to be a single, coherent, hardly touched art object. Yet when attending to practices, the opposite appears to be the case. Over the years *One Candle* has been changed in many ways.

The point that I have raised is that the activities of collecting and conservation assume that an artwork has an authentic state that can be preserved as such. Yet, the assumption is also self-fulfilling; by aiming to capture the authenticity of an artwork, conservation as a practice also constitutes 'the authenticity' of a work of art. Authenticity, in this view,

is not something 'out there' waiting to be discovered. Rather, it is part of practice and can be studied as being 'done'.

Instead of locating authenticity with the artwork or the artist, or reducing the claim of authenticity to a matter of perspectives only, I have suggested an alternative view on authenticity by analysing how authenticity is 'done' or enacted in practice: how the repertoire of singularity is manufactured and reinforced in practices of tinkering with, replacing, emphasising certain events while forgetting others. But also through actants (Latour 1987) such as photographs, space, loan agreements, wall labels, artist's statements, artist's assistants, the period of instalment, and specific choices of vocabulary.[63] Only when the spotlight is redirected towards the practices by which *One Candle* is lit, turned on, repaired, stored, replaced, reinstalled, put on loan, labelled, measured, and discussed, does its multiplicity become visible.

As demonstrated, the status of *One Candle* as an authentic artwork is carefully manufactured within the museum and its authenticity is enacted through a diverse range of actants such as agreements, taxonomies, wall labels, photographs etc. Moreover, an important actant is the way in which the MMK's *One Candle* is disconnected from the other *One Candles* and vice versa. The MMK's *One Candle* can maintain its singularity only as long as incompatible *One Candles* do not meet each other. As an 'exhibition copy' or a *One Candle* with a slightly different name, *One Candle* can be fairly flexible in terms of location and experience. Yet, if *One Candle* can be more than one, why is it not many?

Perhaps here the notion of 'continuity' can be useful. For an artwork's career to be prolonged it needs continuity. But changes perceived as significant ruptures – for example, if the work deteriorates beyond a certain point or if its components are replaced at once (which we would perhaps speak of a reproduction) instead of gradually – will break this chain of continuity. In that case, the agreement of sameness is threatened. From this we learn that, in order for an artwork to keep up the appearance of being intact or at least relatively stable, its changes have to happen slowly and gradually.[64]

Within the museum in Frankfurt, *One Candle*'s continuity is ensured by its long-term display and specific space. Continuity of the external

63 On the notion of 'actant', see the introductory chapter and chapter 4.
64 See also Becker et al. (2006, 9).

*One Candle*s is secured by the distribution of one and the same image and by the involvement of Paik's assistant as representative of the artist. *One Candle* at the MMK today holds many traces of previous elements, but also reflects its many changes and influences over the years. The concept of authenticity implies a point zero, a frozen moment in time to which the work of art should return. Employing the concept of continuity in describing the continued life of the artwork, however, provides room to account for alterations and a more accurate way of understanding the artwork's trajectory than the work's residing in the single-date paradigm and the original/copy divide.[65]

One Candle as currently on display at the MMK is hardly the same object as it was in 1988 at Portikus, but is it still the same artwork? The information on the wall label used at the MMK suggests it is. There is no sign of any alteration. In reaction to the common way of describing artworks in terms of a single artist, date, medium, dimension and collection, John Ippolito suggests a different way of labelling new media artworks:

> One of the biggest dilemmas curators of conceptual, performative, and media art face is determining which date to write on the wall label. Some artists insist, perhaps on the advice of their dealers, on the year of the original work – or even of its conception. As misleading as it may seem to date a plywood box back to 1961 if it was hammered together yesterday, it is equally misleading to cite only the year of a refabrication or new variant without reference to its history. (2008, 114)

To account for the work's richness and to avoid fixity and reduction, Ippolito suggests that a versioning system offers a solution to the issue of originality in relation to works that require reconfiguration over time.[66] Ippolito's argument seems to be evoked by the specific characteristics of

65 Although interesting, in this chapter little reference will be made to the obvious ties between authen-ticity, power structures and the art market. I will come back to this theme in chapter 4. For a more polit-ically oriented account on the original/copy divide see, for example, Cameron (2007), who leans heavily on Fyfe's (2004) exposé of the manufacturing of authenticity explained from the perspective of cultural capital (Bourdieu) and the history of the hidden labour of reproduction.

66 Ippolito prefers the term 'variation' over the more common 'version' to 'counter the presumption that newer releases are better than older ones' (2008, 132). Interestingly, Ippolito also employs such a versioning system for his own articles. The article 'Death by Wall Label' published in Paul (2008) has the following under-caption: 'V 2.5. edited by Stephanie Fay and Christiane Paul'.

new media art as variable in authors (collaboration, interpreters), titles, dates, media, dimensions and collections. In his signature provocative style, he argues that the common, conventional 'fixative' paradigm of museums not only wrongly fixes and reduces works of new media art, it ultimately also leads to their death. Ippolito: 'While the reductionism of the wall label enfeebles conceptual and single-performance art, it threatens to obliterate digital culture. For new media art can survive only by multiplying and mutating' (2008, 106).

Based on the findings related to *One Candle*, I would add to Ippolito's argument that such a differentiated way of labelling an artwork would not only account for the artwork's variability, it would also provide more insight into the activity that ensures a work's continued existence. In other words, such accounts would turn it from a liability (like Ippolito's critique on the way museums are kept captive in their old paradigm) to an asset, a way to be more transparent about museum's working practices, and to open up discussions about these practices.

The research on *One Candle* has demonstrated that singularity is manufactured by keeping the repertoire of multiplicity outside of the museum and by using specific terminology. What would it mean for both repertoires to come together? Acknowledging *One Candle*'s multiplicity as the outcome of a particular practice, could, for example, raise new possibilities for displaying different versions of *One Candle* next to each other and informing the museum visitors about the museum's practices and its challenges – for instance, by acknowledging (and crediting) the person(s) who reinstalled the work. Why keep this part of museum practices behind closed doors? In the same manner as documentation may guide decisions in conservation, also gaps in documentation or blind spots may influence practices.

This case study in particular has demonstrated that institutional policies and routine practices have their effect on the life course of *One Candle*. According to Appelbaum (2007, 77) these are often a crucial – but unseen – party in the decision-making processes. Appelbaum: 'The transition of objects into museum life is signaled by their placement in a new kind of space under a new set of rules. Both what the object has lost and what it has gained are key to understanding it fully' (2007, 161).

Besides learning about the perpetuation and multiple lives of *One Candle*, my attention was directed towards the museum practices in which the artwork was done. What then can we learn about the museum and its

practices by studying the life of an artwork within the institution? This question will be addressed in the following chapter in which two seemingly distinct museum practices of dealing with reinstallation of works by the artist Joëlle Tuerlinckx are compared.

From Intention to Interaction: Artist's Intention Reconsidered

FIG. 13 – *A Stretch Museum Scale 1:1, a proposition for the Bonnefantenmuseum (Exhibition space)* (2001–2003) by Joëlle Tuerlinckx. Collection Bonnefantenmuseum, Maastricht, the Netherlands. This space resembles Tuerlinckx's earlier work at the Documenta of 2002 in Kassel, and consists, among other elements, of several slide projectors with carousels projecting still images onto self-made projection walls, a video projector, a TV monitor mounted on one of the walls showing a video recorded during installation, paper roles, a large table with drawings underneath a glass plate and a show case with drawings of the Aldo Rossi building and invitations to Tuerlinckx's solo-exhibition of 2001 in the Bonnefantenmuseum.

I follow the curator of the Bonnefantenmuseum up the stairs, through the doors to the first floor. We pass by other works from the collection and then enter the room where four people are working. The walls and floor are covered with green paper strips. A museum worker is standing on a ladder, patiently waiting for instructions from the artist. In his hand he holds a strip of bright green paper. The ladder is held by another museum worker who is also looking at the artist. In the middle of the gallery space are the artist and her assistant. They are in the middle of a conversation, and when the curator walks up to them in order to introduce me, they look a bit agitated. I feel out of place. The room just feels too small for the artist, the assistant, two museum workers, the curator and me. In the intimacy of the room, I don't want my presence to interfere too much, so I watch in silence as the artist confers with her assistant and instructs the workers to organise the papers on the walls, slowly transforming the white space into a green space. Like paint on a canvas.

It is May 2004 when I am introduced to Joëlle Tuerlinckx (b. Brussels, 1958), a Belgian artist who at the time was installing her work at the Bonnefantenmuseum in Maastricht (the Netherlands). The artist looked focused while working on the room-filling installation, which she later called *A Stretch Museum Scale 1:1, een voorstel voor het Bonnefantenmuseum (Groene zaal).*[1] This green room, installed by the artist, her assistant and two museum workers, was the last in a series of three room-filling installations that were acquired by the museum between 2002 and 2003. [figures 13, 14, 15, 16] The acquisition of these three installations (or spaces) emerged from an earlier solo exhibition by the artist: *A Stretch Museum Scale 1:1 (proposition for a stretched walk in a compact museum)* at the Bonnefantenmuseum in 2001.[2]

Although the acquisition by the Bonnefantenmuseum was not a case study within the Inside Installations project, after seeing the installations and talking to the curator of the museum, I decided to perform

1 From here on I will use the English title: *A Stretch Museum Scale 1:1, a proposition for the Bonnefantenmuseum* (*Green Space*).

2 This title is taken from Tuerlinckx's biography as listed by her former gallery Stella Lohaus, Antwerp, at: www.stellalohausgallery.com. In the documentation of the Bonnefantenmuseum, the exhibition is, however, referred to as 'A stretch museum scale 1:1, invitation to a stretched walk in a compact museum'. To avoid confusion, I will use the titles as indicated by the artist's gallery.

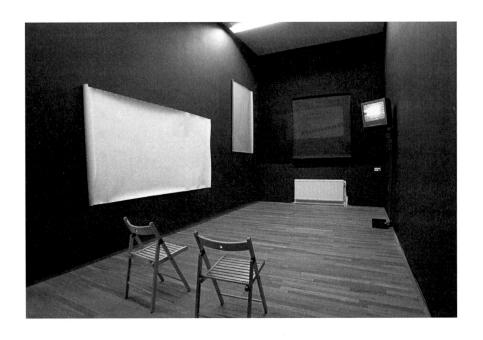

FIG. 14 – *A Stretch Museum Scale 1:1, a proposition for the Bonnefantenmuseum (Cinema space)* (2001–2003) by Joëlle Tuerlinckx. Collection Bonnefantenmuseum, Maastricht, the Netherlands. Installation view 2004 at Bonnefantenmuseum. In a small room painted black, a couple of chairs invite the visitor to sit down and view the video programme (which has a total duration of sixty minutes). The video images, some of them recognisably recorded at the Bonnefantenmuseum, are projected on the back wall (partially painted white) and simultaneously shown on a monitor. The lights are turned off for a period of ten minutes, thereby rendering the room a cinema feel, and then suddenly the lights in the space are switched on and left on for five minutes. The sudden change of light and atmosphere (from a dark cinema space to a bright light exhibition space) prompts the visitor to get up from his or her chair and walk around the gallery, exploring the space as if it were a painting.

research on the works.[3] There were several reasons for me to do so. First of all, the conservation problems, especially those involved with reinstallation, promised rich materials for my research. A more pragmatic reason for me to choose the Bonnefantenmuseum as a site was its convenient location: the museum was only a bike ride away from the university where I was working. This made it possible for me to interview the museum staff on several occasions and allowed me to visit the artworks frequently throughout the period of their installation. Moreover, as a partner of the Inside Installations project, the museum was committed to research on issues in the conservation of installation art and was willing to open up its practices to me. However, the most important reason to choose this case study as part of my inquiry was that it allowed me to compare the practices of two museums: Bonnefantenmuseum in Maastricht and the Stedelijk Museum voor Actuele Kunst (s.m.a.k.) in Ghent (Belgium).

s.m.a.k. had selected from their collection an earlier work by Tuerlinckx, *ensemble autour* MUR (1998), for the Inside Installations project.[4] [figure 17] Originally conceived in 1998 and acquired in 1999 on the occasion of the exhibition *this book, LIKE A BOOK* at s.m.a.k., *ensemble autour de* MUR had a longer history than the works at the Bonnefantenmuseum.[5] In 1998, *ensemble autour de* MUR consisted of a projection of the word MUR onto a white museum wall by means of a slide projector. The word MUR, written on the slide, was crossed out as if it were both a proclamation and a denial. Over the years, *ensemble autour de* MUR was installed in several different spaces. For each of these installations, the artist was invited to reinstall the work. On those occasions, the artist rearranged the 'ensemble' and added new elements to the work.[6] This variability, however, also brought about certain concerns and questions about longterm conservation. For s.m.a.k. these questions formed the basis for their research into the work performed during Inside Installations. In an article

3 With the exception of *A Stretch Museum Scale 1:1, een voorstel voor het Bonnefantenmuseum*, all of the case studies explored in this book were part of the Inside Installations project. The Bonnefantenmuseum selected a work from their collection by the Dutch artist Suchan Kinoshita as a case study for Inside Installations. See the introductory chapter to this book for more information on the project Inside Installations.

4 Although sometimes 1999 is mentioned as date of creation, most sources refer to 1998.

5 January 7 to February 7, 1999. The exhibition was accompanied by the publication *this book, LIKE A BOOK* (1999).

6 Mattheus and Wittocx (2004).

about *ensemble autour de* MUR, the head of conservation at S.M.A.K. writes: 'we wanted to investigate how this variable installation work of art could be dealt with and which interpretations could be made'.[7]

At the time of the Inside Installations project, both museums, S.M.A.K. and Bonnefantenmuseum, were separately coping with similar problems related to future reinstallation of Tuerlinckx's works. The question posed by the museums boiled down to this: How could the works be reinstalled according to the artist's intent, yet without the artist being present for each reinstallation? As part of their conservation practices and in order to be able to display the works in the future, both museums set out to document the works and to develop protocols and guidelines for future reinstallation. As there were no standards available for drawing up installation guidelines for the purpose of conservation and reinstallation, the museums developed their own strategies and approaches as they went along. How did the museums tackle the problem of reinstallation? How did they arrive at the installation guidelines? And, more importantly, how do the guidelines developed as part of museum conservation practices affect the works of art in question?

This chapter explores how two different museums, the Bonnefantenmuseum and S.M.A.K., deal with the perpetuation of the works by Joëlle Tuerlinckx in their collections. Installation guidelines, as outcome of documentation practices, I argue, not only provide information *about* the objects: how they are generated and what they consist of also co-determines the ongoing life of the artwork. This chapter will therefore pay particular attention to the documentation strategies of both museums, while also analysing the impact of these documentation strategies on the perpetuation of the artworks under study. More than traditional artworks, installation artworks depend heavily on documentation as conservation strategy because the works, after dismantling, need to be reinstalled or re-executed in order to be presented. Therefore, in the context of installation art, forms of documentation such as installation guidelines consisting of texts, plans, digital images of different presentation forms, artist's interviews and records of working techniques are considered indispensable (see, e.g., Mancusi-Ungaro 1999; Buskirk 2003; Muñoz Viñas 2005;

7 Artwork description from Inside Installations: www.inside-installations.org/artworks/artwork-.php?r_id=311.

Kraemer 2007; Hummelen & Scholte 2006, 2012). The artist may play a large role here. Especially if the material artwork does not provide enough answers to guide conservation and reinstallation decisions, knowing the 'artist's intents' becomes increasingly important.

Based on the study of the documentation procedures of both museums, this chapter argues that 'artist intention' is not simply derived from the artist or the artwork, a view still commonly held in conservation practice, but is *produced* instead. Artist's intent, in other words, is the result of what is *done* in knowledge and documentation practices. This implies that rather than being a facilitator or 'passive custodian', the curator or conservator of contemporary art can be considered an interpreter, mediator or even a co-producer of what is designated as 'the artist's intention'.

Based on interviews and empirical research in both museums, sections 3.3 and 3.4 consist of a detailed analysis of the documentation procedures of the Bonnefantenmuseum and s.m.a.k. carried out by the museums in relation to the works of Joëlle Tuerlinckx.[8] In section 3.5 the strategies of conservation and documentation are compared and analysed in the context of the concept of artist's intent. Before I move to the concrete cases, section 3.2 will first discuss conservation literature on the problem of reinstallation and the related notion of 'site specificity'.

3.2 PROBLEMS OF REINSTALLATION: ARTIST'S INTENT IN PRACTICE

In order to better understand the challenges of reinstallation both museums are facing, it is useful to take a brief look at the notion of site-specificity in relation to installation artworks. Art historian Miwon Kwon (2000, 2002), who wrote extensively about the notion of site specificity, describes site-specific artworks as follows:

8 Many of the materials presented here were produced during several visits to the Bonnefantenmuseum in Maastricht and to s.m.a.k. in Ghent. Fieldwork at the Bonnefantenmuseum was done between January 2003 and November 2008. Fieldwork at s.m.a.k. took place during several visits between December 2003 and December 2005. Fieldwork included observations, archival research and interviews with museum staff. Interviews that were originally in Dutch have been translated by me. In March 2005, I attended a lecture by Joëlle Tuerlinckx entitled 'Action without knowing, deux ans plus tard. Response to Matt Mullican', organised and hosted by the Jan van Eyck Academy in Maastricht. I am grateful to the staff of both museums for their hospitality, time and cooperation. Special thanks go out to Ineke Kleijn, Frederika Huys, Anne De Buck and Maryline Terrier for letting me in on their practices and for opening up the two museums' archives to me.

[T]hey take the 'site' as an actual location, a tangible reality, its identity composed of a unique combination of constitutive physical elements: length, depth, height, texture and shape of walls and rooms; scale and proportion of plazas, buildings, or parks; existing conditions of lighting, ventilation, traffic patterns; distinctive topographical features. (2002, 38)

In the early days of Minimalism, 'site specific' was synonymous with 'irremovable' and 'temporary' as the specific relationship between the work and its site was considered to be definite and therefore unrepeatable. Relocating the work would, in other words, imply changing its meaning. In a 1969 interview artist Robert Barry, for instance, declared that his installations made out of wire 'cannot be moved without being destroyed'.[9] As Kwon observed, the meaning of the term 'site specific' eventually changed and became less rigid. Kwon: 'contrary to the earlier conception of site specificity, the current museological and commercial practices of refabricating (in order to travel) once site-bound works make transferability and mobilization new norms for site specificity' (2000, 49). Instead of unmovable, site specific has now come to mean 'movable under the right circumstances'.[10]

One of the consequences of this development is, according to Kwon, that the relationship between the artist-as-person and the artwork-as-process has become much more interlocked. To an increasing extent artists are involved in the continued existence of the artwork because the perpetuation of the artwork is dependent on the artist. In relation to site-specific artworks and with reference to Roland Barthes' famous essay 'The Death of the Author' (1967), Kwon speaks of the 'necessary return of the author' and the artist as 'a reappeared protagonist':

Perhaps because of the 'absence' of the artist from the physical manifestation of the work, the presence of the artist has become an absolute prerequisite for the execution/presentation of the site-oriented projects. It is now the performative aspect of an artist's characteristic mode of operation (or even collaboration) that

9 Barry quoted by Kwon (2000, 49).
10 Susan Hapgood quoted by Kwon (2000, 49). Kwon is critical about this development. According to the author this is the result of art surrendering to institutionalisation and commercialisation. See also Crimp (1993) for a redefinition of the notion of site specificity.

is repeated and circulated as a new art commodity, with the artist functioning as the primary vehicle for its verification, repetition, and circulation. (2000, 52)

In line with Kwon, art historian Martha Buskirk (2003) argues that removing the 'artist's hand', rather than diminishing the importance of artistic authorship, makes the connection between work and artist much more significant. As the physical object has become increasingly unstable as a marker of what constitutes the work, the continued existence of the work of art is highly dependent on the presence and engagement of the artist. Buskirk argues that although the artist's touch may be less evident in the physical process of making, the artist's ongoing presence and decision-making have become more important for contingent works where the physical boundaries of the piece have to be reconceived each time they are exhibited (Buskirk 2003, 16).[11]

In the first chapter of this book, it is argued that in conservation literature and practice 'artist's intent' often coincides with 'what the artist means with the work'. Despite theoretical discussions in literature and the arts on the subject of intention, in conservation practice and theory there is a strong insistence on the term 'artist's intentions'. It is generally acknowledged that especially if the material artwork does not provide enough answers to solve conservation and reinstallation dilemmas, retrieving the 'original intent of the artist' becomes increasingly important. Therefore, when matters of reinstallation or conservation are at stake, answers are searched for in artist's statements and interviews. Conservator Hiltrud Schinzel regards this as an intrinsic characteristic of contemporary art:

> [It is] typical for modern art that the abstract character of the works and the complexity of the artistic theories behind them force artists to express their intentions verbally in order to be rightly understood. [...] The way to the artistic experience had become so complicated that the work has to be supplied so to speak with an instruction booklet. (2004, 171)

11 For the centralisation of the artist in transnational networks, see Cherry (2002, 134–154).

In the conservation of contemporary artworks we see an expansion of the artist's role: the artist, although not being the actual owner of the work, is generally considered to be a – if not *the* – crucial stakeholder in the perpetuation of the work. A pressing concern addressed in recent literature and current debates about contemporary art conservation is the degree of the artist's involvement in practices (such as documentation) that since the rise of the conservation profession have been considered to be among the job responsibilities of museum professionals.[12]

Conservators sometimes express a reluctance to involve artists directly when conservation dilemmas arise, for fear of the artist wanting to change the art object. Traditionally, when an artwork leaves the artist's studio, it is generally understood to be finished.[13] To which extent is an artist allowed to alter a work after the museum has acquired it, even if he or she is considered the maker? Indeed, a question that is often addressed in relation to the current development of increasing artist's intervention is: How much can a work change before it becomes something else? A similar question was addressed in one of the first articles about the conservation challenges of installation art by the head of conservation at the Guggenheim Museum in New York, Carol Stringari:

> The ambiguity of the artist may be reflected when the institution who purchased the piece attempts to contact the artist during a reinstallation and the artist wishes to conceive the work differently. This is not necessarily a problem, but if one of the museum's goals is to preserve the integrity of the work it owns the question arises: can such works be mutable, or will each new conception be a new acquisition? What exactly, then, is being purchased when a museum acquires an installation? (1999, 273)

Philosopher Sherri Irvin, in an article about artist's intent describes how the National Gallery of Canada resisted the alterations to an acquired work proposed by the artist Jana Sterbak for the reason that 'a change

12 See, for example, Davenport (1995); Marontate (1997); Sturman (1999); and Huys (2000).

13 There are, however, many examples and anecdotes of artists who have crossed this line. There is, for example, a famous trope about how the painter Pierre Bonnard used to sneak into museums to continue to work on his paintings displayed in the gallery. For other examples as well as discussions on the question of 'When is an artwork finished?', see Becker et al. (2006).

in the display undermines the work they initially acquired' (2006, 154).[14]

However, in some cases (for instance, with commissions and in situ installations) collaboration between curator or conservator and artist starts at the very beginning of the artistic process. Collaboration can sometimes continue for years and take the form of a friendship.[15] This designation raises other questions posed by conservators, such as: how can one maintain critical distance, and how far do ethics allow museum professionals to involve themselves in conceptual and physical dimensions of the artwork?

Tate conservators Laura Davies and Jackie Heuman, for instance, explore the question of the extent to which it is appropriate for conservators to interfere with the artist's creativity. In their article 'Meaning Matters: Collaborating with Contemporary Artists' they describe their involvement in three cases. The conservators reflect on their own practices and explain how the negotiations with the artists evolved in each particular case. Their engagement varies from repigmenting a work following the precise indications of the artist, Anish Kapoor, to advising Anya Gallacio in finding the right materials for her work *Now the Day is Over*. From the article it becomes clear that the conservators are particularly ill at ease with their new role as coproducers. With regard to the latter case, they write: 'Yet perhaps we became too involved', and: 'we ask whether we overstepped our role and hampered the creativity of the artist' (Davies and Heuman 2004, 32–33). The outcry surfaces that the conventional 'hands-off/keep your distance' conservation ideology is at odds with the everyday practice of contemporary art conservators. In an article on conservation of contemporary painting, conservator Albert Albano takes the discussion a step further when he declares:

14 Irvin concludes: 'Thus the museum is free to invite or permit artists to modify their works after acquisition, but is, as far as I can see, under no obligation to do so' (2006, 155). This topic was also discussed during the panel discussion: 'Artist's voice: historical claim' during the conference 'Object in Transition: A Cross-disciplinary Conference on the Preservation and Study of Modern and Contemporary Art' held at the Getty Institute on January 25–26, 2008. The panel discussion was moderated by Carol Mancusi-Ungaro, Associate Director of Conservation and Research, Whitney Museum of American Art, and is accessible through www.getty.edu/conservation/publications/videos/object_in_transition_day1.html. Interestingly, panel members were asked to present an example of when they went against artists' wishes (Learner 2008).

15 See, for instance, Christian Scheidemann's lectures and publications on his conservation work and friendships with artists such as Mike Kelly and the now deceased Jason Rhoades: www.contemporaryconservation.com/ConservationCont.swf.

We, as conservation professionals, have in many ways begun to isolate the artist from our work. This trend is clearly ironic. It recalls previous periods when restorers were often artists and it was commonplace during restoration for them to impose their own aesthetic on another artist's works. In the same vein, we now seem to resent what is considered to be a lack of material and technical knowledge on the part of artists, and thus feel justified in imposing our own concepts of timelessness on them. This has even been carried to the extreme of the artist being prohibited from touching his or her work ever again; as such interventions are considered better left to the conservator. (1996, 183)

Naturally, there is not just one answer to the question of how much a conservator (or curator) should be involved in the creative process of the artist, just as there is not just one answer to the question of the extent to which an artist should dictate conservation decisions or be involved in the conservation process. And, just as there is no consensus among museum professionals regarding how much authority should be given to artists or their legal representatives, there is no consensus among artists with regard to their role in the life of an artwork. The degree to which artists want to get involved and stay involved (or in control) once a work has entered the museum collection will vary from artist to artist and from case to case. Some installation artists, for example, stipulate in their con- tracts with collectors that they or their representatives are to be involved with each reinstallation of their work. Others indicate that they are avail- able for consultation or lay down that they want to have the final say in authorising the work.

For the conservator this can lead to difficult situations. A report from the Tate on a Carlos Garaicoa case study reads: 'Negotiating the rela- tionship with the artist, while the artist is still very much involved in the work, is one of the challenges of contemporary art conservation.'[16] In the same vein, Carol Stringari expresses her worries: 'Artists may even wish to re-invent the piece – which is perfectly understandable from their per- spective, but what about our responsibility as care-takers of historical ob- jects?' (1999, 272). Pip Laurenson, now head of collection care research

16 'Carlos Garaicoa Case Study', Tate website, at: www2.tate.org.uk/garaicoa/themes_1.htm.

at Tate, London, also acknowledges that, in the context of reinstallation, problems may arise in the case of sometimes-differing values between artists and museum professionals. She observes that it is most likely that the museum values historical authenticity more highly 'than artists who, unlike the museum, have the option of being uninterested in historical links' (2004, 51). Laurenson distinguishes between two phases in what she calls the 'process of formalisation' of an artwork in a museum collection: 'early in the relationship with a new work, the museum often accommodates exploration and development of the identity of the work, only later acting more conservatively to contain the work in its established form. This shift in stance can be difficult for the artist to comprehend' (Laurenson 2004, 51). In her own practices, Laurenson thus recognises a change in the museum's values that is related to a shift in authority in the life of the artwork.[17]

Contemporary art practices have brought about a variety of new relations between artist and museum. At some stage of the artwork, artists, conservators and curators are most likely confronted with the need to communicate and collaborate with each other.[18] As stated above, this collaboration is often directed towards producing documentation such as installation guidelines or protocols. Guidelines such as these can be understood as ordering structures in which, generally speaking, both the museum and the artist (or his or her representatives) have an interest. For the artist it becomes possible to delegate part of her or his ordering to the museum. For the museum staff, installation guidelines function as a point of reference: they fend off uncertainty and are a basis for action.[19] Installation guidelines are developed to lead the staff in their handling of the artwork and as a means to transfer knowledge about the work from artist to museum staff member, between staff members, from museum staff to a next generation of museum staff, and, in the event of loans, from one museum to another.

17 See also Irvin's (2006) analyses of several cases in which there is a conflict between instructions specified by the artist and those adopted by the museum.

18 In the conservation literature dealing with this topic, it is interesting to see that the perspective shifts between the artist and the conservator. Some, like Pip Laurenson, take on the position of the conservator and explain from this position how they approach the artist. Others adopt more of a bird's-eye perspective and focus on the process of negotiation where conservator and artist meet. As far as I am aware, there are no publications on collaborating with museums from an artist's perspective.

19 See also Law and Mol (2002) and Mesman (2008) on guidelines as mode of ordering.

Documentation in contemporary art conservation is regarded as extremely important and can even come to substitute for the physical artwork. Yet, the collaborative character of knowledge production and documentation in contemporary art conservation is largely underestimated. By exception, philosopher Sherri Irvin (2006) in a discussion of artist's sanction (her term) as part of installation guidelines, places emphasis on the interactive aspect. Rather than concentrating only on the artist's part, she stresses the active role of museums within the process of information gathering:

> Although the artist is responsible for sanctioning these features, it is important to note that the artist did so, in this case [the case of artist Liz Magor as discussed in Irvin's article], only as a result of dialogues in which museum curators were crucial participants. The museum and its agents may play a central causal role in the generation of sanctions, and thus in the determination of features of the work. (Irvin 2006, 145)

In the following section, by exploring the documentation strategies of two different museums (the Bonnefantenmuseum and s.m.a.k., respectively), I will examine the question of how museums and their agents play a central causal role in producing documentation and guidelines.

3.3 BY MEANS OF MEASURING: *A STRETCH MUSEUM SCALE 1:1*

On one of my first visits to the Bonnefantenmuseum in the context of my research, the artist Joëlle Tuerlinckx and her team were working on site at the museum. Rather than acquiring a completed and portable artwork from an artist's studio or gallery, the museum had commissioned Tuerlinckx to produce her work on site. For the Bonnefantenmuseum it was quite a novelty to commission a work for acquisition.[20] In the absence of

20 The Bonnefantenmuseum in Maastricht is a provincial museum for old master painting and sculpture, and contemporary art. The monumental building, designed by Italian architect Aldo Rossi, is located on the banks of the River Meuse and opened its doors in 1995. American Minimal art and Italian Arte Povera form the basis of the contemporary art collection, which includes works by Jan Dibbets, Sol LeWitt and Marcel Broodthaers, as well as painters such as Peter Doig, Gary Hume and Neo Rauch. The museum has around 28 staff members including a collection registrar, a coordinator of contemporary art, a curator of

concrete knowledge about what they were acquiring, agreements about budgets, fees and mutual expectations were negotiated over time to later be formulated in a written agreement. The curator of the museum recalls that it was an exciting process in which the outcome of Tuerlinckx's work period was far from concrete. There was, however, according to the curator an important agreement in terms of the purchase by the museum: anticipating questions about how to proceed with future reinstallations, the museum stipulated the need for installation guidelines and attributed the responsibility for creating these to the artist and artist's gallery. The commissioned works were to be accompanied by installation guidelines. In this sense, the acquisition went beyond the purchase of a set of physical objects: it extended to a set of installation instructions. Without these guidelines the acquisition transfer, according to the museum, would not be considered completed.[21] Moreover, in the contract, it was stipulated that the artist is not allowed to change any aspect of the work after its completion.[22]

In order to grasp the complexity of the seemingly simple statement that 'the work is not to be changed after completion', it is important to look into the origins of the acquisition, as the commissioned works derived from a solo-exhibition held at the Bonnefantenmuseum in 2001. This show titled *A Stretch Museum Scale 1:1, or an invitation for a stretch walk in a compact museum*, was considered to be an actual size (1:1) scale model of the museum; hence the title.

In a description of the artist's works, the exhibition is described as follows:

> [It is] the project of an exhibition integrated in the structure
> of a museum designed by an architect (Aldo Rossi). The exhi-
> bition as a thought about the difference between the space
> designed and built by the architect and the same space re-de-

contemporary art, a depot manager and a facility manager. The artistic director at the time of research was Alexander van Grevenstein. For around three years there had been no conservator on staff. In case of conservation problems, like in most Dutch museums with a contemporary art collection, a conservator in private practice is contracted. For more information about the Bonnefantenmuseum, see www.bonnefanten.nl.

21 The acquisition contract dictates that the last part of production costs shall be transferred after receiving the installation guidelines. Such an agreement is not uncommon in collecting installation artworks.

22 Interview with Paula van den Bosch, curator, contemporary art, Bonnefantenmuseum, 23.04.2004.

signed and re-thought by an artist: the means to measure space, to mark its openings, its heights, its air cubages, to experiment its size.[23]

An important element of the exhibition was the gradual opening and closing of the daylight lamellas in the roof. Colours and video projections disappeared when the lamellas were opened. At the same time, with the darkening of adjoining spaces, video projections reappeared. The altering light turned the exhibition into a continuous changing environment. Time and its passing was a key theme of the exhibition, according to the curator of the museum: a theme that is recurrent in Tuerlinckx's oeuvre.[24]

In May 2001, the exhibition came to an end and the director and curator proposed to acquire the so-called '*salle noire*' for the collection. The artist, however, proposed an alternative plan, claiming that the '*salle noire*' could not simply be extracted from its former exhibition context.[25]

Rather than selling an existing work, Tuerlinckx proposed to create new work for the collection of the Bonnefantenmuseum. The director of the museum recalls that the agreement was for her to take up one gallery room, but soon the artist came up with ideas for other spaces as well and in the end, over a period of two years, and after several working periods at the museum, this resulted in three-room filling installations: *A Stretch Museum Scale 1:1, een voorstel voor het Bonnefantenmuseum (Tentoonstellingszaal 1)* (2001–2003) [figure 13], *A Stretch Museum Scale 1:1, een voorstel voor het Bonnefantenmuseum (Cinemazaal)* (2001–2003) [figure 14] and *A Stretch Museum Scale 1:1, een voorstel voor het Bonnefantenmuseum (Groene zaal)* (2001–2003) [figures 15, 16].[26] The initial plan for one room-filling installation expanded into three rooms. The rooms are close to each other and take up a corner of the museum. With reference to the word 'stretch' in the title of the works, Stella Lohaus, then Tuerlinckx's gallery owner,

23 This description is taken from a list given to me by the artist's assistant. The list contains descriptions of each of Tuerlinckx's artworks (unpublished).

24 Interview with Paula van den Bosch, curator, contemporary art, Bonnefantenmuseum, 23.04.04. For texts on and interpretations of Tuerlinckx's work, see, for example, Kuijken (1994); Tuerlinckx (1999); Theys (1999); Brams and Pültau (2006, 2007).

25 Interview with Paula van den Bosch, curator, contemporary art, Bonnefantenmuseum, 23.04.2004.

26 Interview with Alexander van Grevenstein, artistic director, Bonnefantenmuseum 13.08.2008.

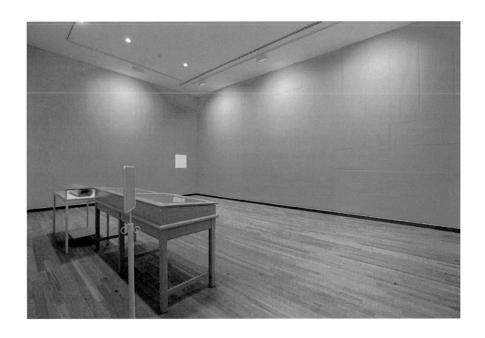

FIG. 15 – *A Stretch Museum Scale 1:1, a proposition for the Bonnefantenmuseum (Green space)* (2001–2003) by Joëlle Tuerlinckx. Collection: Bonnefantenmuseum Maastricht. Installation view 2003. The walls are covered with large strips of green paper: together with the ceiling light they produce a bright green, nearly fluorescent atmosphere. The layer structure and careful arrangement of paper strokes (in different sizes but each with the same width) bear a resemblance to the brush strokes of a painter. In a glass show case, a role of green paper is put on display. The attached label depicts a floor plan of one of the wings of the Bonnefantenmuseum. The mark on the floor plan and the date refer to the *Stretch Museum* of 2001. Here the current 'salle verte' is explicitly linked to its predecessor of 2001.

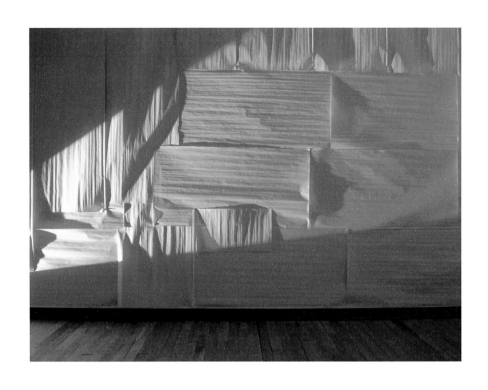

FIG. 16 – Detail of *A Stretch Museum Scale 1:1, a proposition for the Bonnefantenmuseum (Green space)* (2001–2003) by Joëlle Tuerlinckx. Collection: Bonnefantenmuseum Maastricht. The photo is taken with skimming light and clearly shows what the coordinator contemporary art of the Bonnefantenmuseum refers to as 'the life of the papers'.

writes: 'The idea that her work is stretchable; that it can be displayed in a smaller or larger constellation is important.'[27]

Throughout the period of display, some parts of the configurations in the three rooms were altered by request of the artist. The most prominent change initiated by the artist involved the drawings originally displayed on the table in the '*tentoonstellingszaal*'. At the artist's request, the drawings from the table were given on loan to a museum in Great Britain and other drawings by Tuerlinckx temporarily replaced the 'original' drawings.[28] Another alteration sanctioned by the artist is the fading of the colours on the slides used in the work. Tuerlinckx is interested in the history of objects and materials (for instance, she sometimes uses paper that has been laying out in the sun for some time to make visible the change in colour) and addresses the passing of time by archiving and showing figures on slides that have become discoloured during the exhibition. The artist, according to the curator of the museum, wants to address the passage of time and intends to make visible the inevitable changing of material objects.[29]

The room-filling works acquired by the Bonnefantenmuseum were on display for a period of almost three years after which the '*groene zaal*' (green room) and the '*tentoonstellingszaal*' (exhibition room) gave way to another collection presentation.[30] Prior to dismantling the rooms, each of the installations was carefully measured and documented in photos and floor plans by conservation interns as well the technical staff of the museum. This documenting, according to the curator, is the backbone of proper reinstallation. Explaining how the museum intends to reinstall the work in the future, the curator says:

> You hold on to the artist and install it exactly as she has done. It is possible to reconstruct how she did it. Yes, her specific touch

27 E-mail correspondence between Paula van den Bosch and the gallery owner, Stella Lohaus, 02.09.2003.

28 Interview with Ineke Kleijn, coordinator, contemporary art, Bonnefantenmuseum, 16.07.2008.

29 Interview with Paula van den Bosch, curator, contemporary art, Bonnefantenmuseum, 23.04.2004.

30 The black 'cinemazaal' (movie room), however, was left intact and is considered a (semi-)permanent work. The small room is nearly always open except when the museum considers it incompatible with other temporary displays nearby. In that case the door of the cinemazaal is temporarily closed and visitors are not allowed in. Interview Alexander van Grevenstein, artistic director, Bonnefantenmuseum, 13.08.2008.

makes it what it is, but once it is there you can document it and later bring it back the way it was. In the end, the work is made out of pieces of paper; there are no handmade drawings. You can reconstruct it by measuring it in a precise way. For example, you have to document what kind of light is used. It is a matter of making accurate documentation.[31]

In order to understand the possible effects of particular documentation strategies, it is useful to take a closer look at the documentation procedures carried out for the green room by a conservator of contemporary art in training. The documentation looks very meticulous: the exact layering of the paper strokes has been measured and documented and the strokes have been numbered in order to be able to reconstruct the entire room in the future on the basis of the plan. As part of the documentation and conservation plan, the green paper strips that had suffered from this display have been carefully restored. The documentation, however, does not include argumentation to explain the decision to preserve the green strips. From studying the documentation, it did not become clear to me why the strips of paper (which had been acquired at a paper factory) needed to be restored, rather than replaced. Surely the latter solution would have been much cheaper and easier in the long run. What, in other words, was the motivation behind documenting and storing the green paper strips?

When I asked the contemporary art coordinator these questions, she seemed a bit startled. Indeed, from a conservation perspective, my inquiries may have seemed rather odd. Yet, I learned that the original green paper materials were not just kept for the sake of material authenticity. Rather, the coordinator explained that it was important for her to preserve 'the traces of life' of the used paper. Under influence of the light and heat circumstances in the green space and because of their own weight, the green paper strokes had changed in appearance, giving them a kind of patina. [figure 16] The specific documentation strategy and the activity of preserving the green strokes thus turned out to be a deliberate choice rather than falling back on routine practices.

The specific choice of documentation suggests that the museum intends to recreate the exact same configurations and to preserve the work in its current form. Although the arrangements may have already

31 Interview with Paula van den Bosch, curator, contemporary art, Bonnefantenmuseum, 23.04.2004.

been altered slightly during the display in the Bonnefantenmuseum, the rooms are documented as if they had stayed and will stay the same. This kind of documentation presupposes that an artwork should 'freeze' in its original state. Gathered from the documentation practices, the current state, installed and therefore authorised by the artist, seems to be considered as the standard to which future displays will mirror. The curator's argument that all aspects of the works can be measured and as such can be reinstalled in exactly the same manner emphasises this.

On several occasions, the artist during the display of the installations at the Bonnefantenmuseum altered the rooms by arranging things slightly differently. The museum staff, however, seems reluctant to make any such changes to the work by themselves. The coordinator of contemporary art explains that even a small alteration may make a huge difference, and that they don't feel capable of making such decisions.[32] In a later interview she says: 'I have the feeling that the "*tentoonstellingszaal*" could still be in motion. Although I don't think that we will do it, we know it is allowed.'[33] When I ask whether the work can be displayed in other spaces, she replies: 'I think it could be, yes. But whether you want to do that is a different question. It will be a different work, for sure.'[34]

In summary: instead of documenting the *working practices* of the artist, the procedures of the Bonnefantenmuseum are geared towards documenting the *work of art*, the outcome of these practices. From studying the documentation archive at the Bonnefantenmuseum, it, for example, appeared to me that there was little documentation available of Joëlle Tuerlinckx working on site at the Bonnefantenmuseum. Apart from some memos and correspondence between the curator, the artist and the gallery, I hardly found any traces of Tuerlinckx's past working practices in the museum. Despite repeated working periods of the artist at the Bonnefantenmuseum, no images of her or her team at work were kept in the archive. Instead I found several images of the completed works. Interestingly, the coordinator of contemporary art explains the urge to document by pointing at the artist's working practice, rather than the work itself:

When she [Joëlle Tuerlinckx] is at work, it is hard to keep track of what she is doing. It is difficult to follow; you lose your sense

32 Interview with Ineke Kleijn, coordinator, contemporary art, Bonnefantenmuseum, 14.12.2006.

33 Interview with Ineke Kleijn, coordinator, contemporary art, Bonnefantenmuseum, 10.07.2008

34 Interview with Ineke Kleijn, coordinator, contemporary art, Bonnefantenmuseum, 10.07.2008.

of grip. When she leaves the museum and used material stays behind, I have the urge to keep it just in case she wants to use it again – even though it may only be rest-material. This makes that you want to document or register everything she does. I think the urge to document emerges from her way of working.[35]

Interpretation difficulties at the level of capturing the artist's practice are also illustrated by the following conflicting analysis. In his article 'Something about How a Tuerlinckx Machine Traverses the Exhibition Machine' philosopher Frank Vande Veire writes:

> It is very hard to discover what Joëlle Tuerlinckx is doing because – paradoxically – she is very consciously doing what she does not know. Or better still: she is attentively busy ignoring what she is doing. Why? Because she does not want to do this or that but wants to show us the general significance of 'doing': what one does when one is doing (anything at all). (Vande Veire 1996, 452)[36]

Art critic Luc Derycke, however, writes:

> Rather than 'being very consciously involved with something she does not know', she seems – by the clear presence of a strategy – to know, with great precision and deliberation, exactly what she is doing, sticking closely to the re-categorising, at times excru-ciatingly slow, at times quick as lightning – moments when she would put an army of men to work – and observing the effects (on herself, in the first place). (Derycke 2002, 24)

The documentation strategies of the Bonnefantenmuseum have been geared towards measuring the works in order to reproduce them in the same manner. This specific method of documentation will affect how museum workers in the future will reinstall the work. When the artist is no longer around to be consulted, and without any additional information, the chances are that reinstallation will start from the documentation and thus repeat the plans and images. The kind of document produced by the

35 Interview with Ineke Kleijn, coordinator, contemporary art, Bonnefantenmuseum, 10.07.2008.
36 See also Vande Veire (1997, 77).

Bonnefantenmuseum, in other words, may lead to a fixation of the work.

In 2008 the relationship between the Bonnefantenmuseum and the artists entered a new chapter, however. According to the director of the museum, it was the artist who re-opened the conversations after some time by inviting the director to participate in one of her video works. From this, they started talking about *A Stretch Museum* and the artist unfolded her plans to further explore and reinstall her works in the collection of the Bonnefantenmuseum.[37]

3.4 NEVER STOP STARTING: *ENSEMBLE AUTOUR DE ~~MUR~~*

ensemble autour de ~~MUR~~ (1998) was acquired by the former director, Jan Hoet, in 1999 on the occasion of Tuerlinckx's exhibition *this book, LIKE A BOOK*, which took place at S.M.A.K while the museum building was still under construction.[38] The acquisition was described as: the purchase of the projection of the word ~~MUR~~ and its possibilities into an ensemble; *un ensemble autour de ~~MUR~~*. In order to explore these possibilities, between 1998 and 2003, the work was installed three more times by the artist, each time in a different space and different configuration, adding new materials to the ensemble and adapting the ensemble to its particular context. Most of the materials and objects used in *ensemble autour de ~~MUR~~*, such as a chair, pieces of wood (*barres*), and post-its, are *objets trouvés*; retrieved from the museum by the artist. Rather than a contained object, the museum considers the ensemble 'variable' and a 'work in progress'.[39]

Right from the moment of acquisition the conservation department of s.m.a.k. had started to develop installation guidelines with the artist. Yet, in the context of Inside Installations, and with the aim of being able to present the work in the future in different spaces without the need to consult the artist for each reinstallation, s.m.a.k. aspired to generate

37 Interview Alexander van Grevenstein, artistic director, Bonnefantenmuseum, 13.08.2008.
38 Stedelijk Museum voor Actuele Kunst (s.m.a.k.) is a municipal museum of contemporary art in Ghent, Belgium. Former director Jan Hoet was instrumental in the establishment of the museum in its current location: a former casino in the city's Citadelle park that opened its doors for museum visitors in 1999. The museum counts over 60 employees and includes a curatorial department (around 8 people on staff) as well as a collection department (around 8 people on staff). The collection concentrates on art after 1945 and consists of over 2000 works by international as well as national artists. The artistic director is Philippe Van Cauteren. For more information about the museum visit www.smak.be/.
39 Museum brochure, s.m.a.k., Summer, 2005.

an installation protocol and establish guidelines for conservation. Conservation in this context is not necessarily defined, however, as keeping the work in a single material state. Rather, according to the then head of conservation at s.m.a.k., what is important for the perpetuation of this artwork is defining which aspects of the work are unique and therefore irreplaceable, and which are not.⁴⁰

The question arises whether in these particular working practices the common conservation dictum of 'freeze' is being replaced by a new doctrine that proclaims the negation of freeze. What does it take for the ensemble to avoid fixation? [figures 17, 18, 19, 20]

In order for the artwork to keep developing and changing, a lot of work needs to be done. To keep track of the successive installations, with each installation moment a large body of documentation was produced by the artist in co-operation with the museum. Each part of the ensembles is documented by photographs with an explanatory text that starts from the material used describing each element and the way it can be displayed. The documentation is stored in the conservation department of the museum. For example:
- Barre blancsmak 2002/s.m.a.k.
- Barre geschilderd in het wit anno 2002
- Andere zijde: s.m.a.k.
- Beide zijdes mogen worden getoond.⁴¹

In an interview, the conservator explains: 'We have acquired a concept which is expressed in materials. For an institution it is of great importance to define what is unique and what is not.'⁴² One of the elements, for example, is a cloth with the word 'object' on it. This cloth is, according to the artist, unique and therefore irreplaceable. Other elements such as the constructions of paper can be replaced by similar pieces of paper. For the slides (coloured or with texts written on them) used in the work, there are also certain protocols. The conservator explains that every two weeks,

40 Interview with Frederika Huys, head of conservation, s.m.a.k., 18.03.2004.

41 Description of the work in the documentation archive of s.m.a.k. Most of the documentation is bilingual (French and Dutch). Translated in English: bar painted in white in 2002, other side: s.m.a.k. Both sides may be displayed.

42 Interview with Frederika Huys, 18.03.2004. Citations from interviews originally in Dutch were translated into English by the author.

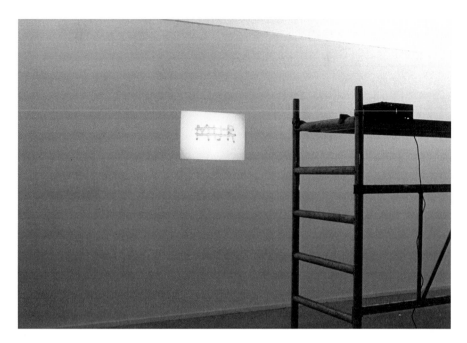

FIG. 17 – *ensemble autour de ~~MUR~~* (1998) by Joëlle Tuerlinckx. Collection Stedelijk Museum voor Actuele Kunst (S.M.A.K.), Ghent, Belgium. Installation view 1998 at S.M.A.K. In 1998, the work consisted of projecting the word MUR onto a white museum wall by means of a slide projector. The word MUR, written on the slide, was crossed out.

FIG. 18 – *ensemble autour de ~~MUR~~* (1998) by Joëlle Tuerlinckx. Collection Stedelijk Museum voor Actuele Kunst (S.M.A.K.), Ghent, Belgium. Installation view 1999 at S.M.A.K.

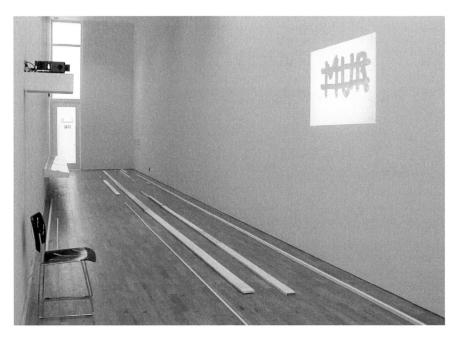

FIG. 19 – *ensemble autour de* ~~MUR~~ (1998) by Joëlle Tuerlinckx. Collection Stedelijk Museum voor Actuele Kunst (s.m.a.k.), Ghent, Belgium. Installation view 2002 at s.m.a.k.

FIG. 20 – *ensemble autour de* ~~MUR~~ (1998) by Joëlle Tuerlinckx. Collection Stedelijk Museum voor Actuele Kunst (s.m.a.k.), Ghent, Belgium. Installation view during the exhibition 'Gelijk het leven is' at s.m.a.k., June 28 to September 14, 2003. The work was adjusted to the colours of surrounding works in the collection by selecting the elements of one particular colour, in this case: yellow.

when the work is on display, the museum takes out the slides and copies them to document the fading of colours and the passage of time. New originals are created and the collection of slides as an indication of time grows. The slides can become part of the installation.

In order to document Tuerlinckx's working practices some of her particular techniques, for example, the folding of paper, have been video-recorded and documented by S.M.A.K. in cooperation with the artist. The museum and the artist agreed that when the artist considers conservation of the elements no longer possible, the museum is authorised to reproduce these elements according to the specifications provided by the artist. In the video recording we see the artist gently folding a small stroke of paper while explaining to the viewer what she is doing and what it has to look like.[43] She says she 'listens' to the paper and elucidates her practice as *'je fais comme une machine'* (I act like a machine).[44] The head of conservation at S.M.A.K. explains the value of these video recordings for the artist:

> For Tuerlinckx, the video is of major importance, even essential: without it she cannot transfer works to museums or collectors. Once the work is installed, without the video one would have no idea how to handle the works. The presentation of the work would remain unchanged, until finally its fragility causes it to disintegrate. [...] For this sort of work the artist's guidelines are the only guarantee that it will continue to exist. (Huys 2000)

The conservation process of this acquisition is depicted as a quest that engages both the artist and the museum staff (Mattheus and Wittocx 2004, 24). According to the conservator it is a search that the artist particularly enjoys because it relates to her way of working with – and thinking about – the materials she uses and how an artwork can change, yet stay the same.[45] The head of conservation explains how she sees the museum and the artist working together in the search for possibilities that meet the challenges of conservation:

43 According to the conservator these video recordings are not for display but explicitly made for documentation purposes only. Interview with Frederika Huys, head of conservation, S.M.A.K., 18.03.2004.

44 Video documentation from 1999, S.M.A.K. archive.

45 Interview with Frederika Huys, head of conservation, S.M.A.K., 18.03.2004. See also Huys (2000).

Cooperating with the artist Joëlle Tuerlinckx is fascinating because of the way various parts of her work combine within her oeuvre. The aspect of transferring a work to a collection constitutes a very significant act for Tuerlinckx. Together with us she wishes to develop a concept within which her work fits, but which is also flexible. (Huys 2000)

In the context of Inside Installations and to further explore the possibilities and limitations of *ensemble autour de* ᴍ̶ᴜ̶ʀ̶, in 2005 the museum employed an assistant (trained as a paper conservator) to observe the artist's working practice and advance installation protocols. The head of conservation states that the museum wanted to invest in the relationship with the artist in order to gain access and understand her working process.

Between July and September 2005 several new arrangements were explored and extensively documented in order to specify the parameters of change.[46] The goal of these arrangements was, according to the brochure, to produce an installation protocol and establish conservation guidelines so as to be able to display other authorised configurations.[47] An exhibition space at s.m.a.k. was reserved in which the assistant created a series of five *ensembles* to be criticised by the artist. Although some principles were set by the artist (for example: the work must consist of the chair and a projection of the word ᴍ̶ᴜ̶ʀ̶), there were, according to the assistant, still a lot of decisions to be made and experimentations to be explored.[48] The assistant explains their working procedure:

[A]t the end of each day, I took photos, short video sequences, as well as notes that I communicated to Joëlle Tuerlinckx. After discussion, I went back to the space, modified the installation, and so on, until the proposition seemed to us coherent and appropriate to the space. At that point, she came to the site and made the last modifications before validating the installation. The last modifications were essential; without them, she did not consider my intervention as constituting an artwork, but it is probably that, were the interpreter an artist, she would not have to inter-

46 Museum brochure, June to September 2005.
47 Artwork description from Inside Installations website: www.inside-installations.org.
48 Interview with Maryline Terrier, assistant and conservator in training, 31.08.2005.

vene. However, this remains an open question. We carried out five scenarios for *un ensemble autour de* MUR, each of which is, in turn, variable. (Terrier 2006)

Interesting is that the assistant describes how she, in Tuerlinckx's studio, was given small tasks by the artist to perform an activity such as making a pattern by putting pins in a wall. Rather than directing the assistant towards a particular pattern, Tuerlinckx taught the assistant to 'stop thinking and start doing'.[49] Reflecting on her time with the artist, Tuerlinckx's assistant recalls:

> Following her in the different stages of her work progress gave me access to an enormous quantity of information. Conservators sometimes complain about the unavailability of artists and the lack of information. I had the opposite difficulty; I was constantly receiving new information since, with each conversation – in the studio, at the exhibition site or while driving from one place to another – Joëlle would suggest new points of view. So the question was how to retain this information and sort through it with a view to the elaboration of a synthesis for the future installation guide. (Terrier 2006)

From these conversations and exercises eventually an installation guideline was developed.[50] Together with an object inventory and agreements on the rights concerning possible reproduction or transformation of the various objects, this resulted in an extensive manual.

The role of Tuerlinckx's assistant can be understood as that of an intermediary between the artist and the museum, translating and thus transforming knowledge from one to the other. Like a dance student learning from a choreographer how to perform a certain movement, the assistant observes and appropriates the artist's working practices. The assistant, together with the artist then aims to transfer this embodied knowledge to a written document, with the aim of producing an installation manual that makes it possible to retain the knowledge and skills of reinstalling the ensemble *and* to pass it on to others.

49 Interview with Maryline Terrier, assistant and conservator in training, 31.08.2005.
50 Interview with Maryline Terrier, assistant and conservator in training, 31.08.2005.

In conclusion: with the particular documentation strategy in combination with the successive reinstallations since 1999, S.M.A.K. seems to have incorporated the concept of variability in their conservation practices. The museum's approach was to work closely and intensively with the artist in defining the parameters of change. Producing documentation is used as a means to explore and specify which features should be considered essential to the work and which are suitable for change or replacement. The production of documentation is a process in which several actors are involved. For the head of conservation, the successive installations are understood as a means to reach the core of the work; when the core is known, the possible variations of the ensemble will also become clear. In the collaborative process of installing, creating installation guidelines, and formulating conservation options, the ensemble was done. The result is a shelf of folders full of documentation, plans, drawings, texts, memos, photographs and video footage.

Yet, despite the extensive documentation of *ensemble autour de MUR* and the installation guidelines, the head of conservation conveys that the museum does not feel comfortable reinstalling the work without the artist. This, according to the conservator, will require at least two or more installation exercises.[51] Tuerlinckx's assistant seems to agree as she writes:

> Ideally Joëlle Tuerlinckx would no longer need to intervene, but, in my opinion, this is far from being a reality and it is perhaps not a feasible goal. This being said, as the guide was constructed according to a model closely related to the work, it remains the most concrete testimony to its variability. If, in the future, the museum decides to show one of the old applications, it will be able to reconstruct the parameters of the context. But ideally, for the person willing to take the time to go through the guide, it should be possible to extrapolate a few future applications, so that the work continues to never stop starting. (Terrier 2006)

51 Conversation with Frederika Huys, head of conservation, S.M.A.K, 18.03.2004.

Irvin (2006), Kwon (2000, 2002), Buskirk (2003) and others have observed that in collecting installation art the artist's art-making activity regularly goes beyond the making or bringing together of a set of physical objects. The artistic practice extends to certain aspects of relationships with curators, conservators and other agents of the institution that acquires the work. From the perspective of the institution this means that accessioning installation artworks into a museum collection does not stop at the purchase of physical objects: the museum so to say buys into a relationship with the artist.

This chapter has explored this relationship in two different settings. My interest was not to demonstrate how different museums use differing concepts of intention, nor was it my goal to unravel what their ideas about Joëlle Tuerlinckx's intentions are. The key point of this chapter was to demonstrate that – what is in conservation literature and practice commonly referred to as 'intention' – is actually done in practices and in processes in which different actors are involved.

The research showed that the documentation practices in which the artworks are enacted affect what the work is, but also what it can be made into. In the case of the Bonnefantenmuseum, the documentation format (measuring) used may have as effect that every reinstallation will mimic the first installation, resulting in freezing the work in its initial state. Given the documentation of the Bonnefantenmuseum it is unlikely that, without the artist present, their acquisitions will be installed in other spaces or in different configurations. In that case, the original installation by the artist will be considered as a prototype and successive reinstallations a (inferior) derivative of this prototype. The 'prototype' may, however, be re-negotiated if the artist comes back into play again and reinstalls the work differently.

s.m.a.k.'s documentation practices, on the other hand, focused on recording the (temporary) outcomes (the successive installations) of processes as well as the process (Tuerlinckx's working practices) itself. s.m.a.k. does not employ a single prototype but a chain of prototypes. The documentation procedures used in this museum (exploring variability) may have as their effect that each reinstallation will be different than its predecessors. Rather than freezing the work, this approach may lead to the negation of freeze.

In order to get a better grip on the differences in approach between s.m.a.k. and the Bonnefantenmuseum, it is useful to turn to a philosophical account that seeks to understand human action in terms of 'knowing how' and 'knowing that' (Ryle 1949). As it is beyond the scope of this chapter to go into this too deeply, I will just briefly outline the two different concepts of knowing in order to position the two museum practices more clearly. In his seminal *The Concept of Mind,* Ryle distinguishes between 'knowing how' and 'knowing that'. 'Knowing how' refers to the kind of knowledge involved in action and movement whereas 'knowing that' is a knowledge of facts and information (Ryle 1949, 25–61). Ryle argues that 'know how' is shown in the things that people do: in the physical movement and overt behaviour. 'Knowing how', in other words, is concerned with practical reason and doing, and is related to tacit, practical knowledge, and skill as distinct from theoretical knowledge and reasoning.[52] In terms of Ryle's classification of knowledge, s.m.a.k.'s approach of documentation resembles what he classifies as 'knowing how', while the Bonnefantenmuseum with its focus on the finished artwork and its formal aspects represents 'knowing that'.

The two museums thus have a distinct approach; they employ two different practices in terms of organisational structure, people, matter and the extent to which these people are involved (or not). These practices have an effect on the perpetuation of the artwork in the museum. In this chapter I concentrated on the relationship between artist and museum agents and demonstrated that the artwork's career is affected by this relation. For museum agents accessioning an installation into a museum collection it thus becomes important to reflect on this relationship and make deliberate choices in how to proceed with the artist. What are the consequences of particular strategies? Acquiring installation artworks implies that questions emerge on how to enter into a relationship with the artist. When and what kind of interaction between the museum and artist is required and what does this mean in terms of organisation (people, finance, skills, work divisions, etc.)? This then also means that certain organisational aspects may need to be reconsidered.

Focusing on practices, as I have proposed in this chapter, shows that questions about 'artist's intention' become less relevant. Rather than exploring the concept of intention which assumes a one-way knowledge

52 On the distinctions between practical, technical and theoretical knowledge, see also Carr (1978, 15).

transfer (from artist to museum practitioners), I suggested the employment of a concept of knowledge that acknowledges interaction. Exploring forms of *interaction* in museum practices opens up options which have up till now remained implicit and invisible due to traditional conservation theory with its focus on intention.

From Object to Collective, from Artists to Actants: Ownership Reframed

What does it mean for a museum to purchase such a project? What are the possibilities for showing the work and what is the impact of such possibilities on the significance of the project itself? How do the individual works relate to the whole and to the context in which they are shown? What happens when the components scatter in time and space? What happens when the works take up other spaces, like the virtual one of the Internet? (Museum brochure Van Abbemuseum 2005)

This excerpt is taken from the museum brochure accompanying a presentation of the project *No Ghost Just a Shell* in 2005 at the Van Abbemuseum in Eindhoven, the Netherlands.[1] The brochure, available in the gallery space, reflected the curator of collection's questions evoked by the ownership of *No Ghost Just a Shell* (1999–2002). This seminal project initiated by French-based artists Philippe Parreno (b. 1962) and Pierre Huyghe (b. 1964) was acquired by the Van Abbemuseum on the occasion of the opening of the new museum building in 2003 and consists of about twenty-five artworks by over a dozen artists and artist groups, each work revolving around the fictional character of 'Annlee'.[2] Before the artworks featuring Annlee were gathered together in one 'Annlee exhibition' they already existed as individual artworks. From 1999 onwards the figure of Annlee appeared in many different places, eventually culminating in an exhibition in Zürich (entitled *No Ghost Just a Shell*) which later travelled to Cambridge and San Francisco. By the time the Van Abbemuseum decided to purchase the whole exhibition, many of the individual Ann-

1 The Van Abbemuseum, established in 1936, is a municipality museum located in the former industrial city Eindhoven (The Netherlands). In 2003 the building, which was designed by architect A.J. Kropholler, was renovated and integrated within a new building designed by architect A. Cohen. The new museum building opened its doors in 2003. The museum concentrates exclusively on modern and contemporary art from the 20th and 21st centuries. To date, the collection, formed around ensembles of artists, holds close to 2700 artworks. The museum employs around 50 people directly. There are 3 curatorial staff members including a curator of collection, curator of exhibitions and curator/head of exhibition as well as numerous guest curators. The museum has no conservators on staff but instead works with freelance conservators. Successive directors are: W.J.A. Visser (1936–1946), Edy de Wilde (1946–1964), Jean Leering (1964–1973), Rudi Fuchs (1973–1987), Jan Debbaut (1987–2003) and Charles Esche (from 2003 onwards). More information about the museum can be found at: www.vanabbe-museum.nl/.

2 In several sources, the name 'Annlee' is sometimes written as 'AnnLee'. I shall refer to the figure as 'Annlee'.

lee-artworks had thus already been showcased in the international art scene: each of the works carrying its own exhibition history.

In the dominant literature, the acquisition of *No Ghost Just a Shell* is regarded as an endpoint of the project: no more new Annlee-works will be produced and the project has reached its final destination. In this line of thought, the exhibition is understood as a residue, a result of an artistic exploration that has now come to its end, tucked away in a museum building. These writings on *No Ghost Just a Shell* only consider the initial emergence of the project up until its exhibition, thereby neglecting the formative role of the acquisition and conservation process. In contrast, this chapter sets out to study its continuous career in the museum collection.[3] The chapter shows that with the transfer of *No Ghost Just a Shell* to the museum, the project entered not only a new space and a new set of rules but also a new sequence of movement in its career. What does it mean for the project to be acquired by the Van Abbemuseum? But also: what does it mean for the museum to acquire such a project?[4]

With the acquisition of *No Ghost Just a Shell* the Van Abbemuseum has wilfully confronted itself with problems that are exemplified in many of today's artworks. The acquisition of an exhibition undermines the traditional notion of the artwork as a single, autonomous product of an individual artist. Some of the challenges the museum is confronted with have already been addressed in previous chapters, such as a realignment of roles attributed to artists, curators and conservators, the existence of more than one version of an artwork, and the complexity of copyright

3 On the notion of 'career', see the introductory chapter.

4 This chapter is based on literature research as well as on fieldwork performed at the Van Abbemuseum, Eindhoven (the Netherlands). Interviews with (former) staff members were conducted between 2004 and 2008. Data were also produced during less formal conversations with museum staff members during conferences, meetings, dinners and drinks. In addition, I attended a talk by Pierre Huyghe in November 2006, followed by a short conversation with the artist. Unfortunately, the artists Huyghe and Parreno did not respond to a later interview request. I therefore turned to other sources such as artist's texts and interviews with the artists conducted by others. I am grateful to the staff of the Van Abbemuseum for their generosity and time in conversations. Special thanks go out to Christiane Berndes and Margo van de Wiel. Citations from interviews that were originally in Dutch have been translated into English by myself. These, and citations in English have been slightly altered in order to improve legibility. The chapter has benefited from comments by Noah Horowitz, Ruth Benschop, Tatja Scholte, fellow Ph.D. students of the 2007 publication workshop, and by the organisers and participants of 'Shifting Practice, Shifting Roles? Artists' Installations and the Museum', March 22, 2007, Tate Modern, London. Webcast available at: www.tate.org.uk/onlineevents/webcasts/shifting_practice_shifting-_roles/default.jsp.

issues. However, the challenges posed by the acquisition of *No Ghost Just a Shell*, as we shall see, exceed the problems of Paik's *One Candle* and the works by Joëlle Tuerlinckx.

Although *No Ghost Just a Shell* is – admittedly – a rather extreme case study at some points, it can be regarded as paradigmatic for many contemporary artworks today. In this sense *No Ghost Just a Shell*, even more so than the previous cases, lends itself to an analysis of how, by acquiring and preserving such indeterminate artworks, new questions and strategies emerge. Moreover, an analysis of the project demonstrates how museum activities of collecting and conservation co-shape the constitution of artworks (and, in this case, a whole project).

Building on the insights of previous chapters, this chapter further explores a way of understanding collection management and conservation in which aspects of *change* and *intervention* are acknowledged, instead of being bracketed or even erased. Based upon empirical research and drawing from the previous case studies, it will take a closer look at the roles of the various elements involved in these processes. Instead of referring to *No Ghost Just a Shell* as a stable, autonomous artwork, I will approach it, in the language of philosopher of science Bruno Latour, as a 'collective' (Latour 1999b).

In short, Latour argues that machinery, technology and scientific theories are the result of dynamic processes. These processes are characterised by controversies, decisions, uncertainties and risks. Eventually, when the science or technology has evolved to what we believe or culturally accept, none of this chaos is visible. We can then speak of a 'black box': a box of which we do not know the construction or internal functioning, but of which only the input and output are known and relevant for the user. Only when these black boxes are opened, the complexity of choices, the heterogeneous variety of actors and negotiations come to the fore. The approach of opening black boxes thus turns the focus of investigation to how something has *become* at a certain stage rather than what something *is*. It studies the causes of outcomes, rather than the outcomes.

This is what Latour refers to as 'reversible blackboxing' (1999b, 183) which is explained by the example of an overhead projector. During a lecture, the projector is rendered as an unproblematic object, determined by its function. Only when the projector breaks down and repairmen gather around it to take it apart do we remember that it is composed of several individual parts, each with its own relatively independent goals

and functions. Thus, the projector is no longer simply an object, but has become an assemblage consisting of all kinds of different entities. Once the projector is repaired and the lecture continues, then the projector will again be taken for granted, perceived as a single object. What this example shows is that the number of actants involved at any moment will vary, as is true of the configuration.

The opening up of black boxes can be done by following the actors. This is what Latour and others have called an actor-network approach or actor-network theory (ANT). One of the most important strands of this approach is that it recognizes that non-humans, like humans, can play an essential role in the performance of actions and are considered to contribute to agency by virtue of their connections to other subjects and objects. In *Pandora's Hope: Essays of the Reality of Science Studies*, Latour describes the relation between two agents as a translation of their goals that results in a new goal that does not correspond to the previous two 'programs of action' (1999b, 178). In the process of goal translation, besides a new goal, also a new hybrid actor emerges. Latour explains that this translation is symmetrical, for example: 'You are different with a gun in your hand; the gun is different with you holding it. You are another subject because you hold the gun; the gun is another object because it has entered into a relationship with you' (1999b, 179). Instead of distributing particular actions to one single entity (the gun or the citizen), Latour's point here is that origin of action is distributed within a collective, rather than localized with a single entity. Latour: 'It is neither people nor guns that kill', instead it's the gun-citizen/citizen-gun and this is why 'responsibility for action must be shared among the various actants' (1999b, 180). Action, Latour explains, emerges out of the relationships in which the actants are involved and is not simply a property of humans (1999b, 182).[5]

In this chapter, I will conduct an actor-network approach by recon-

5 On actor-network theory in science and technology studies, here mainly associated with the early work of Latour, see, for example, Latour (1987, 1999a, 1999b, 2005); Law and Hassard (1999). For an actor-network approach in the context of arts and museums see, for example, Yaneva (2003a, 2003b) on art installations and Macdonald (2001, 2002) on the science museum, and Gielen (2003) on artistic selection processes in the fields of the contemporary dance and fine arts in Flanders (Belgium). In these studies it has been argued that with the help of ANT, the artwork – previously a forgotten actor within empirical sociological studies – can be studied as an agent. Hoogsteyns (2008) has explored the usefulness of ANT for the discipline of material culture studies and clarifies the recent appropriation of ANT by material culture studies by pointing at its renewed interest in materiality.

structing the actants in the conservation process of *No Ghost Just a Shell*.[6] Opening the black box of *No Ghost Just a Shell* and tracing the actants will show the appearance of a continuously changing collective and allows us to address the mixture of materials, humans, spaces, spatial arrangements, procedures and protocols. Moreover, we will see that when the configuration of actants (both human and non-human) changes, the project does so too: the project – unlike a fixed and stable object – shifts to some degree, never being the same as before. Reconstructing the acquisition and conservation process of *No Ghost Just a Shell* using Latour's conceptual framework of 'collective', as a continuously altering association of humans and nonhumans, thus allows me to address the changing mixture of materials, humans, materiality of the museum, negotiations and agreements. Instead of an autonomous art object created by an individual artist, instead of a fixed, stable entity, and instead of a conceptual artwork, in the following, I analyse *No Ghost Just a Shell* in terms of a collective. Such an approach allows analysis of the hybrid character of the acquisition and conservation practice, creating insight into the roles of the actors involved in the process of collecting and conservation.

In my analysis, four different stages of the project's career are distinguished: (1) the emergence of the project, (2) the acquisition (the transfer from artist to museum), (3) the transfer within the museum from temporary exhibition to permanent collection (from the 'curator of exhibitions' in charge of temporary exhibitions to the 'curator of collection' in charge of the museum collection), and (4) the appearance of another *No Ghost Just a Shell*.

This chapter also deals with aspects of conservation that until now have received little attention in this book: the tangled relationship between commodity values and conservation, between the art market and museums for contemporary art. Since the 'boom' of the contemporary art market in the 1980s, this area of the art world has been analysed from the perspective of finance, the humanities as well as the social sciences.[7] De-

6 With reference to actor-network theory, the terms 'actor' and 'actant' (a term Latour borrowed from semiotics) are often used interchangeably. However, in *Pandora's Hope* (1999b), Latour makes the point that he prefers 'actant' because 'actor' is typically reserved for humans (180). Following Latour and to place emphasis on human *and* nonhuman agency (which could easily be overlooked when adopting the term actor, which in general use refers to humans only), from here on I employ the term 'actant'.

7 See, for example, Velthuis (2003, 2005) (a sociological perspective on the financial and symbolic meanings of prices and how dealers determine prices for contemporary art), Thompson (2008) (an economic perspective on the importance of 'branding' in the contemporary art business), Thornton (2008)

spite the fact that conservators of contemporary art have come to play an increasingly large part in art production and dissemination, their involvement is hardly ever accounted for in literature centred on the art trade.[8] Although museum conservators can hardly be said to be key players in the art business, whilst working on collections within museums they also do not operate *outside* of the art trade dynamics. Replacing materials may have an impact on the monetary value of artworks; and conservation treatment and the expenses dedicated to it will also be influenced by how much the work is valued financially, or, in other words, what it is considered to be worth economically.

Another possible tie between the conservator's work and the world of art dealing is, for example, their involvement in preparing artworks for the art market, enhancing their commodity and monetary value by, for example, advising artists or art dealers on the durability of materials used or by providing manuals for complex works. In a lecture organised by the Foundation for the Conservation of Contemporary Art (SBMK) in the Netherlands, Christian Scheidemann, a renowned freelance conservator based in New York who works extensively with artists such as Matthew Barney and Robert Gober as well as with private collectors, called this the 'pre-natal' phase of the artwork, suggesting that his interventions should not be considered as part of the life of the artwork as they generally take part before the work actually enters the public domain.[9]

Interestingly, during conversations I had with conservators in the context of my research, mundane issues such as economic realities, monetary issues, politics and power relations were often waved aside by my informants as irrelevant to matters of conservation. Although such issues were often mentioned in conversation in order to explain why a certain choice was made, it was also immediately stated not to be of any real importance to the work itself. This apparent lack of emphasis can perhaps be partly explained by pointing at the more general reluctance of art practitioners to talk about the less exalted aspects of art.[10] In this context, Keller and

(focusing on the contemporary art world at large, and the art market in particular) and Horowitz (2010) on the commodification of video and installation art.

8 The same has been argued for curators (Horowitz 2006, 82).

9 Lecture by C. Scheidemann held at the symposium 'The Inconvenient Truth', organised by the Foundation for the Conservation of Contemporary Art (SBMK), hosted by Van Abbemuseum Eindhoven, June 19, 2008, see also Scheidemann (1999, 2005).

10 In his study of American and Dutch contemporary art dealers, Velthuis (2003, 2005) observes how despite initial reluctance to make references to commerce in the business space, prices surfaced prom-

Invoice

FROM		
Tax ID:	87-0460119	
Contact Name:	Ryou Sugiyama	
Kenichi Konaka Inc	928465144	
K works	2-2-17 Kundan-minami	
	Chiyoda-Ku	
	102-0054	
	Japan	

Shipment ID:	3X8W40G4VSP
Invoice No:	
Date:	
PO No:	
Terms of sale (incoterm)	
Reason for export: Sale	

SHIP TO		
Tax ID:	87-0460119	
Contact Name:	Pierre Huyghe	
	Philippe Parreno	
	1 rue d Hauteville	
	Paris, 75010	
	France	
Phone:	0142463829	

SOLD TO COMMERCIAL USES	
Tax ID:	3X8W40G4VSP
Contact Name:	
Same as Ship	

Units/UM Descriptions of Goods		Harm.code	C/O	Unit Value	Total Value
1 ea	All Rights	4911100050	JP	¥ 46000	¥ 46000

Additional Comments:

Declaration Statements:

Shipper Date

These commodities, technology or software were exported from Japan in accordance with the Export Administration Regulation.

FIG. 21 – Invoice of K-work, a Japanese company specialised in designing *manga* and comic images for commercial sales. The invoice stipulates the rights to use the figure, later known as 'Annlee'. In an interview Parreno explains the choice for this particular image: 'We looked for a character and we found this one. A character without a name, a two-dimensional image, with no turn-around. A character without biography and without qualities, very cheap, which had that melancholic look, as if it were conscious of the fact that its capacity to survive stories was very limited (Parreno quoted in Huyghe and Parreno 2003, 15).'

Ward speak about the myth that art, 'while relying on market forces to circulate, is priceless and above such concerns' (2006, 10). Rather than placing the work that goes into art outside of art, I consider the mundane as a meaningful part of practice.

In the following story about *No Ghost Just a Shell*, I will take particular notice of such issues as part of working practices. However, before entering into the museum, I will first briefly discuss the beginnings of *No Ghost Just a Shell*.

4.2 THE EMERGENCE OF *NO GHOST JUST A SHELL*

The history of *No Ghost Just a Shell* goes back to 1999 when Philippe Parreno and Pierre Huyghe decided to buy a virtual character [figure 21], modelled the image in 3–D, gave it a name (Annlee) and a voice, and made two short real-time animation films on the character. Between 1999 and 2002 they shared the character with other artists and artist groups, inviting them to create their own artworks using 'Annlee' as a point of departure. Over a period of three years works were shown individually or with other Annlee-works at approximately twenty-five different locations mainly in Europe but also in Japan and the us. There were paintings (by Barande and Phillips), videos (by, for instance, Huyghe [figures 22, 23], Gonzalez-Foerster [figure 24], Curlet [figure 25], and Gillick [figure 26]), toys for Annlee (Bulloch and Wagener), wallpaper (M/M Paris), music (Vaney), and even a coffin for Annlee by Joe Scanlan [figures 27, 30].[11]

Initiated by the director of the Kunsthalle Zürich, in 2002 a group of Annlee-works were first shown together in the exhibition titled *No Ghost Just a Shell* – a title derived from Masamune Shirow's classic *manga* film *Ghost in the Shell* – at the Kunsthalle Zürich (Switzerland), later travel-

inently in the art dealers' discourses when casually describing their day-to-day world. From this observation, Velthuis sets out to analyse this discourse and 'how prices, price differences, and price changes convey multiple meanings related to the reputation of artists, the social status of dealers, and the quality of the art works that are traded' (2003, 181).

11 In May 2006, the Van Abbemuseum lists twenty-seven inventory numbers representing works by the following contributors: Pierre Huyghe, Philippe Parreno, Henry Barande, Angela Bulloch and Imke Wagener, François Curlet, Lili Fleury, Liam Gillick, Dominique Gonzalez-Foerster, Pierre Joseph and Mehdi Belhaj-Kacem, M/M Paris (Matthias Augustyniak and Michel Amzalag), Melik Ohanian, Richard Phillips, Joe Scanlan, Rirkrit Tiravanija, and Anna-Léna Vaney (source: Museum registration system, Van Abbemuseum, May 2006).

FIG. 22 – *Two Minutes out of Life* (2000) by Pierre Huyghe. Still from video.

FIG. 23 – *One Million Kingdoms* (2000) by Pierre Huyghe. Still from video.

FIG. 24 – *Annlee in Anzen Zone* (2000) by Dominique Gonzalez-Foerster. Collection Van Abbe-museum, Eindhoven, the Netherlands. Still from video.

FIG. 25 – *Witness Screen* (2002) by François Curlet. Collection Van Abbemuseum, Eindhoven, the Netherlands. Still from video.

FIG. 26 – *Annlee You Proposes* (2001) by Liam Gillick. Collection Van Abbemuseum, Eindhoven, the Netherlands. Still from video.

FIG. 27 – *Do It Yourself Dead on Arrival (AnnLee)* (2002) by Joe Scanlan. IKEA parts: melamine, chipboard, plastic wire, cotton, polyester, metal; DIY book: offset, ink on paper. Dimensions variable. Collection Van Abbemuseum, Eindhoven, the Netherlands.

ling to the San Francisco MOMA (US) and the Institute of Visual Culture in Cambridge (UK).[12] On each of these occasions the selection of artworks varied and its presentation was adjusted to the specific exhibition sites.

In retrospect, displaying all Annlee-artworks together in a single show can be considered a key event in the career of the project for two reasons: (1) it facilitated thinking in terms of an exhibition at one location and (2) it enabled the initiating artists to start thinking about ending the project. A press release accompanying the SF MOMA exhibition in San Francisco indicates that Parreno and Huyghe had commenced to transfer the copyrights of Annlee to her imaginary character in order to prevent other artists from using the image. The wish was 'to protect Annlee' and 'to ensure that the image of Annlee will never appear beyond the existing representations'.[13] In fact, an intellectual property lawyer was hired to draw up a contract transferring the rights back to Annlee. Moreover, in 2002 Huyghe and Parreno, by transferring the copyrights to Annlee herself, tried to make it legally impossible to continue exploiting Annlee. Whereas the acquisition of the rights to use Annlee marked the beginning of the project, the transference of the rights to Annlee in 2002 marked the ending of the project. The dates '1999–2002' later mentioned on *No Ghost Just a Shell*'s wall label, in this respect, mark a clear beginning as well as a defined ending. On December 4th, 2002, at 21:30 the vanishing of Annlee was celebrated by means of a staged fireworks display during the inaugural night of Art Basel Miami Beach. Huyghe: 'This will be her last manifestation as her silhouette sparkles and dissipates in a series of fireworks over the skies of Miami Beach as she is finally disappearing from the kingdom of representation.'[14] Thus, from the heterogeneous unplanned process came a unifying, identifying act, as if it was saying 'This is Annlee, here it ends!' This major event heralded a lot of publicity and exposure for Annlee, including the cover and centrefold of *Artforum*'s January 2003 issue (Nobel 2003).

12 Kunsthalle Zürich, August 24 to October 27, 2002; San Francisco MOMA (December 14, 2002 to March 16, 2003); Cambridge (December 8, 2002 to January 26, 2003).

13 See Huyghe and Parreno (2003, 25) and press release SF MOMA (September 13, 2002) at www.sfmoma.org/documents/press_releases/NoGhostJustaShellpdf.pdf.

14 www.transmag.org/annlee/index.htm.

Around the beginning of 2000, *No Ghost Just a Shell* received a great deal of publicity. In addition to several articles in *October* and the cover of *Artforum,* renowned freelance curator Hans Ulrich Obrist, for example, spoke and wrote frequently about the project.[15] Although most critics wrote positively about the project, some were less enthusiastic. Adrian Searle from *The Guardian* wrote: 'The project seems to be everywhere, from Venice to Glasgow, from Eindhoven to Cambridge. But it is time for AnnLee to retire. She was never such a great idea to begin with' (Searle 2003, 7). What comes to the fore, in studying the many articles and reviews on *No Ghost Just a Shell*, is that most writers and critics explicitly refer to the complicated, pioneering nature of the project. In the words of critic Elizabeth Bard: 'The AnnLee project is as much a liberation from the traditional notion of an exhibition (fixed time, fixed place) as from the traditional notion of product (buy, sell)' (Bard 2003).

In efforts to describe and interpret *No Ghost Just a Shell* several alternative, often less object-centred concepts are introduced to capture the project. Common art concepts seem to be rendered inadequate to describe the project's characteristics, and new vocabularies are explored. Art critic Jan Verwoert, for example, stresses the difficulty of defining the project. After an extensive search for alternative ways to understand *No Ghost*, he concludes his article 'Copyright, Ghosts and Commodity Fetishism' with a series of suggestions of what the project might be:

> a ghost in the matrix of global capitalism; an emanation of the postmodern sublime; an incarnation of the spirit of the information age; a revelation to the paranoid; a mermaid in a sea of silicon; a sister of Maxwell's demon; a mediator in a closed system; the key to the secret laws of synchronicity; a metaphoric signifier with a shifting spectral body. To be continued. (Verwoert 2003)

Some of the alternative concepts introduced in the context of *No Ghost Just a Shell* refer to the hybrid character of the project's beginnings, while other descriptions refer more to the display or reception of the project.

15 See, for example, Obrist (2003) and the special issue of *October* (issue 110, 2004) that centres on relational aesthetics and pays particular attention to *No Ghost Just a Shell*. See, for example, an interview with Pierre Huyghe by George Baker, and articles by Claire Bishop and Tom McDonough.

An example of the latter is the metaphor of 'a virus' which is used in relation to the various exhibitions of Annlee before the works came together in one exhibition. Yet, it is also used in relation to the exhibition of the project in 2002/2003 at the Van Abbemuseum in which the Annlee-artworks were dispersed over several spaces of the museum including the library, the cantina, and several exhibition rooms.[16]

To indicate the vibrant and unpredictable character of *No Ghost Just a Shell,* Van der Beek (2003, 42) describes the project as having its own network with connections in different social and artistic spheres. In a similar fashion, Hal Foster in a special issue of *October* labelled *No Ghost Just a Shell* 'archival art'. He explains: '...much archival art does appear to ramify like a weed or "rhizome"' (Foster 2004, 6). In interviews the artists say not to regard the development of the project as a linear process, but rather as a kind of rhizome that grows organically, appearing and disappearing depending on the connections that it is able to make. Pierre Huyghe objects to the idea of *No Ghost Just a Shell* as a process: 'It is less a question of "process", which is too linear, but of a vibrating temporality' (Huyghe quoted in Baker 2004, 88). This way of working is said to be exemplary for both Philippe Parreno and Pierre Huyghe. Rather than being studio-bound and creating finished art objects, their projects develop in diverse settings and often in close interaction with other projects and people. It starts with a plan, but the plan, as they say, may change along the way.

In *No Ghost Just a Shell* also several other themes that have been addressed in earlier works by the artists can be recognised. Examples are investigations into artists' collaboration projects, copyright issues (Liam Gillick and Philippe Parreno's *Briannnnnn and Feryyyyy* (2004)) and the legal ownership of works of fiction (*Blanche Neige Lucie* (1997) and *Anna Sanders. L'Histoire d'un sentimental* (1996)). Another recurring element, in particular of Huyghe's work, is the desire to reformulate the existing protocols of exhibition against the constraints of 'fixed time and fixed space', and to extend the concept of 'the exhibition' beyond its spatial and temporal boundaries (*L'Association des temps libérés 1995* by Pierre Huyghe).[17]

16 Interview with Phillip Van den Bossche, curator of exhibitions, Van Abbemuseum, 13.01.2005. See also Pingen (2005, 526–527).

17 *L'Association des temps libérés* (1995) was a contribution by Pierre Huyghe to a group exhibition. Instead of a place for the temporary exhibition of products, the exhibition is a departure point for other projects of indeterminate length, such as: *The House or Home?* (1995), *Mobil TV* (1995/1998), and *Tempo-*

The work *Esthétique relationnelle* (1998) by French philosopher, art critic and curator Nicolas Bourriaud should be considered here because it belongs to the particular discourse that *No Ghost Just a Shell* is part of.[18] In fact, Huyghe, in an interview about *No Ghost Just a Shell*, refers to Nicolas Bourriaud as being 'instrumental to setting up this group of artists'. The artist continues: 'In a certain way, Nicolas's book was like the production of a new scenario, in the manner I discuss this in my own practice. His book and his words provided a linkage between various artists and people' (Huyghe quoted in Huyghe and Parreno 2003, 100–110). Relational aesthetics attempts to characterise the artistic practices of the mid- and late nineties, including work by Huyghe and Parreno as well as artists such as Rirkrit Tiravanija and Liam Gillick. In his now famous book, Bourriaud sets out to develop a new interpretation of the aesthetic object according to which the art object is no longer defined materially or conceptually but *relationally.* Rather than individual consumption or contemplation, relational art seeks to establish social encounters by setting up situations in which the audience is invited to communicate and create a community: an art form which takes social encounters and being-together as a central theme. Relational art, in short, discards conventional notions of the artwork as finality. However, a question that remains unexplored in Bourriaud's relational aesthetics is the question of materiality. Although Bourriaud is the first to deny that relational artworks celebrate immateriality *per se*, many of the examples he describes seem to have discarded the physical object as the dominant form of expression and take on more immaterial, temporary and interactive forms such as events or services. An interesting question, though not addressed by Bourriaud, is what role is there for physical objects and the museum in relational art?

In discussing Annlee, art historians and critics have mainly focused on artistic and art-theoretical discourse: on the conceptual considerations shaping the project. Up till now the history of *No Ghost Just a Shell* has been written from, to use the words of Latour, an *internalist* point of view,

rary School (1996) (Pierre Huyghe in an interview with George Baker (2004, 88)). *Briannnnnn and Feryyyyy* (2004), a series of short animations, offers a reflection on the relationship between artists and copyright law. *Blanche Neige Lucie* (1997) is a video recording of Pierre Huyghe interviewing a French woman who dubbed the voice of the cartoon character Snow White in the Walt Disney film and lost the copyrights of her own voice. *Anna Sanders. L'Histoire d'un sentimental* (1996) evolves around a fictional character that gains a virtual existence, appears in various stories and films, and starts to live a life of her own.
18　From here on I will refer to the English translation, *Relational Aesthetics* (2002).

meaning that particular attention is paid to – in this case – artistic ideas, principles, and knowledge from within the art historical discipline.[19] There are, however, also other elements and developments that play an important role in the art project's career. A focus on these other elements such as (museum) politics, (property) law, (art market) economics, institutional organisation, and the moods and ways of people involved, is what Latour would call an *externalist* account of history (Latour 1999b, 85). The following section will show that – just like in science – neither an internalist nor a externalist account is adequate when the career of *No Ghost Just a Shell* is considered in relation to the practices in which it is enacted.

4.4 ACQUIRING *NO GHOST JUST A SHELL*: FROM ARTISTS TO MUSEUM

In hindsight, it seems so simple and almost logical: there was an image, two artists used this image, then more artists appropriated it and this resulted in an exhibition that was eventually acquired by a museum. However, what is important to recognise is that the project did not evolve according to a predetermined plan. In the words of Huyghe: 'I provide a framework, and then I let the framework go and things happen within the framework that are subject to chance, to interaction. These things are far beyond my control' (Huyghe quoted in Baker 2004, 86).

The wish of the Van Abbemuseum to acquire the whole exhibition fits into the dynamics of the project. Traditionally, exhibitions unlike objects are regarded as ephemeral statements that tend not to be collected. In this light, the artists were surprised: 'They were very enthusiastic and said that they could never have dreamed that somebody would come up with the idea to try and acquire all these artworks', says the curator of exhibitions.[20] Later, in the publication accompanying the acquisition of *No Ghost Just a Shell*, Pierre Huyghe proclaimed:

19 Latour distinguishes between internalist and externalist accounts by describing the history of Joliot's discovery of the neutron. An internalist account of this history would describe the history of Joliot's accomplishments in terms of science only, thus focusing on neutrons, laboratory work, ideas, principles, knowledge and procedures. An externalist approach would, however, emphasise the circumstance of Joliot's work and portray its history as a story of politics, economical developments etc., while neglecting the scientific aspects. (Latour 1999b, 84–112).

20 Interview with Phillip Van den Bossche, curator of exhibitions, Van Abbemuseum, 13.01.2005.

The implications of this acquisition have to be invented. There's this book, plus a museum that may take the name of Annlee. Through acquisition the Van Abbemuseum will be contractually bound to the project. (Huyghe quoted in Huyghe and Parreno 2003, 23)

Right from the start, *No Ghost Just a Shell* was depicted as a 'special purchase' and a breakthrough in collection activities, for instead of an individual object, an entire exhibition was acquired. Yet, it will come as no surprise that this acquisition involved much more than merely purchasing and transporting several objects. Rather than stabilising the art project and freezing it into a single form, from the activity of acquisition new relations were established and mutations emerged. Thus, despite the assumed termination of the project and the unifying, identifying act of the disappearance of 'Annlee' in fireworks, *No Ghost Just a Shell* remained in its state of becoming.

With this acquisition it took the director, curator of exhibitions and other museum staff at least one year to sort out the required legal apparatus of the project and to agree with the artists and their dealers as to which works could and should be purchased. Moreover, the acquisition not only entailed challenging practicalities, it also generated conceptual demands: what first had been a one-off temporary travelling exhibition consisting of individual artworks now had to be reconceptualised as a museum acquisition: a commodity.

It is interesting that the museum was closed for renovation when the idea arose to purchase *No Ghost Just a Shell.* The museum, in its state of being closed, can be considered, in the vocabulary of Latour, an actant because the unusual situation of the Van Abbemuseum being closed actually provided the possibility of the purchase. In this situation the museum's organisation could adjust to the amount of work that was needed to redefine the project. Rather than preparing for temporary exhibitions, the curator of exhibitions could dedicate all his time to preparations for the purchase and the first presentation of *No Ghost Just a Shell* at the opening exhibition of the new museum building. In his new role as project leader, the curator of exhibitions was responsible not only for the exhibition, but also for all negotiations involved with the purchase.[21]

21 Within the organisational structure of the Van Abbemuseum the latter normally belongs to the tasks

The first step was to negotiate exactly what the museum would acquire. For organising artists Parreno and Huyghe, it was important that the acquisition would be accompanied by a publication for which they invited several authors to reflect upon Annlee, much as they had earlier invited artists to work with the figure. The book figures as a catalogue but it is also regarded as an acquisition and as one of the artworks amongst the other objects. Thus, through the acquisition by the Van Abbemuseum, *No Ghost Just a Shell* was extended by the production of a book that, as an artwork, also became part of the project itself. The book simultaneously exists as an expensive art object in the museum collection as well as a more modestly priced commodity in the public domain. The curator of collection recalls the awkward situation of having to explain to the board of trustees why the Foundation had to pay such a large amount for a book that could easily and much more cheaply also be acquired in the museum gift shop. The particular book copy of *No Ghost Just a Shell* that has become part of the collection of the Van Abbemuseum is most likely signed by the artist and has thereby become unique, but of course, the museum paid for the production of the book *No Ghost Just a Shell* and not for a particular copy.[22]

4.5 A NEW ARTWORK: *TRAVELLING POD*

Besides the production of the book, the curator of exhibitions was also in charge of acquiring each individual Annlee-artwork. The artists Huyghe and Parreno acted as intermediaries between the museum and all individual artists who had contributed to the project. In this sense, by turning *No Ghost Just a Shell* into a commodity, the artists themselves were actively involved in the process of collecting. Of over thirty works, each had to be purchased under separate cover from the relevant artist or gallery since

of the curator of collection but in this case, according to both the curator of exhibitions and the curator of collection, it made more sense to allocate the aspects involved with the acquisition to the curator of exhibitions simply because the domains of exhibition production and purchase were so heavily intertwined. Interview with Phillip Van den Bossche, curator of exhibitions, Van Abbemuseum, 13.01.2005.

22 For an explanation of price arrangements in contemporary art, see, for example, Thornton (2008) and Jones (2004). I bought my copy of the book in the museum gift shop for the reasonable price of approximately forty Euros. When I inquired about the price of the LP of Anna-Lená Vaney's soundtrack *Asleep in the Deep: AnnLee No Ghost Just a Shell* from 2003, also available in the gift shop, the shop keeper tried her best to explain its high price to me by pointing to its relative uniqueness as a limited edition.

FIG. 28 – *Travelling Pod* (2003) by Pierre Huyghe and Philippe Parreno. Collection Van Abbe-museum, Eindhoven, the Netherlands. In 2003, the robot was programmed in such a way that it could project the video works of the Annlee project on the gallery walls while moving on its own behalf according to the scale of the exhibition room and the patterns of the floor carpet. The video projected is *Annlee You Proposes* (2001) by Liam Gillick.

there was no specifically developed economic system within which the Annlee-works had been produced. Instead, all works were created within a system that showed all the conventional economic characteristics of art production and distribution.[23] Some of the works were produced as limited editions and had already circulated in the art market. As a result, not all Annlee-artworks were still available for acquisition.

It soon became clear, for instance, that the first Annlee video works by Philippe Parreno and Pierre Huyghe, which were considered essential components of *No Ghost Just a Shell* but produced in a limited edition, were sold out and no longer available on the art market. The artists solved this problem of the limited edition by reproducing the two videos and integrating them into a newly designed artwork: a robot entitled *Travelling Pod* (2003). [figure 28] The *Travelling Pod*, a white, shiny, amorphous-looking object, was programmed in such a way that it could project the video works of the Annlee project on the gallery walls while moving by itself according to the scale of the exhibition room and the patterns of the floor carpet that was specially designed for this purpose. This way, by incorporating the videos within a new artwork and giving the work a different title, the artists could work around the problem of the sold-out authorised video works. Thus, although, from an administrative point of view, the videos do not exist in the collection of the museum (they do not have an inventory number), thanks to the robot, the Van Abbemuseum can show them in the context of their acquisition. This means that the video works are only to be shown through the robot. Their mobility within the Van Abbemuseum has thus become limited as they are not to be displayed outside the context of the robot.

From the above, we see that the fact that two initial videos were sold out re-shaped *No Ghost Just a Shell* as it was acquired by the Van Abbemuseum: a new artwork is added to the project and the initial videos were integrated into this new work. Analysing the robot as a collective is particularly interesting as it shows how existing structures and seemingly irrelevant contingencies co-shape artworks in the museum. Moreover, the robot as part of this collective can also be considered to have agency as it, for example, produces new relationships and transforms others.

The robot plays a part in, for instance, the continuation of the concept of dispersion of time and space. As stated above, the element of

23 Interview with Phillip Van den Bossche, curator of exhibitions, Van Abbemuseum, 13.01.2005.

dispersion in time and space is considered crucial to the project. The Annlee-artworks were shown separately from each other, appearing in exhibitions all over the world, like 'a sign scattered in space'. Collecting and displaying all Annlee-works in one place, as if they constitute a regular art object or exhibition, would thus destroy the initial and vital idea of the project. To preserve this idea, during the first exhibition of *No Ghost Just a Shell* the works were scattered through the museum building. In this sense *Travelling Pod* is important, too, because, in a different way, it also stands in for the notion of dispersion that is regarded so crucial to the project. By way of the robot, the idea and materialisation of dispersion is slightly transformed, but still present.

The curator of exhibitions of the Van Abbemuseum explains that the idea of producing a robot stems from the time that Parreno and Huyghe were preparing for the Zürich exhibition in 2002. The exhibit in the Kunsthalle, like any exhibition, was a compromise in the sense that the artists' initial ideas could not be fully realised due to insufficient financial sources and lack of time. The original plan for Zürich, according to the curator of exhibitions, was to design a robot that would run on a track (like the rails for the film camera used at a film set). This robot would travel through the exhibition and randomly project the Annlee videos on the walls of the different spaces of the Kunsthalle. To this end, the artists had designed an exhibition concept that transformed the open structures of the Kunsthalle into several rooms separated by doors and with a greyish carpet on the floor, giving the whole space a certain domestic touch. The projection robot would connect the single spaces with each other and introduce a dynamic element to the show. Although the gallery space was indeed transformed according to this plan, the robot was never realised. Instead, most video works were displayed on a small monitor placed on the floor.

In the Van Abbemuseum, however, the sold-out videos brought the initial plan of designing a robot back into the picture. In this particular setting, the idea of producing a robot could be realised because the Van Abbemuseum already had ties with the Eindhoven-based company Philips. Moreover, at the time this company was in the process of developing autonomous soccer-playing robots for the Philips Robocup Team. Thus, for the production of the museum robot, the help of engineers of the Philips Applied Technology Research team was requested and Philips engineers became enrolled in the artistic project. The robot, with an exterior based on a design by Parreno, was custom-made for the Van Abbe-

museum but its interior workings were derived from the Philips soccer robots.

In summary: the museum's goal was to purchase *No Ghost Just a Shell*, but what the project consisted of had yet to be decided and agreed upon. In order to achieve the acquisition, the museum needed to find a way of solving the problem of the limited edition of the two video works. Thus, the transformation of the temporary exhibition to a museum acquisition had a large impact on the career and components of the art project: a new artwork was added and the idea of diffused time and space now became manifested in the moving robot projecting the various video works randomly in the exhibition space.[24]

At this point, the curator of exhibitions, the artists, the individual Annlee artworks, the producers of the book, the robot and the Philips Company are all part of the collective, a hybrid actor called *No Ghost Just a Shell*. They are all mobilised in order to realise the acquisition of the exhibition. Besides actants such as the artists, the museum space, the robot and the curator of exhibitions, less obvious actants such as a museum building (by being closed) and video tapes (by being sold out) could also be distinguished. All these actants take part in the shaping of *No Ghost Just a Shell* – and vice versa.

4.6 THE MUSEUM SYSTEM

There is yet another important but less obvious actant in the story of the acquisition of the exhibition: the administrative system of the museum. As mentioned before, although each work was acquired individually from the artist or the relevant gallery, the curator of exhibitions felt strongly about purchasing an *exhibition* instead of singular artworks. He was particularly interested in how Parreno and Huyghe thought of the work in terms of an exhibition and how *No Ghost Just a Shell* allows us to reflect upon the notions of exhibitions and collecting. This, according to the curator of exhibitions, is one of the crucial aspects of the Annlee project:

It is not a group exhibition in the traditional sense of the word.
All these artworks are in fact one thing. It is kind of an exhibition

24 On the notion of career, see the introductory chapter.

conceptualised as an object, if something like that would exist. But of course it is not one object. As a museum we have acquired a whole exhibition and that, according to the artists, had never been done before.[25]

The curator of exhibitions stresses the conceptual necessity of considering the exhibition as a whole rather than a collection of individual artworks:

> I was interested in the idea that an *exhibition* would become part of a collection, thus questioning the object-centred approach of museums. At first, I didn't succeed as the exhibition was not registered under one collection number. Instead all individual objects received their own inventory numbers just like regular practice.[26]

For the curator of exhibitions it was important to register the exhibition in the museum's documentation system as if it were *one* acquisition, one work. Registration of the purchase under one single inventory number, however, would cause several administrative problems for the museum registration system. The existing protocols stipulate that when individual artworks are not registered in the museum database system, they are administratively not visible and simply do not exist in terms of collection management. If *No Ghost Just a Shell* received only one inventory number, the danger existed that the individual Annlee-artworks would be overlooked or simply lost because they were not registered.[27] Moreover, if artworks are not registered, they cannot be insured and fall outside other museum protocols.

The curator of collection, responsible for the acquisitions of the Van Abbemuseum, although agreeing with the curator of exhibitions that it was important to maintain the idea of *No Ghost Just a Shell* as one, objected to the idea of giving *No Ghost Just a Shell* one inventory number. To her it was important that each of the Annlee-works receive an entry in the system. This, however, posed a new problem because if the individual works were registered as individual art objects, then how could their relations to *No Ghost Just a Shell* remain visible? The curator of collec-

25 Interview with Phillip Van den Bossche, curator of exhibitions, Van Abbemuseum, 13.01.2005.

26 Interview with Phillip Van den Bossche, curator of exhibitions, Van Abbemuseum, 13.01.2005.

27 Interview with Phillip Van den Bossche, curator of exhibitions, Van Abbemuseum, 21.10. 2005.

tion was confronted with a problem stemming from the limitations of the museum's registration system, 'The Museum System' (TMS). TMS is a standardised commercial collection management system used by many museums, including the Van Abbemuseum. [figure 29] The system is developed for more traditional, stable works and thus represents the single-artist, single-artwork paradigm. The preset entry descriptions do not leave much room for variability and reduce each artwork into fixed categories such as: single date, single artist, medium, single dimensions and single collection.[28] The specific design of TMS has an effect on the practices in which it is used.

FIG. 29 – Screenshot of The Museum System (TMS), March 2007, Van Abbemuseum. Each art-work that was acquired in the context of *No Ghost Just a Shell* has its own inventory number. This installation by Joe Scanlan for example has inventory number 2653. TMS, a standardised commercial collection management system, is designed for less complicated, stable acquisi-tions and is considered to leave little room for information outside the available information boxes.

28 On museum registration systems, see also Ippolito 2008, 106–107. Based on concerns about new media, Ippolito advocates a more differentiated and precise tagging system that would capture the variability of artworks and would allow for its captions and wall labels to do so too (see also the chapter on *One Candle*).

It will come as no surprise that the acquisition of *No Ghost Just a Shell*, in more than one way, falls outside of these prefixed entry boxes. In order for the project to be accounted for as an acquisition, it needs to be fragmented into single objects or registered under one entry. The curator of collection was thus left with two choices: *No Ghost Just a Shell* is either reduced to one artwork (with the danger of losing sight of the individual artworks) *or* all artworks are registered separately (with the danger of losing sight of the relations among the individual artworks). Either way, crucial connections are lost. TMS transforms the acquisition and will have an effect on the artwork's future career.

During one of my last visits to the museum, in 2008, the registrator explained that the museum had by then solved this administrative problem by creating 'work-sets' in which the relations between the Annlee-works are registered and thus secured. The exhibition as a whole received an inventory number and the separate works can be found through its relations.[29] Still, future staff members with less knowledge about the project may be less aware of the relationships among – and the histories of – the Annlee-artworks in the collection of the Van Abbemuseum. This will have an effect on the project's career. For now, the curator of collection who is still very much connected to *No Ghost Just a Shell* fills in the gap, but what will happen when she is no longer there to clarify, correct or adjust?

4.7 'WHAT EXACTLY HAVE WE ACQUIRED?'

In the shift from temporary exhibition display to *collection* exhibition display, the museum's responsibility for *No Ghost Just a Shell* shifted from the *curator of exhibitions* to the *curator of collection*: the latter is in charge of collection management and conservation issues. Under the care of the curator of collection, the initial question 'What exactly are we acquiring?' posed during the acquisition phase, now shifted to: 'What exactly have we acquired?'

29 Interview with Margo van de Wiel, registrator of collection, Van Abbemuseum, 15.05.2008. It is important to mention that a paper documentation file is now also created for each individual Annlee-work. In these paper files the connection between the individual work and *No Ghost Just a Shell* is secured by a copy of the acquisition proposal document mentioning that the artwork belongs to the *No Ghost Just a Shell* project.

Faced by the conservation challenges related to the indeterminate character of *No Ghost Just a Shell*, the curator of collection seized the opportunity provided by the European research project Inside Installations: Preservation and Presentation of Installation Art to investigate the parameters of *No Ghost Just a Shell*.[30] In this context the curator of collection arranged to present the project anew. As mentioned above, this second presentation of *No Ghost Just a Shell* at the Van Abbemuseum was accompanied by a brochure reflecting the kinds of questions the curator of collection was dealing with. Interestingly, rather than mimicking the previous display of *No Ghost Just a Shell* at the Van Abbemuseum, and freezing the exhibition into one single format, the curator of collection suggested a more experimental approach. 'Acting in the spirit of Annlee's founding fathers', she suggested a presentation in different 'instalments'. Referring to the genesis of the project, the curator of collection envisaged an exhibition that developed in time, challenging the limits of the Van Abbemuseum, and possibly even disseminating some works outside the context of the museum building once more.[31] Eventually, three different instalments were realised in which in total twenty of the Annlee works were set up with a purple carpet connecting the different displays.

However, in the unfolding and execution of her plans, the curator of collection found herself confronted with several questions and challenges in the display and future conservation of *No Ghost Just a Shell* that had not been anticipated so much at the time of acquisition. One of the main problems, according to the curator of collection, was that the initiating artists seemed less approachable for consultation and authorisation of her plans. Although the artists actively participated in the first phase of accommodating Annlee to the museum, it turned out to be very difficult to mobilise them for this next sequence. Perhaps, the curator of collection suggests, they were too occupied with new works and no longer regarded Annlee as their priority or even responsibility. In any case, the curator of collection regrets that they were less actively involved because she feels it restricts the potentiality of displaying the work in novel manners. The director formulates this as follows:

30 See the introductory chapter.
31 Interview with Christiane Berndes, curator of collection, Van Abbemuseum, 21.10.2005. See also the curator of collection's research report on: www.inside-installations.org.

As an artwork, it is something that still needs a lot of development. It is a work that is not yet fully realised, but it was an excellent thing to buy in many ways because it does bring all these questions up which are fascinating for us and for the future as well. Also, what is very good about it: it is precisely this kind of flexibility that should be built into it. However, the flexibility or the permission to be flexible is imagined to lie with the artists.[32]

The project, according to the director, is in this stage in need of the artists' involvement:

Once you talk about installation art, you talk about this expanded field and then the question of 'the thing itself' really disappears and it is all about context and decision-making. With a work like *No Ghost Just a Shell* the context is, in a sense, everything. And then: who can control the context? Nobody can, so that condition is always a negotiation. The question is: how do you manage to make the negotiation effective? The artists, the persons who supposedly have the sovereign right to make such decisions, have to be engaged in that negotiation. Otherwise, where are we? But to what extent are the other players involved? The borders of responsibility are not at all clear.[33]

The story of Annlee here seems to illustrate Martha Buskirk's (2003) observation that the artist's ongoing presence and decision-making have become more important for a work of art as the physical object has become increasingly unstable as a marker of what constitutes the work of art. Yet, when artworks are being purchased and change owners, artists may at some point feel less responsible and become less involved with their work.[34] In the case of *No Ghost Just a Shell* this is met with feelings of discomfort in the museum. The director:

32 Interview with Charles Esche, artistic director, Van Abbemuseum, 27.03.2007.

33 Interview with Charles Esche, artistic director, Van Abbemuseum, 27.03.2007.

34 In response to my interview request, Pierre Huyghe replied that he would try to make time to talk about the project. He also added that for the time being he was through with *No Ghost Just a Shell*. To him it was a finished project. After talking about the project for one and a half years, he said, it was time to move on and focus on future works (personal conversation, November 2006).

It is the kind of collaborative nature of the project, with the various artists being involved in it that also leads to some confusion because some artists give some permission for some things and not for others. There is no overall control so we are now taking that overall control to some extent, but then also not wanting to tread on territory which we imagine is theirs [the artists']. But actually maybe it is not theirs? There are certain conditions which they have agreed to but then those conditions changed depending on what moment and to whom you are talking to. In the end, the work is a kind of movable feast of artistic decisions that crucially effect how the work is shown, what the artists will agree to or not agree to; for instance, with the robot, without the robot – is a fundamental thing.[35]

Because Parreno and Huyghe seem to have (at least for the moment) withdrawn from the process, questions about management of this project remain and new challenges for the museum emerge.

One of the problems, for example, concerns the robot *Travelling Pod*, which was especially designed by Philips for the Van Abbemuseum. When the museum wanted to display *No Ghost Just a Shell* in 2005, it turned out that the robot only functioned in the space it was originally designed for. Due to the closed, licensed software programmed by Philips, the robot was thus severely limited in its exhibition possibilities. The curator of collection was faced with a problem: could *No Ghost Just a Shell* be displayed without the robot? What would it mean to display the robot without having it move? How crucial has the robot become for *No Ghost Just a Shell*? What was its significance? What, for example, would remain of the idea of dispersion if the robot is not displayed? After deliberation, the museum decided that the robot had to become more mobile, allowing for it to function in other spaces. An effort was made to crack the closed software code developed by Philips and replace it with a new programme based on open source structure.[36] Although they have not yet been able to achieve this goal, it again shows how new people enrol in the project. *No Ghost Just a Shell* continues to change and develop within the museum walls: new artworks, for example, are produced, new people are enrolled

35 Interview with Charles Esche, artistic director, Van Abbemuseum, 27.03.2007.
36 This effort has not been successful. Interview with Christiane Berndes, curator of collection, Van Abbemuseum, 21.10.2005 & interview Charles Esche, artistic director, Van Abbemuseum, 27.03.2007.

while other connections end, and existing artworks are improved. More-over, despite the contract which stipulates that no new Annlee-works are to be made, new works featuring Annlee do pop up outside of the ini-tial *No Ghost Just a Shell* context, such as Mercio Cantor's *I'm still alive* (2006) and Tino Sehgal's *Ann Lee* (2011) performed by a child actor. The Van Abbemuseum has been pondering whether they should acquire such works as well.

Whilst the artists are currently unavailable to provide parameters and clarity, the curator of collection turns to other available sources to guide her working practices and create some sense of stability with regard to the acquisition. It is telling that since the acquisition of *No Ghost Just a Shell* by the Van Abbemuseum, the curator of collection, museum regis-trar as well as several interns and other researchers (including myself) have spent considerable time collecting, ordering, re-ordering, producing and analysing all kinds of documentation, such as information about the exhibition history of each object as well as installation guidelines. During its relatively short existence *No Ghost Just a Shell* has already produced a vast amount of research documents, articles, interviews, discussions as well as traces on the Internet, theses and other kinds of documentation activities. Capturing 'Annlee' seems a challenging but captivating enter-prise indeed.[37]

4.8 ANOTHER *NO GHOST JUST A SHELL*

Meanwhile, around 2004 another *No Ghost Just a Shell* came into the pub-lic domain when private collectors Rosa and Carlos de la Cruz announced the acquisition of *No Ghost Just a Shell* for their collection in Florida. Instead of one, there were now two *No Ghost Just a Shell* projects. This of course had implications for the conceptualisation of the Van Abbemu-seum's *No Ghost Just a Shell*. For the Van Abbemuseum, for example, it triggered thinking about whether what they had acquired was a unique work of art – and whether that matters. The curator of exhibitions vividly remembers the moment he first heard about another *No Ghost Just a Shell* for the first time:

37 Particularly noteworthy in this context is the master's thesis of Kristel Van Audenaeren (2005) in which she describes all individual artworks and links the production of *No Ghost Just a Shell* to network theories. See also the internship report of Anne Mink (2007).

I remember: I was in Madrid, the show at the Van Abbemuseum had just opened and then I received a phone call from Pierre Huyghe saying that this private collector is going to buy the whole thing. My first reaction was: well there goes the unique status of our *No Ghost Just a Shell*. Yes, because at first you fall back onto these old-fashioned ideas. Now, to date, I think it doesn't really matter that there are two versions out there.[38]

He continues by emphasising that the two instances of *No Ghost Just a Shell* are not the same:

In essence, Huyghe and Parreno made a different kind of Annlee exhibition in Miami and that is what they sold to De la Cruz. Not all our artworks are identical; there are differences such as the robot, which is only ours. It is very complex material and I think we could continue talking for hours trying to figure out what a 'complete' Annlee project is. I still have questions about that myself.[39]

The curator of collection, for different reasons than the curator of exhibitions, is also interested in this other *No Ghost Just a Shell*. She would, for example, like to know how the works are installed, and to what extent the artists are involved in the care of the artworks in the De la Cruz collection. According to the curator of collection, as private collectors, Rosa and Carlos de la Cruz have a different responsibility towards artworks than a public institution such as the Van Abbemuseum. From the perspective of collection management, she argues, it would be interesting to look at the differences and parallels between private and public ownership.[40]

However, two years later, on March 16, 2007, the story of *No Ghost*

38 Interview with Phillip Van den Bossche, curator of exhibitions, Van Abbemuseum, 13.01.2005. What also played a part in his initial reaction, the curator of exhibitions confides, is that for the acquisition by the Van Abbemuseum a robot had to be created in order to incorporate the two first video works since they were sold out. How was it possible for Rosa de la Cruz to acquire the two video works after the Van Abbemuseum had unsuccessfully tried to do so before? The curator of exhibitions suggests that perhaps the artists had sold their own artist's copies to Rosa de la Cruz (these so-called artist's proofs are not included in the count of an edition or referred to as 'o'. They belong to the artist and are usually not considered to be for sale).
39 Interview with Phillip Van den Bossche, curator of exhibitions, Van Abbemuseum, 13.01.2005.
40 Interview with Christiane Berndes, curator of collection, Van Abbemuseum, 21.10.2005.

FIG. 30 – *Do It Yourself Dead on Arrival (AnnLee)* (2002) by Joe Scanlan. Installation view 2004 at the home of Rosa and Carlos de la Cruz, Key Biscayne, Florida. Collection Tate Modern, London and the Museum of Contemporary Art, North Miami, donated by Rosa and Carlos de la Cruz.

Just a Shell enters a new chapter when the Museum of Contemporary Art (MOCA) in North Miami and Tate announce that *No Ghost Just a Shell* was donated to them by Rosa de la Cruz. In the press release accompanying the donation it reads: 'MOCA and Tate now jointly hold the only complete version outside the Van Abbemuseum in the Netherlands, thanks to the extraordinary generosity and foresight of Rosa and Carlos de la Cruz.'[41] [figure 30]

41 Press release, MOCA, North Miami, www.mocanomi.org/moca-tate.html. The press release includes a full list of all the enclosed works, including the number of editions.

In an interview published in the December 2008 issue of *Art + Auction*, Rosa de la Cruz mentions *No Ghost Just a Shell* as an example of one of the works she donated to a museum because it was too difficult for her to put on display. She explains: 'It involved video, sound, a hard drive and bringing the people who do Disney World animations to my house. It was a language I didn't understand.'[42] It is not uncommon for private collectors to donate complicated artworks to museums that are usually better equipped to take care of such high-maintenance works of art. In an article on ephemeral art in private collections, *New York Times* journalist Christopher Mason, for example, reports on an installation piece – involving a series of hand-knitted sweaters, fishing wire and a constant supply of fresh melons and vegetables – by German artist John Bock that was donated to the Carnegie Institute in Pittsburgh when the owners grew tired of maintaining the sculpture. '"I didn't want to be putting out fresh vegetables every week as those things rotted," Mr. Fletcher said' (Mason 2005). Also, increasingly, in the case of large, complex or expensive works of art, museums are joining forces by purchasing works in a consortium of museums: sharing ownership, sharing the price paid for the work, and sharing the responsibility of maintaining the work.

By coincidence, only a week after Tate and MOCA announced their new acquisition, I delivered a paper on the Van Abbemuseum's *No Ghost Just a Shell* at a symposium on conservation and curating at Tate Modern in London.[43] In response to my talk, the curator of exhibitions and head of international modern and contemporary collections at Tate commented on their recent acquisition:

> It has come to us as a very generous gift from a Miami-based collector and I had assumed that it was going to be a rather straightforward acquisition that would arrive, and we would condition-check it, make lots of inventories. But as you were talking, I realised that although it is an editioned work – and when you purchase an editioned work you normally get a kind of a copy of something that already exists – it seems to me that probably what we are getting is a number of object items that exist in a particular formulation at the Van Abbemuseum, another particular formu-

42 www.artinfo.com/news/story/29405/conversation-with-rosa-de-la-cruz/.

43 The paper was presented at 'Shifting Practice, Shifting Roles? Artists' Installations and the Museum', 22 March, 2007 Tate Modern, London, held in the context of Inside Installations.

lation in the store in Miami, and once they get to the Tate and we begin talking with Huyghe and Parreno it will probably evolve into something completely different. I think that is quite interesting because it raises all kinds of questions of what constitutes the unique work, and what is an edition. I am not sure whether we have the language or the systems to cope with that yet.[44]

Of particular interest here is the acknowledgement that the Van Abbemuseum's *No Ghost Just a Shell* is different from the private collector's *No Ghost Just a Shell*, as will be the Tate's/MOCA's *No Ghost Just a Shell*. Indeed, through the ownership of the Van Abbemuseum and its particular practices and interventions their *No Ghost Just a Shell* has become what it is today. The 'career' of the De la Cruz's *No Ghost Just a Shell* is and will be very different: it is these specific careers that make them unique. Yet, although the Rosa de la Cruz version was already known to the Van Abbemuseum, the transfer of *No Ghost Just a Shell* from the private collection in the United States to a public collection in Europe changed the thinking about *No Ghost Just a Shell* at the Van Abbemuseum as well. The director of the Van Abbemuseum expresses his concern that their *No Ghost Just a Shell* may become a kind of secondary version. The director, only just confronted with the move from De la Cruz to the two museums, says:

> Maybe the Tate will clarify certain things. But also: what is the relationship between these two versions? That is a big question. Are they editions? Are they different versions? What are the differences? And the De la Cruz version, can that be everything? Maybe that will be the one that has got all the possibilities and ours will be kind of, you know, a minimized version of it without clear lines of control?[45]

In a sense, *No Ghost Just a Shell* again unearths a part of museum practice that is not often spoken about, namely the competitive edge of museums and the driving force to create unique collections by which museums are

44 Transcribed from the symposium's webcast: www.tate.org.uk/onlineevents/webcasts/shifting_-practice_shifting_roles/default.jsp.
45 Interview with Charles Esche, artistic director, Van Abbemuseum, 27.03.2007.

branded.[46] Beside this political economy problem, it also exposes a more philosophical question about collecting and ownership of contemporary art, which is addressed by the director:

> I think the problem is that traditionally the control is vested in the artists, even after the purchase. You know, the whole question of purchasing a thing in museums is actually up for grabs now. Because basically, purchasing has always been about 'the thing'. It has never been about the intellectual property. It has never been about the copyright. It has never been about: What do we do with this image? It has always been: You collect the object, the painting or sculpture. You buy this and put it in storage and make sure that it doesn't fade. I mean, that is so inadequate to most contemporary work.[47]

In the case of *No Ghost Just a Shell* at the Van Abbemuseum, the 'object' is the still evolving outcome of a process that has been initiated by the artists. Tate and MOCA do not own the same object as the Van Abbemuseum, but rather have been given a different outcome. Interestingly, *Travelling Pod*, the robot introduced earlier in this chapter, is brought to the fore and gains importance. Since the robot is only included in the Van Abbemuseum's *No Ghost Just a Shell*, it becomes an identifier: the robot is, according to the curator of exhibitions and curator of collection, what distinguishes *No Ghost Just a Shell* from the other *No Ghost Just a Shell*.

For the director of the Van Abbemuseum, the further development of *No Ghost Just a Shell* remains open. Talking about possible directions, the director shares his first thoughts:

> I don't know what will happen because I don't know what the relationship between these two are; I haven't seen the other one so I don't know. Maybe we should give ours to the Tate and they could combine both and do what they want. I mean, that would be an option if it would make the art work stronger.[48]

46 See Thompson (2008) on the 'branded museum' and Ippolito (2008) on the issue of competition between museums.

47 Interview with Charles Esche, artistic director, Van Abbemuseum, 27.03.2007.

48 Interview with Charles Esche, artistic director, Van Abbemuseum, 27.03.2007.

He pauses for a short while and then continues:

> Yes, maybe there should be one version. I wouldn't mind. I mean, ownership isn't that important. We could give our version also to the Tate so the Tate would have everything and they could actually work it out and we would have the right to show it when we want, for instance, or something like that. It would be difficult to do it because then we would have paid all this money for nothing, which is somehow an important issue in people's heads. So I can't see it happening immediately but I think it would really depend on the discussion that we would have. [...] I have never seen the De la Cruz version. I don't know what the difference is. So it would only be assumptions that I make, and that is not really so useful I think. But what I hope is that they have some sort of... either they have their own distinct qualities and that one is not a secondary version of a primary one because I don't think that what Jan Debbaut thought he was buying was a secondary version. I think he imagined that he bought a primary version. If it becomes a secondary version after the fact – that is a problem, I think.[49]

Currently, three museums have ownership of *No Ghost Just a Shell*. What this means and how these processes develop from here is very much a matter of the future rather than, as the traditional notion of conservation assumes, solely of the past.

4.9 BY WAY OF CONCLUSION

In the practices of the Van Abbemuseum, alternative notions of the art object are being explored. In fact, the purchase of *No Ghost Just a Shell* may even be regarded as a means to explore the possibilities and limitations of the traditional museum. *No Ghost Just a Shell* in many ways challenged existing museum concepts and strategies, such as the single-author, single-object, and single-collection paradigm, to an extreme extent, yet it can be argued that (also less extreme) artworks such as time-based art and installation art pose similar challenges.

49 Interview with Charles Esche, artistic director, Van Abbemuseum, 27.03.2007

Besides challenging common concepts and strategies, *No Ghost Just a Shell* also demonstrates a realignment of the conventional roles attributed to artists and museum professionals: the artists at one point became collectors, the curator of exhibitions engaged in production as well as collection management, while the curator of collection at a certain moment emphasised her role as curator, rather than keeper. Also, although the initiating artists are still very much considered to be the main authors of the project, we have seen that many other actants became involved and co-determine the process. The chapter argues that these challenges and the way they are dealt with co-determine the nature of *No Ghost Just a Shell* and should therefore also be taken into account. The chapter has shown that through the acquisition of Annlee accomplished knowledge and existing practices in different areas (vocabularies, the work itself, artist's intent, professional roles, economic models) needed to be revised. The notion of ownership defined as freezing the art object in a singular state is in need of a new conception: one that acknowledges a more tactile, practice-based, and interventionist kind of engagement of the museum professional.

The analysis of the project's career in the museum shows that neither the project's physical existence nor the artists' involvement provided enough grip for the museum to go by and therefore other areas for guidance were explored, for example, in the production of guidelines and documentation. In that sense, *No Ghost Just a Shell* can be regarded as paradigmatic for a considerable part of contemporary artworks for which, in terms of their perpetuation, traditional questions about the materiality of the object are increasingly being replaced by questions about ownership, authorship and copyright.

From studying the practices in which the project is enacted, we also learn a great deal about the concepts that are regarded as crucial to the meaning and identity of the project. The story of the robot has, however, also shown that significance and functions changes along the way. In this chapter, I have argued that these practices, the contingent processes in which artworks are done, are not external to the 'artwork itself'. Rather, they play a formative role in what the artwork is and what it can be made into. Therefore, if we want to enhance our understanding of installation art, 'all that grubby stuff' (in the words of Becker et al. (2006, 3)) deserves our attention.

In this chapter *No Ghost Just a Shell* has been analysed in terms of a

collective, as an assembly of ever-changing coalitions in which humans as well as nonhumans have agency. In the case of *No Ghost Just a Shell* the relational aspect that is emphasised in the concept of collective seems predictable or even inevitable, and could (as an internalist account would have it) be explained entirely in terms of the art project's conceptual roots. In describing its history, the emphasis could be placed on contingencies (such as was the case in the development of the robot) and the accidental character of the project's development. However, the chapter has also shown that deliberately mobilising new relations, allowing new networks to emerge can also become a conservation strategy. Connecting the Van Abbemuseum's *No Ghost Just a Shell* to the Tate/MOCA *No Ghost Just a Shell* may, for example, lead to new meaningful relations. Analysing installation artworks in terms of collectives may therefore also prove to be instrumental in terms of future conservation decisions, as it uncovers connections that were not visible in other accounts, and opens up possibilities for creating and exploring new relationships and directions for the art project that – in a more conventional account – were unthinkable or considered unsuitable for a museum.

Reconstructing the acquisition and conservation process of *No Ghost Just a Shell* using Latour's conceptual framework of 'collective', as a continuously altering association of humans and nonhumans, allowed me to address the changing mixture of materials, humans, materiality of the museum, negotiations and agreements. Such an approach allowed me to analyse the hybrid character of the acquisition and conservation practice, creating insight into the roles of the actors involved in the process of collecting and conservation. The case study shows that the idea of the artwork as a fixed and stable entity is outdated and cannot account for artworks like this, and that we need to expand our view of what makes art.

Challenges and Potentialities of Installation Art

In March 2007, after a period of three years, the European research project Inside Installations came to an end. The project participants (mainly conservators, conservation researchers, curators and registrars) finalised the case study research they had been carrying out, and the results of their research were disseminated through the project's website.[1] Some of the project participants had found answers to the questions they formulated at the beginning of the project; others had discovered new questions along the way. On the occasion of the project's closing meeting, hosted by Tate Modern in London, all participants were invited to gather around in small working groups and to formulate, on the spot, what they thought to be the main insights gained from the project. The first two observations formulated by the project participants of the working groups deserve particular attention, as they epitomise today's thinking about contemporary art conservation:

- 'Understanding the significance is key to designing your preservation strategy. Don't acquire art without it.'
- 'Are you prepared to let things fall apart – Installation art takes conservators to places that are not always comfortable.'

To start with the latter: here, caring for installation artworks is depicted as unsettling and uncomfortable. This statement clearly reflects the feeling of uncertainty that stems from entering into new territory. It refers to the challenges and difficult decisions conservators are confronted with when they engage with installation artworks. Moreover, it suggests that as a conservator involved with installation art, you should be willing to let go of long-accepted certainties. The statement reflects that in the care of installation artworks, routine practices and long-held assumptions are being questioned. Secured positions and accomplished expertise (as found in conventional scientific conservation, for example) can no longer be relied upon. Installation art calls upon the need to rethink fundamental concepts such as authenticity and artist's intention, to re-examine commonly accepted treatment procedures, and to restructure established work divisions and routine practices. Entering into these less familiar

1 Inside Installations project website: www.inside-installations.org.

directions often involves a sense of uncertainty as well as a strong urge to look for alternative grounds of stability.

The sense of instability, and – in its wake – the need for guidelines and directions, are also emphasised in the first thesis ('Understanding the significance is key to designing your preservation strategy. Don't acquire art without it.'). This statement, however, seems to be more of a warning directed towards those in charge of accessioning artworks into museum collections: do not bring an artwork into your collection unless you know what it is and can stipulate a preservation plan in advance.

FOREGROUNDING PRACTICES

This book started with an account of the key concepts (authenticity and artist's intention) that form the back-bone of traditional conservation theory and practice. I also showed how and why these concepts have become problematic for contemporary art conservation. Yet, rather than replacing old concepts with alternative theoretical concepts, I explored a different route by analysing how authenticity and artist's intention are *done* in practices of collecting and conservation. My point was that foregrounding concepts stands in the way of inquiries and questions that are more useful and productive in terms of bringing the development of contemporary art conservation theory forward. Through empirical research into several case studies, I have shown that much of conservation theory and ethics is distant from the day-to-day practices of contemporary art conservators. A theory of contemporary art conservation should therefore be more in tune with its practices.

When attending to practices, it becomes apparent that artworks are done in these museum practices and are therefore also entangled with the museum's repertoires, organisational structures, work divisions, politics, documentation procedures and levels of engagement. Throughout the case study chapters, for example, it became clear that the role of the artist(s) within processes of collecting and conservation has a causal effect on the artwork's career. For the artwork it matters whether the artist is dead (chapter two), continuously involved (chapter three) or no longer involved (chapter four). And, as the case studies showed, there are also other circumstances and people whose decisions affect the artwork's career.

Rather than focusing on fixed and finished artworks, I have been concerned with what shapes the artwork's continued existence in museum contexts. By reconstructing the careers of artworks as part of museum practices, I have tried to make these practices more legible. I wanted to understand, for example, why some discussions, decisions, and events (such as alterations of the physical artwork) are bracketed or erased, while others instead are emphasised (such as the authentication of artworks by artists).

The overarching argument of this book concerns the blurring of front and back. While most museums are keen on maintaining a sharp distinction between front (presentation and display) and back (conservation and administration), my ethnographical material shows that this distinction is particularly untenable for installation art. So far, in museum studies and history of art, what happens behind the scenes of museums stays relatively unseen and unspoken about. In the arts generally speaking, what is dismissed as mundane and irrelevant (e.g. the realm of practices) is deliberately detached from what is thought to really matter: theory, discourse, content and meaning. Front/back, theory/practice, content/practicalities are treated as dichotomies: clearly separated from one and each other.

The present research has revealed, however, that the behind-the-scenes working practices of curators and conservators play an important role in the constitution of installation artworks. In several ways these working practices and related organisational structures have an effect on the artwork's career and co-shape how the artwork is installed in the gallery space, and appears to the viewer. Therefore, I have shown that if one wants to understand art installations, one needs to study and reflect upon these processes. Museum practices, I argue, should become a necessary part of studies into installation artworks.

By investigating the causes of the changes and stages in an artwork's career, opening black boxes reminds us that things could have been different. Moreover, it shows that attending to certain strategies and rejecting others is largely a matter of choice. Rather than following a well-established theory and operating within a more or less clear-cut framework such as the scientific freeze, conservators of contemporary art are constantly making decisions (sometimes deliberate, sometimes not) such as those involved with the level and the kind of intervention. These decisions and the processes in which they are done are hardly visible.

At the least, a more open discussion and recognition of multiple practices may take conservation out of the realm of controversies. Of course, this would first and foremost imply that those doing the work are prepared to open up their practices, allow for doubt and be evaluated. Uncertainty then may also become a productive notion in museum studies as such. As Annemarie Mol has observed in the context of hospitals, also in museums there would at least be these two repertoires: 'Keeping the practicalities of enacting disease [in this context, artworks] visible so that what happens may be doubted, *and* bracketing practicalities while working along and being confident in doing so' (Mol 2002: 163).

NEW VISTAS

This research started with an exploration of the challenges and problems museums for contemporary art are currently facing in their efforts to acquire, present and preserve installation artworks. Indeed, the dilemmas of installation art conservation are often depicted as daunting. Yet, the challenges posed by accessioning installation artworks into museum collections also give rise to new vistas in several areas. This book therefore concludes with an exploration of some of the potentialities that may emerge from these same challenges. Thus, whilst my research started with focusing on the challenges installation art poses to museums in terms of conservation, it ends on a more optimistic note by addressing new vistas for the museum of contemporary art in general, and the conservation profession in particular.

The chapters of this book have shown that the perpetuation of installation art in a museum context requires conservators to engage with artworks, artists, colleagues and other stakeholders to an extent that was until now unknown to the profession. In the context of contemporary art it becomes increasingly difficult to hold on to the conservator's dictum of hands-off, minimal intervention and related preventive conservation strategies. Rather than a passive custodian, the conservator is acknowledged to be an interpreter or even a co-producer and conservation is increasingly recognised as a productive activity. The conservation field concerned with this part of art heritage is challenged to rethink its professional standards and becomes increasingly reflexive of its own doings. Indeed, contemporary art conservation has proved to be in an exciting

stage of development in which long-held norms are no longer taken for granted. In time, the insights and developments that emerged from contemporary art conservation (such as the introduction of new vocabularies) will most likely have their effect on traditional art conservation theory and practice as well.

In this book, I have argued that conservation practices deserve more attention in art historical and critical accounts of installation art. Currently, conservation activities are discussed only among specialists and museum professionals. Only the outcomes of these discussions are sometimes – if at all – explicitly communicated to a larger public. This is, as I have shown, understandable from the perspective of the history of conservation, but a different approach is now needed. How then can these working practices of conservators become more visible and transparent to a diversity of audiences? What kind of medium should be used to open up these practices to different audiences: exhibitions, films, books like this one, podcasts in museums, and articles in newspapers – or perhaps a multitude of media?

And, in terms of assessment and encouraging open debate among practitioners: what would it take to move towards criteria for evaluating these processes? What would it mean to acknowledge those involved in the artwork's careers? But also, could successive reinstallations be seen as analogous to successive executions of dance, musical or theatre pieces? How can the field of conservation learn from discussions in music and theatre criticism? To what extent are the criteria developed for music performance, for example, relevant to the field of conservation?

My call for more debate and criticism in the context of conservation can be situated within a wider discussion about the legitimisation of the contemporary art museum. Right from its birth, the museum for contemporary art has been critiqued from several positions and for several reasons, one of them claiming that the museum for contemporary art remains a conventional stronghold: inadequate to keep up with developments in contemporary art and society. The museum's many crises of the past have resulted in a body of literature, research projects, exhibitions and conferences on the future of the contemporary art museum.[2] What my argument has also underscored, however, is that the criticism

2 Kraemer (2007: 195), for example, discusses several perspectives on the museum by referring to Anne Benichou, John Weber, Nicolas Serota and Peter Weibel – all of whom outline the challenges confronting today's art museums.

of museums as a last repository or mausoleum of 'dead' objects is challenged by contemporary artworks. Including conservation practices in its public repertoire would allow new vistas for the museum. Owning up to conservation dilemmas and decisions would provide the museum for contemporary art with rich and highly relevant resources.

Although this research examined the careers of particular artworks in particular institutions at a particular period in time and in the context of a particular (European) research project, many of the repertoires and issues discussed in this book also speak beyond the individual cases. It is, however, important to mention that this research mainly focused on middle-size public contemporary art museums, rather than larger institutions. Further (comparative) research would be a prerequisite to draw conclusions about conservation practices in larger institutes or private collections.

Indeed, what struck me most during my research was the diversity of museum practices and the insight that these practices, the conscious and unconscious repertoires, are intertwined with the organisational structures of museums. Seemingly extraneous factors such as differences in size, finances, communication flows, work dividing arrangements, architecture and other organisational structures in museums have an effect on how artworks are done and what they are made into. This, I have argued, is still largely underestimated in conservation studies, history of art and museum studies. At the heart of my research was the issue of change. Studying change and the *doing* of artworks asked for a different approach than commonly found in history of art and museum studies. By studying the inner workings of art and what happens in art conservation practices from a constructivist and empirical approach, the book adds to studies in social sciences (in terms of research area) as well as to museum studies (in terms of research method). In this sense, the book has aimed to show that studying artworks and museums through conservation practices offers a rich and exciting vista for further explorations in order to expand our notions of what makes art.

List of Illustrations

The photographs are reproduced by kind permission of the artists, photographers and museums concerned. Every effort has been made to obtain permission to use all copyrighted illustrations reproduced in this book. Nonetheless, whosoever believes to have rights to this material is advised to contact the publisher.

FIG. 1 – *25 Caramboles and Variations: A Birthday Present for a 25 Year Old* (1979) by Miguel-Ángel Cárdenas. Collection Stedelijk Museum, Amsterdam, the Netherlands. Installation view 1980 at Salon O, Leiden, the Netherlands. Courtesy the artist.

FIG. 2 – *25 Caramboles and Variations: A Birthday Present for a 25 Year Old* (1979) by Miguel-Ángel Cárdenas. Collection Stedelijk Museum, Amsterdam, the Netherlands. Installation view 2003 at the Netherlands Media Art Institute/Montevideo Time Based Arts (NIMk), Amsterdam. Courtesy NIMk and the artist.

FIG. 3 – Image taken during field work. Photo by Agnes Brokerhof. Courtesy the photographer.

FIG. 4 – *One Candle* (1988) by Nam June Paik. Collection Museum für Moderne Kunst (MMK), Frankfurt am Main, Germany. Installation view 2006 at MMK. Photo by the author. © Nam June Paik Estate.

FIG. 5 – *One Candle* (1988) by Nam June Paik. Collection Museum für Moderne Kunst (MMK), Frankfurt am Main, Germany. Installation view 1991 at MMK. Courtesy Jochen Saueracker and MMK. © Nam June Paik Estate.

FIG. 6 – *One Candle* (1988) by Nam June Paik. Collection Museum für Moderne Kunst (MMK), Frankfurt am Main, Germany. Installation view 2007 at MMK. Photo by Axel Schneider, Frankfurt am Main. Courtesy MMK. © Nam June Paik Estate.

FIG. 7 – *One Candle* (1988) by Nam June Paik. Collection Museum für Moderne Kunst (MMK), Frankfurt am Main, Germany. Installation view 2004 during the exhibition 'Global Groove 2004', Deutsche

Guggenheim Berlin, Germany. Photo by Barbera Brakel, Photoaffairs. Courtesy photographer. © Nam June Paik Estate.

FIG. 8 – Drawing plan of *One Candle* by Nam June Paik. Archive/Courtesy Jochen Saueracker.

FIG. 9 – *One Candle* (1988) by Nam June Paik. Collection Museum für Moderne Kunst (MMK), Frankfurt am Main, Germany. Installation view 1992 at the National Museum of Modern Art, Seoul, South Korea. Photo by Jochen Saueracker. Courtesy photographer. © Nam June Paik Estate.

FIG. 10 – Fax from Jochen Saueracker to Nam June Paik (2000). Archive/Courtesy Jochen Saueracker.

FIG. 11 – *TV Buddha* (1974) by Nam June Paik. Collection Stedelijk Museum, Amsterdam, the Netherlands. © Nam June Paik Estate.

FIG. 12 – Candle in a jar. Archive Jochen Saueracker. Photo by the author.

FIG. 13 – *A Stretch Museum Scale 1:1, a proposition for the Bonnefantenmuseum (Exhibition space)* (2001–2003) by Joëlle Tuerlinckx. Collection Bonnefantenmuseum, Maastricht, the Netherlands. Installation view 2003 at Bonnefantenmuseum, Maastricht. Photo by Peter Cox, Eindhoven, the Netherlands. © Joëlle Tuerlinckx

FIG. 14 – *A Stretch Museum Scale 1:1, a proposition for the Bonnefantenmuseum (Cinema space)* (2001–2003) by Joëlle Tuerlinckx. Collection Bonnefantenmuseum, Maastricht, the Netherlands. Installation view 2004 at Bonnefantenmuseum, Maastricht. Photo by Peter Cox, Eindhoven, the Netherlands. © Joëlle Tuerlinckx

FIG. 15 – *A Stretch Museum Scale 1:1, a proposition for the Bonnefantenmuseum (Green space)* (2001–2003) by Joëlle Tuerlinckx. Collection Bonnefantenmuseum, Maastricht, the Netherlands. Installation view 2004 at Bonnefantenmuseum, Maastricht. Photo by Peter Cox, Eindhoven, the Netherlands. © Joëlle Tuerlinckx

FIG. 16 – *A Stretch Museum Scale 1:1, a proposition for the Bonnefantenmuseum (Green space)* (2001–2003) by Joëlle Tuerlinckx. Collection Bonnefantenmuseum, Maastricht, the Netherlands. Installation view 2006 at Bonnefantenmuseum, Maastricht. Photo by Evelyne Snijders. © Joëlle Tuerlinckx

FIG. 17 – *ensemble autour de MUR* (1998) by Joëlle Tuerlinckx. Collection Stedelijk Museum voor Actuele Kunst (S.M.A.K.), Ghent, Belgium.

Installation view 1998 at s.m.a.k. Photo by Dirk Pauwels. Courtesy photographer and s.m.a.k. © Joëlle Tuerlinckx

FIG. 18 – *ensemble autour de ̶M̶U̶R̶* (1998) by Joëlle Tuerlinckx. Collection Stedelijk Museum voor Actuele Kunst (s.m.a.k.), Ghent, Belgium. Installation view 1999 at s.m.a.k. Photo by Dirk Pauwels. Courtesy photographer and s.m.a.k. © Joëlle Tuerlinckx

FIG. 19 – *ensemble autour de ̶M̶U̶R̶* (1998) by Joëlle Tuerlinckx. Collection Stedelijk Museum voor Actuele Kunst (s.m.a.k.), Ghent, Belgium. Installation view 2002 at s.m.a.k. Photo by Dirk Pauwels. Courtesy photographer and s.m.a.k. © Joëlle Tuerlinckx

FIG. 20 – *ensemble autour de ̶M̶U̶R̶* (1998) by Joëlle Tuerlinckx. Collection Stedelijk Museum voor Actuele Kunst (s.m.a.k.), Ghent, Belgium. Installation view 2003 at s.m.a.k. Photo by Dirk Pauwels. Courtesy photographer and s.m.a.k. © Joëlle Tuerlinckx

FIG. 21 – Invoice of K-work. © c/o Pictoright Amsterdam 2012

FIG. 22 – *Two Minutes out of Life* (2000) by Pierre Huyghe. Still from video. © c/o Pictoright Amsterdam 2012

FIG. 23 – *One Million Kingdoms* (2000) by Pierre Huyghe. Still from video. © c/o Pictoright Amsterdam 2012

FIG. 24 – *Annlee in Anzen Zone* (2000) by Dominique Gonzalez-Foerster. Collection Van Abbemuseum, Eindhoven, the Netherlands. Still from video. Courtesy the artist and Esther Schipper, Berlin.

FIG. 25 – *Witness Screen* (2002) by François Curlet. Collection Van Abbemuseum, Eindhoven, the Netherlands. Still from video. Courtesy Air de Paris and Micheline Szwajcer.

FIG. 26 – *Annlee You Proposes* (2001) by Liam Gillick. Collection Van Abbemuseum, Eindhoven, the Netherlands. Still from video. Courtesy the artist and Casey Kaplan Gallery, New York.

FIG. 27 – *Do It Yourself Dead on Arrival (AnnLee)* (2002) by Joe Scanlan. Collection Van Abbemuseum, Eindhoven, the Netherlands. Photo by Peter Cox, Eindhoven, the Netherlands. Courtesy the artist.

FIG. 28 – *Travelling Pod* (2003) by Pierre Huyghe and Philippe Parreno. Collection Van Abbemuseum, Eindhoven, the Netherlands. Photo by Peter Cox, Eindhoven, the Netherlands. Courtesy Van Abbemuseum. © c/o Pictoright Amsterdam 2012. The video projected is *Annlee You Proposes* (2001) by Liam Gillick.

FIG. 29 – Screenshot of The Museum System (tms) (2007) Van Abbemuseum, Eindhoven, the Netherlands. Courtesy Van Abbemuseum.

FIG. 30 – *Do It Yourself Dead on Arrival (AnnLee)* (2002) by Joe Scanlan. Collection Tate Modern, London and the Museum of Contemporary Art, North Miami, donated by Rosa and Carlos de la Cruz. Installation view 2004 at the home of Rosa and Carlos de la Cruz, Key Biscayne, Florida. Photo by David de Armas. Courtesy Rosa and Carlos de la Cruz.

References

Albano, Albert. 1996. "Art in Transition." In *Historical and Philosophical Issues in the Conservation of Cultural Heritage*, edited by Nicholas Price, Mansfield Kirby Talley, and Alessandra M. Vaccaro, 176–184. Malibu: J. Paul Getty Trust. Originally published in 1988 in AIC Preprints.

Appelbaum, Barbara. 1987. "Criteria for Treatment: Reversibility." Journal of the American Institute for Conservation 26 (2): 65–73.

Appelbaum, Barbara. 2007. *Conservation Treatment Methodology*. Oxford: Butterworth-Heinemann.

Archer, Michael. 1994. "Towards Installation." In *Installation Art,* edited by Nicolas de Oliveira, Nicola Oxley, and Michael Petry, 11–30. London: Thames and Hudson Ltd.

Ashley-Smith, Jonathan. 1982. "The Ethics of Conservation." *The Conservator* 6 (1): 1–5.

Ashley-Smith, Jonathan. 1999. *Risk Assessment for Object Conservation.* Oxford: Butterworth-Heinemann.

Avrami, Erica, Randall Mason, and Marta de la Torre, eds. 2000. *Values and Heritage Conservation: Research Report.* Los Angeles: The Getty Conservation Institute. www.getty.edu/conservation/publications_ resources/pdf_publications/valuesrpt.pdf.

Bätschmann, Oskar. 1998. "Kunstmacht, Installaties en Ervaringen." *De Witte Raaf* 74 (July-Aug.): 9–11. www.dewitteraaf.be/artikel/detail/ nl/1678.

Baker, George. 2004. "An Interview with Pierre Huyghe." *October* 110 (Fall): 81–106.

Bal, Mieke. 2002. *Travelling Concepts in the Humanities: A Rough Guide.* Toronto: University of Toronto Press.

Bard, Elizabeth. 2003. "Focus: the Road to Digital Heaven." *Contemporary Magazine* 47/48: 44–46. www.contemporary-magazines.com/ focus48&47_1.htm.

Bardiot, Clarisse. 2010. "Noting/Annotating: Documenting the Technology-Based Performing Arts." *Art Press* 2 12: 33–36.

Barker, Rachel, and Alison Bracker. 2005. "Beuys is Dead: Long Live Beuys! Characterising Volition, Longevity, and Decision-Making in the Work of Joseph Beuys." *Tate Papers: Tate's Online Research Journal* 4. www.tate.org.uk/download/file/fid/7404.

Becker, Howard S. 2006. "The Work Itself." In *Art from Start to Finish: Jazz, Painting, Writing, and Other Improvisations,* edited by Howard S. Becker, Robert R. Faulkner, and Barbara Kirshenblatt-Gimblett, 21–30. Chicago: University of Chicago Press.

Becker, Howard S. 1982. *Art Worlds.* Berkeley: University of California Press.

Becker, Howard S., Robert R. Faulkner, and Barbara Kirshenblatt-Gimblett, eds. 2006. "Editors' Introduction." In *Art from Start to Finish: Jazz, Painting, Writing, and Other Improvisations,* xiii-xvii. Chicago: University of Chicago Press.

Beek, Wim van der. 2003. "AnnLee: No Ghost." In *Kunstbeeld Cahier. Het Nieuwe van Abbemuseum,* 41–44. Rijswijk: P/F-Kunstbeeld.

Beerkens, Lydia, Paulien 't Hoen, IJsbrand Hummelen, Vivian van Saaze, Tatja Scholte, and Sanneke Stigter, eds. 2012. *The Artist Interview – For Conservation and Presentation of Contemporary Art: Guidelines and Practice.* Heijningen: Jap Sam Books in cooperation with Foundation for the Conservation of Contemporary Art (SBMK), the Cultural Heritage Agency of the Netherlands (RCE) and the University of Amsterdam (UvA).

Belting, Hans. 2002. "Beyond Iconoclasm: Nam June Paik. The Zen Gaze and the Escape from Representation." In *Iconoclash: Beyond the Image Wars in Science, Religion, and Art*, edited by Bruno Latour and Peter Weibel, 390–411. Karlsruhe: ZKM Karlsruhe Publication Program.

Bennett, Tony. 1995. *The Birth of the Museum: History, Theory, Politics.* London: Routledge.

Benschop, Ruth. 2009. "STS on Art and the Art of STS: An Introduction." *Krisis: Journal for Contemporary Philosophy* 1: 1–4. www.krisis.eu/content/2009–1/2009–1–01–benschop.pdf.

Bergeon, Ségolène. 1997. "Éthique et conservation-restauration: la valeur d'usage d'un bien culturel." In *La conservation: une science en évolu-*

tion. *Bilan et perspectives. Actes des troisièmes journées internationales d'études de l'*ARSAG, *Paris, 21–25 avril 1997*, 16–22. Paris: ARSAG.

Bishop, Claire. 2004. "Antagonism and Relational Aesthetics." *October* 110 (Fall): 51–79.

Bishop, Claire. 2005. *Installation Art: A Critical History.* London: Tate Publishers.

Boomgaard, Jeroen, and Bart Rutten, eds. 2003. *The Magnetic Era: Video Art in the Netherlands, 1970–1985.* Rotterdam: NAi Publishers.

Bors, Nadine. 2000. "Keeping up Appearances. Wulf Herzogenrath over Authenticiteit bij Nam June Paik." *kM* 34: 18–21.

Bourriaud, Nicolas. 2002. *Relational Aesthetics.* Translated by Simon Pleasance and Fronza Woods with the participation of Mathieu Copel. Paris: Les Presses du Réel.

Brajer, Isabelle. 2009. "Taking the Wrong Path: Learning from Oversights, Misconceptions, Failures and Mistakes in Conservation." *CeRoArt* [online] 3. http://ceroart.revues.org/index1127.html.

Brams, Koen, and Dirk Pültau. 2006. "Kunst en Onderzoek: Een Gesprek met Joëlle Tuerlinckx." *De Witte Raaf* 122 (July-Aug.): 6–7.

Brams, Koen, and Dirk Pültau. 2007. "Kunst en Museum: Een Gesprek met Joëlle Tuerlinckx." *De Witte Raaf* 129 (Sept.-Oct.): 1–5.

Brandi, Cesari. 1996. "Theory of Restoration I, II, III." In *Historical and Philosophical Issues in the Conservation of Cultural Heritage,* edited by Nicholas Price, Mansfield Kirby Talley, and Alessandra M. Vaccaro, 230–235; 339–342; 377–379. Malibu: J. Paul Getty Trust. Originally published in 1963 by Edizioni di Storia e Letteratura.

Buskirk, Martha. 2003. *The Contingent Object of Contemporary Art.* Cambridge, MA: MIT Press.

Butt, John. 2002. *Playing with History: The Historical Approach to Musical Performance.* Cambridge: Cambridge University Press.

Cameron, Christina, Carolina Castellanos, Martha Demas, Françoise Descamps, and Jeffrey Levin. 2001. "Building Consensus, Creating a Vision: A Discussion about Site Management Planning." *Conservation: The Getty Conservation Institute Newsletter* 16 (3): 13–19. Available at www.getty.edu/conservation/publications_resources/newsletters/16_3/dialogue.html.

Cameron, Fiona. 2007. "Beyond the Cult of Replicant – Museums and Historical Digital Objects: Traditional Concerns, New Discourses." In *Theorizing Digital Cultural Heritage. A Critical Discourse*, edited by

Fiona Cameron and Sarah Kenderdine, 49–75. Cambridge, MA: MIT Press.

Caple, Chris. 2000. *Conservation Skills: Judgement, Method and Decision Making*. London: Routledge.

Carr, David. 1978. "Practical Reasoning and Knowing How." *Journal of Human Movement Studies* 4 (1): 3–20.

Cherry, Deborah. 2002. "On the Move: My Bed, 1998 to 1999." In *The Art of Tracey Emin*, edited by Chris Townsend and Mandy Merck, 134–154. London: Thames and Hudson.

Clavir, Miriam. 1998. "The Social and Historic Construction of Professional Values in Conservation." *Studies in Conservation* 43 (1): 1–8.

Clavir, Miriam. 2002. *Preserving What is Valued: Museums, Conservation and First Nations*. Columbia: University of British Columbia Press.

Clifford, James. 1998. "On Collecting Art and Culture." In *The Visual Culture Reader*, edited by Nicholas Mirzoeff, 94–107. London: Routledge.

Conti, Alessandro. 2007. *History of the Restoration and Conservation of Works of Art*. Translated by Helen Glanville. Oxford: Butterworth-Heinemann. First published 1973 by Electa.

Cosgrove, Dennis. E. 1994. "Should We Take It All So Seriously? Culture, Conservation, and Meaning in the Contemporary World." In *Durability and Change. The Science, Responsibility, and Cost of Sustaining Cultural Heritage*, edited by Wolfgang E. Krumbein, Peter Brimblecombe, Dennis E. Cosgrove, and Sarah Staniforth, 259–265. London: John Wiley and Sons.

Crimp, Douglas. 1993. "Redefining Site Specificity." In *On the Museum's Ruins*, edited by Douglas Crimp and Louise Lawler, 150–186. Cambridge, MA: MIT Press.

Davenport, Kimberly. 1995. "Impossible Liberties: Contemporary Artists on the Life of Their Work over Time." *Art Journal* 52 (2): 40–52.

Davies, Hugh. M. 1997. "Introducing Installation. Legacy from Lascaux to Last Week." In *Blurring the Boundaries: Installation Art 1969–1996*, edited by Anne Farrell, 6–11. La Jolla: Museum of Contemporary Art San Diego.

Davies, Laura, and Jackie Heuman. 2004. "Meaning Matters: Collaborating with Contemporary Artists." In *Modern Art, New Museums: Contributions to the 2004 IIC Congress, Bilbao*, edited by Ashok Roy

and Perry Smith, 30–33. London: International Institute for Conservation (IIC).

Davies, Stephen. 2001. *Musical Works and Performances: A Philosophical Exploration.* Oxford: Oxford University Press.

Davies, Stephen. 2002. "Authenticity in Musical Performances." In *Arguing about Art: Contemporary Philosophical Debates,* edited by Alex Neill and Aaron Ridley, 57–68. London: Routledge.

De Oliveira, Nicolas, Nicola Oxley, and Michael Petry. 2003. *Installation Art in the New Millennium: The Empire of the Senses.* London: Thames and Hudson.

Denslagen, Wim. 2004. *Romantisch Modernisme. Nostalgie in de Monumentenzorg.* Amsterdam: Uitgeverij SUN.

Depocas, Alain, Jon Ippolito, and Caitlin Jones, eds. 2003. *Permanence Through Change: The Variable Media Approach.* New York: Solomon R. Guggenheim Museum and the Daniel Langlois Foundation for Art, Science, and Technology.

Derycke, Lucas. 2002. "The Archaeology of the Fluid." *Janus* 11 (Summer): 24–28.

Dietz, Steve. 2003. "Interfacing the Digital." Conference paper presented at the Museum and the Web, Charlotte, North Carolina, USA, March 19–22. www.archimuse.com/mw2003/papers/dietz/dietz.html.

Doorman, Maarten. 2004. *De Romantische Orde.* Amsterdam: Bert Bakker.

Dumit, Joseph. 2004. *Picturing Personality.* Princeton: Princeton University Press.

Duncan, Carol. 1995. *Civilizing Rituals: Inside Public Art Museums.* London: Routledge.

Dutton, Denis. 2003. "Authenticity in Art." In *The Oxford Handbook of Aesthetics*, edited by Jerrold Levinson, 258–274. Oxford: Oxford University Press.

Dykstra, Steven. W. 1996. "The Artist's Intention and the Intentional Fallacy in Fine Arts Conservation." *Journal of the American Institute for Conservation* 35 (3): 197–218.

Ex, Nicole. 1993. *Zo Goed als Oud: De Achterkant van het Restaureren.* Amsterdam: Amber.

Fiske, Tina. 2006. "Authenticities and the Contemporary Artwork, or Between Stone and Water." *VDR Beiträge zur Erhaltung von Kunst- und Kulturgut* 2: 34–39.

Foster, Hal. 2004. "An Archival Impulse." *October* 110 (Fall): 3–22.

Fyfe, Gordon. 2004. "Reproduction, Cultural Capital and Museums: Aspects of the Culture of Copies." *Museum and Society* 2 (1): 47–67.

Gantzert-Castrillo, Erich. 1999. "The Frankfurt Museum für Moderne Kunst and a Private Archiv: Registration Systems for Contemporary Art." In *Modern Art: Who Cares?*, edited by IJsbrand Hummelen and Dionne Sillé, 284–289. Amsterdam: Foundation for the Conservation of Modern Art/Netherlands Institute for Cultural Heritage.

Gantzert-Castrillo, Erich. 1996. *Archiv für Technik und Arbeitsmaterialen zeitgenössischer Künstler.* Stuttgart: Ferdinand Enke Verlag. Originally published in 1979 by Harlekin Art.

Geertz, Clifford. 1993. *The Interpretation of Cultures.* London: Fontana Press. First published in 1973 by Basic Books.

Gettens, Rutherford J., and George L. Stout. 1942. *Painting Materials: A Short Encyclopaedia.* New York: D. Van Nostrand Co.

Gielen, Pascal. 2003. *Kunst in Netwerken: Artistieke Selecties in de Hedendaagse Dans en de Beeldende Kunst.* Tielt: Lannoo Campus.

Grau, Oliver, ed. 2006. *MediaArtHistories.* Cambridge, MA: The MIT Press.

Groys, Boris. 1996. "The Restoration of Destruction." *Witte de With Cahier* 4 (March): 155–160.

Grunenberg, Christoph. 1999. "The Modern Art Museum." In *Contemporary Cultures of Display,* edited by Emma Barker, 26–60. New Haven: Yale University Press.

Hammersley, Martyn, and Paul Atkinson, 1995. *Ethnography: Principles in Practice.* London: Routledge.

Handler, Richard, and Eric Gable. 1997. *The New History in an Old Museum: Creating the Past at Colonial Williamsburg.* Durham and London: Duke University Press.

Hanhardt, John G. 1999. "The Media Arts and the Museum: Reflections on a History, 1963–1973." In *Mortality/Immortality? The Legacy of 20th-Century Art,* edited by Miguel Corzo, 95–100. Los Angeles: The Getty Conservation Institute.

Hanhardt, John G. 2003. "*Nam June Paik, TV Garden:* 'Preserving the Immaterial' – Excerpts." In *Permanence Through Change: The Variable Media Approach,* edited by Alain Depocas, Jon Ippolito, and Caitlin Jones, 70–77. New York: The Solomon R. Guggenheim Foundation/

Montreal: The Daniel Langlois Foundation for Art, Science, and Technology.

Hirschauer, Stefan. 1994. "Towards a Methodology of Investigations into the Strangeness of One's Own Culture: A Response to Collins." *Social Studies in Science* 24 (2): 335–346.

Hoogsteyns, Maartje. 2008. *Artefact Mens. Een Interdisciplinair Onderzoek naar het Debat over Materialiteit binnen de Material Culture Studies.* Alphen aan de Maas: Veerhuis.

Hooper-Greenhill, Eilean. 1992. *Museums and the Shaping of Knowledge.* London: Routledge.

Horowitz, Noah. 2006. "Collecting with Light Luggage: A Conversation with Hans Ulrich Obrist." *Immediations: The Research Journal of the Courtauld Institute of Art* 1 (3): 79–99.

Horowitz, Noah. 2010. *Art of the Deal: Contemporary Art in a Global Financial Market.* Princeton: Princeton University Press.

Hummelen, IJsbrand. 1996. "Concept or Fetish: The Theoretical Decision Process in the Conservation of Modern Art." In *The Conservation of Modern Art Project*, edited by Dionne Sillé, 41–45. Amsterdam: Stichting Behoud Moderne Kunst.

Hummelen, IJsbrand. 1997. "Een Halve Eeuw Restauratie-Ethiek." In *Roerend Erfgoed: Ruim een Halve Eeuw Rijkszorg voor Collecties*, edited by Joost Willink, 125–144. Leiden: Primavera Pers/Amsterdam: Instituut Collectie Nederland.

Hummelen, IJsbrand, and Tatja Scholte. 2012. "Collecting and Archiving Information from Living Artists for the Conservation of Contemporary Art." In *Conservation of Easel Paintings: Principles and Practice*, edited by Joyce Hill Stoner and Rebecca Rushfield. London: Routledge.

Hummelen, IJsbrand, and Tatja Scholte. 2004. "Sharing Knowledge for the Conservation of Contemporary Art: Changing Roles in a Museum without Walls?" In *Modern Art, New Museums: Contributions to the 2004 IIC Congress, Bilbao*, edited by Ashok Roy and Perry Smith, 208–212. London: International Institute for Conservation (IIC).

Hummelen, IJsbrand, and Tatja Scholte. 2006. "Capturing the Ephemeral and Unfinished: Archiving and Documentation as Conservation Strategies of Transient (or Transfinit) Contemporary Art." *Technè* 24: 5–11.

Huyghe, Pierre, and Philippe Parreno, eds. 2003. *No Ghost Just a Shell: Un Film d'imaginaire*. Eindhoven: Van Abbemuseum.

Huys, Frederika. 2000. "A Methodology for the Communication with Artists." International Network for the Conservation of Contemporary Art. www.incca.org/files/pdf/resources/a_methodology_for_the_communication_with_artists.pdf.

Ippolito, Jon. 2008. "Death by Wall Label." In *New Media in the White Cube and Beyond: Curatorial Models for Digital Art*, edited by Christiane Paul, 106–130. Berkeley: University of California Press.

Irvin, Sherri. 2005a. "Appropriation and Authorship in Contemporary Art." *The British Journal of Aesthetics* 45: 123–137.

Irvin, Sherri. 2005b. "The Artist's Sanction in Contemporary Art." *The Journal of Aesthetics and Art Criticism* 4 (63): 315–326.

Irvin, Sherri. 2006. "Museums and the Shaping of Contemporary Artworks." *Museum Management and Curatorship* 21: 143–156.

Ito, Nobuo. 1995. "'Authenticity' Inherent in Cultural Heritage in Asia and Japan." In NARA *Conference on Authenticity in Relation to the World Heritage Convention*, edited by Knut E. Larsen, 35–45. Paris: ICOMOS.

Jaeschke, Richard L. 1996. "When Does History End?" In *Preprints of the Contributions to the Copenhagen Congress: Archeological Conservation and its Consequences*, edited by Ashok Roy and Perry Smith, 86–88. London: International Institute for Conservation of Historic and Artistic Works.

Janis, Katrin. 2005. *Restaurierungsethik im Kontext von Wissenschaft und Praxis*. Munich: Martin Meidenbauer Verlagsbuchhandlung.

Jiménez, Alfonso. 1998. "Partial Amendments to the Restoration Theory (II). Value and Values." *Loggia* 2 (5): 104–108.

Jokilehto, Jukka. 1995. "Authenticity: A General Framework for the Concept." In NARA *Conference on Authenticity in Relation to the World Heritage Convention*, edited by Knut E. Larsen, 17–36. Paris: ICOMOS.

Jokilehto, Jukka. 2006. "What about Brandi's Theory Today?" In *Theory and Practice in Conservation: A Tribute to Cesare Brandi: International Seminar*, edited by Delgado J. Rodrigues and Manuel J. Mimoso, 25–29. Lisbon: National Laboratory of Civil Engineering.

Jones, Caitlin, and Carol Stringari. 2008. "Seeing Double: Emulation in Theory and Practice." In *New Media in the White Cube and Beyond:*

Curatorial Models for Digital Art, edited by Christiane Paul, 220–231. Berkeley: University of California Press.

Jones, Caitlin. 2004. "My Art World is Bigger Than Your Art World." *The Believer* 3 (10): 3–13.

Jones, Caitlin. 2009. "The Evolution of Authenticity: Objects and Intent in the Art World." *Art Press* 2 (12): 47–50.

Katz, Stanley. 2006. Foreword to *Art from Start to Finish: Jazz, Painting, Writing, and Other Improvisations*, edited by Howard S. Becker, Robert R. Faulkner, and Barbara Kirshenblatt-Gimblett, ix-xi. Chicago: University of Chicago Press.

Keene, Suzanne. 2002. "Preserving Digital Materials: Confronting Tomorrow's Problems Today." *The Conservator* 26: 93–99.

Keller, Alexandra, and Ward Frazer. 2006. "Matthew Barney and the Paradox of the Neo-Avant-Garde Blockbuster." *Cinema Journal* 45 (2): 3–16.

Kivy, Peter. 1993. *The Fine Art of Repetition: Essays in the Philosophy of Music.* Cambridge: Cambridge University Press.

Kivy, Peter. 1995. *Authenticities: Philosophical Reflections on Musical Performance.* Ithaca: Cornell University Press.

Kraemer, Harold. 2007. "Art is Redeemed, Mystery is Gone: The Documentation of Contemporary Art." In *Theorizing Digital Cultural Heritage: A Critical Discourse*, edited by Fiona Cameron and Sarah Kenderdine. 193–222. Cambridge, MA: MIT Press.

Krens, Tom. 2004. Preface/Acknowledgments to *Nam June Paik Global Groove 2004*, by John G. Hanhardt and Caitlin Jones, 6–9. Berlin: Deutsche Guggenheim. Exhibition catalogue.

Kuhns, Richard. 1960. "Criticism and the Problem of Intention." *The Journal of Philosophy* 57 (1): 5–23.

Keijke, Ilse. 1994. "Passages. Een interview met Joëlle Tuerlinckx." *De Witte Raaf* 52 (Nov.-Dec.): 24–25. httpp://www.dewitteraaf.be/artikel/detail/nl/715.

Kwon, Miwon. 2000. "One Place after Another: Notes on Site Specificity." In *Space, Site, Intervention: Situating Installation Art*, edited by Erika Suderburg, 38–63. Minneapolis: University of Minnesota Press.

Kwon, Miwon. 2002. *One Place after Another: Site-Specific Art and Locational Identity.* Cambridge, MA: MIT Press.

Lacerte, Sylvie. 2007. "The DOCAM Project: A Nam June Paik Work as Case Study." With the collaboration of Emilie Boudrias. Paper

presented at the Nam June Paik Museum Symposium, Suwon City, Korea, October, 23. http://archives.docam.ca/fr/wp-content/uploads/12212_docam_njpm_epresentation_final_logo.pdf.

Latour, Bruno, and Adam Lowe. 2011. "The Migration of the Aura, or How to Explore the Original through Its Facsimiles." In *Switching Codes*, edited by Thomas Bartscherer, 275–297. Chicago: University of Chicago Press.

Latour, Bruno. 1987. *Science in Action: How to Follow Scientists and Engineers Through Society*. Cambridge, MA: Harvard University Press.

Latour, Bruno. 1999a. "On Recalling ANT." In *Actor Network Theory and After*, edited by John Law and John Hassard, 15–25. Oxford: Blackwell.

Latour, Bruno. 1999b. *Pandora's Hope: Essays on the Reality of Science*. London: Harvard University Press.

Latour, Bruno. 2005. *Reassembling the Social: An Introduction to Actor-Network-Theory*. Oxford: Oxford University Press.

Laurenson, Pip. 2001a. "Developing Strategies for the Conservation of Installations Incorporating Time-Based Media with Reference to Gary Hill's *Between Cinema and a Hard Place*." *Journal of the American Institute for Conservation* 40: 259–266.

Laurenson, Pip. 2001b. "'The Mortal Image': The Conservation of Video Installations." In *Material Matters: The Conservation of Modern Sculpture*, edited by Jackie Heuman, 109–115. London: Tate Publishing.

Laurenson, Pip. 2004. "The Management of Display Equipment in Time-Based Media Installation." In *Modern Art, New Museums: Contributions to the 2004 IIC Congress, Bilbao*, edited by Ashok Roy and Perry Smith, 49–53. London: International Institute for Conservation (IIC).

Laurenson, Pip. 2006. "Authenticity, Change and Loss in the Conservation of Time-Based Media Installations." *Tate Papers: Tate's Online Research Journal* 6. www.tate.org.uk/download/file/fid/7401.

Law, John, and Annemarie Mol, eds. 2002. *Complexities: Social Studies of Knowledge Practices*. Durham and London: Duke University Press.

Law, John, and John Hassard, eds. 1999. *Actor Network Theory and After*. Oxford: Blackwell.

Lawson, Colin, and Robin Stowell. 1999. *The Historical Performance of Music: An Introduction*. Cambridge: Cambridge University Press.

Learner, Tom. 2008. "The Object in Transition: A Cross-disciplinary Conference on the Preservation and Study of Modern and Contemporary Art." *CeROArt* [online] 2. http://ceroart.revues.org/425.

Livingston, Paisley. 2003. "Intention in Art." In *The Oxford Handbook of Aesthetics*, edited by Jerrold Levinson, 275–290. Oxford: Oxford University Press.

Lowenthal, David. 1981. *Our Past Before Us: Why Do We Save It?* Oxford: The Blackwell Press.

Lowenthal, David. 1985. *The Past is a Foreign Country*. Cambridge: Cambridge University Press.

Lowenthal, David. 1989. 'Art and Authenticity' In *World Art: Themes of Unity in Diversity*, vol. 3, edited by Irving Lavin, 843–847. London: Pennsylvania State University Press.

Lowenthal, David. 1994. "The Value of Age and Decay." In *Durability and Change: The Science, Responsibility, and Cost of Sustaining Cultural Heritage*, edited by Wolfgang E. Krumbein, Peter Brimblecombe, Dennis E. Cosgrove, and Sarah Staniforth, 39–50. London: John Wiley and Sons.

Lowenthal, David. 1995. "Changing Criteria of Authenticity." In *NARA Conference on Authenticity in Relation to the World Heritage Convention*, edited by Knut E. Larsen, 121–135. Paris: ICOMOS.

Lowenthal, David. 1999. "Authenticity: Rock of Faith or Quicksand Quagmire?" *Conservation: The Getty Center Institute Newsletter* 14 (3): 5–8.

Macdonald, Sharon. 2001. "Ethnography in the Science Museum, London." In *Inside Organizations: Anthropologists at Work*, edited by David N. Gellner and Eric Hirsch, 115–137. Oxford: Berg.

Macdonald, Sharon. 2002. *Behind the Scenes at the Science Museum*. Oxford: Berg.

Macedo, Rita. 2006. "The Artist, the Curator, the Restorer and Their Conflicts within the Context of Contemporary Art." In *Theory and Practice in Conservation: A Tribute to Cesare Brandi: International Seminar*, edited by Delgado J. Rodrigues and Manuel J. Mimoso, 393–398. Lisbon: National Laboratory of Civil Engineering.

MacNeil, Heather, and Bonnie Mak. 2007. "Construction of Authenticity." *Library Trends* 56 (1): 26–52.

Mancusi-Ungaro, Carol. 1999. "Original Intent: The Artist's Voice." In *Modern Art: Who Cares?*, edited by IJsbrand Hummelen and Dionne

Sillé, 392–393. Amsterdam: Foundation for the Conservation of Modern Art/Netherlands Institute for Cultural Heritage.

Marontate, Jan. 1997. "Modern Art: Who Cares?" *Boekmancahier* 9 (34): 407–419.

Marontate, Jan. 2006. "Trans-disciplinary Communication and the Field of Contemporary Art Conservation: Questions of Mission and Constraint." *Techné* 26: 11–18.

Mason, Christopher. 2005. "Ephemeral Art, Eternal Maintenance." *New York Times,* November 10. www.nytimes.com/2005/11/10/garden/10art.html?_r=1.

Mattheus, Lore, and Eva Wittocx. 2004. "La Flèche du Temps. Ensemble Autour de ~~MUR~~ van Joëlle Tuerlinckx." *kM* 49: 24.

McDonough, Tom. 2004. "No Ghost." *October* 110 (Fall): 107–130.

Mesman, Jessica. 2008. *Uncertainty in Medical Innovation: Experienced Pioneers in Neonatal Care.* Hampshire: Palgrave Macmillan.

Mink, Anne. 2007. "No Ghost Just a Shell: Inhoud, context en praktijk." MA thesis, Radboud Universiteit, Nijmegen.

Mol, Annemarie. 2002. *The Body Multiple: Ontology in Medical Practice.* Durham: Duke University Press.

Molina, Tiamat, and Marie Pincemin. 1994. "Restoration: Acceptable to Whom?" In *Restoration – Is It Acceptable?*, edited by William A. Oddy, 77–83. London: British Museum Press.

Mondloch, Kate. 2005. "Thinking through the Screen: Media Installation, Its Spectator, and the Screen." PhD diss., University of California. ProQuest {AAT 3190474}.

Muñoz Viñas, Salvador. 2005. *Contemporary Theory of Conservation.* Oxford: Butterworth-Heinemann.

Nobel, Phillip. 2003. "Annlee: Sign of the Times." *Artforum* 41 (5): 104–109.

Novak, Anja M. 2009. "The Site of Installation Art: Hovering between Inner and Outer Places." In *Take Place, Photography in Multimedia Art and the Concept of Place,* edited by Helen Westgeest, 133–163. Amsterdam: Valiz.

Novak, Anja M. 2010. "Ruimte voor Ervaring. Installatiekunst en Toeschouwerschap." PhD diss., Leiden University. http://hdl.handle.net/1887/15659.

Obrist, Hans U. 2003. "How Annlee Changed Its Spots." In *No Ghost Just a Shell: Un Film d'imaginaire*, edited by Pierre Huyghe and Philippe Parreno, 254–263. Eindhoven: Van Abbemuseum.

Onorato, Ronald. J. 1997. "Blurring the Boundaries." In *Blurring the Boundaries: Installation Art, 1969–1996*, edited by Anne Farrell, 13–29. La Jolla: Museum of Contemporary Art San Diego.

Otterbeck, Bärbel, and Christian Scheidemann, eds. 1995. *Wie haltbar ist Videokunst?/How Durable is Video Art?* Wolfsburg: Kunstmuseum Wolfsburg.

Paul, Christiane, ed. 2008. *New Media in the White Cube and Beyond: Curatorial Models for Digital Art.* Berkeley: University of California Press.

Paul, Christiane. 2006. "The Myth of Immateriality: Presenting and Preserving New Media." In *MediaArtHistories,* edited by Oliver Grau, 251–274. Cambridge, MA: MIT Press.

Pearce, Susan. M, ed. 1989. *Museum Studies in Material Culture.* Leicester: Leicester University Press.

Pearce, Susan. M. 1992. *Museums, Objects and Collections: A Cultural Study.* Leicester: Leicester University Press.

Peters, Peter. 2003. *De Haast van Albertine. Reizen in de Technologische Cultuur: Naar een Theorie van Passages.* Amsterdam: De Balie.

Peters, Peter. 2009. "Retracing Old Organ Sound: Authenticity and the Structure of Artistic Arguments." *Krisis: Journal for Contemporary Philosophy* 1: 5–19. www.krisis.eu/content/2009–1/2009–1–02–peters.pdf.

Philippot, Paul. 1996. "Restoration from the Perspective of the Humanities." In *Historical and Philosophical Issues in the Conservation of Cultural Heritage*, edited by Nicholas Price, Mansfield Kirby Talley, and Alessandra M. Vaccaro, 216–229. Malibu: J. Paul Getty Trust. Originally published in 1983 by Österreichische Zeitschrift für Kunst und Denkmalpflege.

Phillips, David. 1997. *Exhibiting Authenticity.* Manchester: Manchester University Press.

Phillips, Joanna. 2007. "Reconstructing the Forgotten: An Exhibition of 1970s and 1980s Video Installation, Re-staged with Authentic Technology." *Tate Papers: Tate's Online Research Journal* 8. www.tate.org.uk/download/file/fid/7376.

Pingen, René. 2005. *Dat Museum is een Mijnheer. De Geschiedenis van het Van Abbemuseum 1936–2003.* Amsterdam: Artimo/Eindhoven: Van Abbemuseum.

Preziosi, Donald, and Claire Farago, eds. 2004. *Grasping the World: The Idea of the Museum.* Burlington: Ashgate.

Price, Nicholas, Mansfield Kirby Talley, and Alessandra M. Vaccaro, eds. 1996. *Historical and Philosophical Issues in the Conservation of Cultural Heritage.* Malibu: J. Paul Getty Trust.

Pugliese, Marina, Barbara Ferriani, and Antonio Rava. 2008. "Time, Originality and Materiality in Contemporary Art Conservation: The Theory of Restoration by Cesare Brandi, Between Tradition and Innovation." In *Preprints ICOM Committee for Conservation, 15th Triennial Conference New Delhi, 22–26 September 2008,* edited by Janet Bridgland, 475–479. New Delhi: Allied Publishers.

Pültau Dirk. 2000. "Restauratie als Uitvoering." *De Witte Raaf* 85 (May-June): 1–2. www.dewitteraaf.be/artikel/detail/nl/2118.

Real, William A. 2001. "Toward Guidelines for Practice in the Preservation and Documentation of Technology-based Installation Art." *Journal of the American Institute for Conservation* 40 (3): 211–231.

Rebentisch, Juliane. 2003. *Aesthetic der Installation.* Frankfurt am Main: Suhrkamp Verlag.

Reiss, Julie H. 1999. *From Margin to Center: The Spaces of Installation Art.* Cambridge, MA: MIT Press.

Riegl, Alois. 1996. "The Modern Cult of Monuments: Its Essence and Its Development." In *Historical and Philosophical Issues in the Conservation of Cultural Heritage,* edited by Nicholas Price, Mansfield Kirby Talley, and Alessandra M. Vaccaro, 69–83. Malibu: J. Paul Getty Trust. Originally published in 1903 by W. Braumuller.

Rinehart, Richard. 2000. "The Straw That Broke the Museum's Back? Collecting and Preserving Digital Media Art Works for the Next Century." *Switch: New Media Journal* 14 (June). http://switch.sjsu.edu/nextswitch/switch_engine/front/front.php?artc=233.

Rinehart, Richard. 2007. "The Media Art Notation System: Documenting and Preserving Digital/Media Art." *Leonardo* 40 (2): 181–187.

Rose, Gillian. 2001. *Visual Methodologies: An Introduction to the Interpretation of Visual Materials.* London: Sage.

Rosenthal, Mark. 2003. *Understanding Installation Art: From Duchamp to Holzer.* Munich: Prestel Verlag.

Ross, Max. 2004. "Interpreting the New Museology." *Museum and Society* 2 (2): 84–103.

Ruskin, John. 1989. *The Seven Lamps of Architecture*. Mineola: Dover Publications. Originally published in 1849.

Ryle, Gilbert. 1949. *The Concept of Mind*. London: Hutchinson.

Saaze, Vivian van, and Gaby Wijers. 2003. "'Reanimaties'. Onderzoek naar de Presentatie en Registratie van Vier Media-Installaties." *kM* 46: 18–20.

Saaze, Vivian van. 2009. "From Intention to Interaction: Reframing the Artist's Interview in Conservation Research." In *Art Today – Cultural Property Tomorrow: The Conservation and Restoration of Contemporary Artworks*, edited by Marcel Stefanaggi and Regine Hocquette, 20–28. Paris: SFIIC/Institut National du Patrimoine. Conference Proceedings.

Schatzki, Theodore R., Karin Knorr Cetina, and Eike von Savigny, eds. 2001. *The Practice Turn in Contemporary Theory*. London: Routledge.

Scheidemann, Christian. 1999. "Men at Work: The Significance of the Material in the Collaboration Between Artist and Fabricator in the 1960s and 1970s." In *Modern Art: Who Cares?*, edited by IJsbrand Hummelen and Dionne Sillé, 242–246. Amsterdam: Foundation for the Conservation of Modern Art/Netherlands Institute for Cultural Heritage.

Scheidemann, Christian. 2005. "Material as Language in Contemporary Art." In *The Lure of the Object*, edited by Stephen W. Melville. 75–85. Williamstown: Sterling and Francine Clark Institute. Distributed by Yale University Press.

Schinzel, Hiltrud. 2004. *Touching Vision: Essays on Restoration Theory and the Perception of Art*. Ghent: University of Ghent/Brussels: VUB Brussels University Press.

Schinzel, Hiltrud. 2006. "Contemporary Art and Conservation Theory." *The International Council of Museums Committee for Conservation Newsletter* 12 (April): 17–23.

Scholte, Tatja, and Glenn Wharton, eds. 2011. *Inside Installations: Theory and Practice of Installation Art*. Amsterdam: Amsterdam University Press.

Scholte, Tatja, and Paulien 't Hoen, eds. 2007. *Inside Installations: Preservation and Presentation of Installation Art*. Amsterdam: Netherlands Institute for Cultural Heritage/Foundation for the Conservation of Contemporary Art.

Schubiger, Irene, ed. 2009. *Reconstructing Swiss Video Art from the 1970s and 1980s.* Zurich: JRP|Ringier.

Searle, Adrian. 2003. "Is This the Best Gallery in Europe?" *The Guardian*, January 28. www.guardian.co.uk/culture/2003/jan/28/artsfeatures.

Sease, Catherina. 1998. "Codes of Ethics for Conservation." *International Journal of Cultural Property* 7 (1): 98–114.

Selz, Peter. 1996. "Installations, Environments, and Sites: Introduction." In *Theories and Documents of Contemporary Art: A Sourcebook of Artists' Writings*, edited by Kristine Stiles and Peter Selz, 499–508. Berkeley: University of California Press.

Shanken, Edward A. 2009. *Art and Electronic Media.* London: Phaidon Press.

Staniforth, Sarah. 2000. "Conservation: Significance, Relevance and Sustainability." *IIC Bulletin* 6: 3–8.

Stigter, Sanneke. 2004. "Living Artist, Living Artwork? The Problem of Faded Colour Photographs in the Work of Ger van Elk." In *Modern Art, New Museums: Contributions to the 2004 IIC Congress, Bilbao*, edited by Ashok Roy and Perry Smith, 105–108. London: International Institute for Conservation (IIC).

Stoner, Joyce H. 1984. "A Data File on Artists' Techniques Cogent to Conservators." In ICOM 7th Triennial Meeting, Copenhagen, 10–14 September. Preprints, 84.4.7–84.4.8. Paris: The International Council of Museums.

Stoner, Joyce H. 1985. "Ascertaining the Artist's Intent through Discussion, Documentation and Careful Observation." *The International Journal of Museum Management and Curatorship* 4: 87–92.

Stoner, Joyce H. 2005. "Changing Approaches in Art Conservation: 1925 to the Present." In *(Sackler NAS Colloquium) Scientific Examination of Art: Modern Techniques in Conservation and Analysis*, edited by National Research Council, 40–52. Washington, DC: National Academic Press.

Stringari, Carol. 1999. "Installations and Problems of Preservation." In *Modern Art: Who Cares?*, edited by IJsbrand Hummelen and Dionne Sillé, 272–281. Amsterdam: Foundation for the Conservation of Modern Art/Netherlands Institute for Cultural Heritage.

Sturman, Shelley. 1999. "Necessary Dialogue: The Artist as Partner in Conservation." In *Modern Art: Who Cares?*, edited by IJsbrand Hummelen and Dionne Sillé, 393–395. Amsterdam: Foundation for the

Conservation of Modern Art/Netherlands Institute for Cultural Heritage.

Suderburg, Erika, ed. 2000. *Space, Site, Intervention: Situating Installation Art.* Minneapolis: University of Minnesota Press.

Tabasso, Marisa, L. 2006. "The Contribution of the Scientific Disciplines to the Development of Conservation Science: A Short Overview, with Special Reference to the EC Situation." In *Theory and Practice in Conservation: A Tribute to Cesare Brandi: International Seminar*, edited by Delgado J. Rodrigues and Manuel J. Mimoso, 31–40. Lisbon: National Laboratory of Civil Engineering.

Taruskin, Richard. 1995. "The Pastness of the Presence and the Presence of the Past." In *Text and Act: Essays on Music and Performance,* 90–154. Oxford: Oxford University Press.

Terrier, Maryline. 2006. "The Conservation of a Work that 'Never Stops Starting': Or How to Create an Installation Guide for Joëlle Tuerlinckx's *un ensemble autour de* MUR 1998." www.inside-installations. org/OCMT/mydocs/the_conservation_of_a_work.pdf.

Theys, Hans. 1999. "Een Rimpel in de Tijd." 7 Februari-21 Maart 1999. Communique de Presse Exposition Dhont-Dhaenens. Museum Dhondt-Dhaenens Stichting van Openbaar nut.

Thompson, Don. 2008. *The $12 Million Stuffed Shark: The Curious Economics of Contemporary Art and Auction Houses.* London: Aurum Press Ltd.

Thornton, Sarah. 2008. *Seven Days in the Art World.* London: Granta Publications.

Tuerlinckx, Joëlle. 1999. *this book,* LIKE A BOOK. Ghent: Snoeck-Ducaju & Zoon.

Vaccaro, Alessandra M. 1996. "The Idea of Patina: Introduction to Part VII." In *Historical and Philosophical Issues in the Conservation of Cultural Heritage*, edited by Nicholas Price, Mansfield Kirby Talley, and Alessandra M. Vaccaro, 366–371. Malibu: J. Paul Getty Trust.

Vall, Renée van de, Deborah Cherry, IJsbrand Hummelen, Tatja Scholte, and Vivian van Saaze. 2008. "New Strategies in the Conservation of Contemporary Art." NWO research proposal, Research Group UM – UvA – ICN. www.newstrategiesinconservation.nl/files/New_Strategies_in_Conservation_-_NWO_Application.pdf.

Vall, Renée van de. 1994. *Een Subliem Gevoel van Plaats. Een Filosofische Interpretatie van het Werk van Barnett Newman.* Groningen: Historische Uitgeverij.

Vall, Renée van de. 1999. "Painful Decisions: Philosophical Considerations on a Decision-Making Model." In *Modern Art: Who Cares?*, edited by IJsbrand Hummelen and Dionne Sillé, 196–200. Amsterdam: Foundation for the Conservation of Modern Art/Netherlands Institute for Cultural Heritage.

Vall, Renée van de. 2009. "Towards a Theory and Ethics for the Conservation of Contemporary Art." In *Art Today – Cultural Property Tomorrow: The Conservation and Restoration of Contemporary Artworks*, edited by Marcel Stefanaggi and Regine Hocquette, 51–56. Paris: SFIIC/Institut National du Patrimoine. Conference Proceedings.

Van Abbemuseum. 2005. Museum brochure.

Van Audenaeren, Kristel. 2005. "Het Kunstenaarsproject *No Ghost Just a Shell: Un Film d'Imaginaire.* Van Netwerkvorming tot Tentoonstelling." MA thesis, Universiteit Gent. www.inside-installations.org/ocmt/mydocs.

Vande Veire, Frank. 1996. "Something about How a Tuerlinckx Machine Traverses the Exhibition Machine." In *Inside the Visible: An Elliptical Traverse of 20th Century Art in, of, and From the Feminine*, edited by Catherine de Zegher, 451-455. Cambridge, MA: MIT Press.

Vande Veire, Frank. 1997. *De Geplooide Voorstelling: Essays Over Kunst.* Brussel: Yves Gevart.

Velthuis, Olav. 2003. "Symbolic Meanings of Prices: Constructing the Value of Contemporary Art in Amsterdam and New York Galleries." *Theory & Society* 31: 181–215.

Velthuis, Olav. 2005. *Talking Prices: Symbolic Meanings of Prices on the Market for Contemporary Art.* Princeton: Princeton University Press.

Vergo, Peter, ed. 1989. *The New Museology.* London: Reaktion Books.

Versteegh, Matthijs. 2006. "Paint in Action: The Emergence of Facts in Art Research." BA thesis, Maastricht University.

Verwoert, Jan. 2003. "Copyright, Ghosts and Commodity Fetishism." In *No Ghost Just a Shell,* edited by Pierre Huyghe and Philippe Parreno, 184–192. Cologne: Buchhandlung Walther Konig.

Villers, Caroline. 2004. "Post Minimal Intervention." *The Conservator* 28: 3–10.

Viola, Bill. 1999. "Permanent Impermanence." In *Mortality/Immortality? The Legacy of 20th-Century Art,* edited by Miguel Corzo, 85–95. Los Angeles: The Getty Conservation Institute.

Walsh, David (1998). "Doing Ethnography." In *Researching Society and Culture,* edited by Clive Seale, 217–232. London: Sage.

Wegen, Derk H. van. 1999. "Between Fetish and Score: The Position of the Curator of Contemporary Art." In *Modern Art: Who Cares?,* edited by IJsbrand Hummelen and Dionne Sillé, 201–209. Amsterdam: Foundation for the Conservation of Modern Art/Netherlands Institute for Cultural Heritage.

Weidner, Tina. 2004. "Videoinstallationen – und deren Veränderlichkeit?" Diplomarbeit. MA thesis, Technische Universität München.

Weil, Benjamin. 1992. "Remarks on Installations and Changes in Time Dimensions." *Flash Art* (Jan.-Feb.): 104–109.

Wesseling, Janneke. 2003. "Overzicht videokunst lijdt onder chaotische presentatie." NRC *Handelsblad,* January 23.

Wetering, Ernst van de. 1996. "The Autonomy of Restoration: Ethical Considerations in Relation to Artistic Concepts." In *Historical and Philosophical Issues in the Conservation of Cultural Heritage*, edited by Nicholas Price, Mansfield Kirby Talley, and Alessandra M. Vaccaro, 193–199. Malibu: J. Paul Getty Trust. Originally published in 1989 by The Pennsylvania State University Press.

Weyer Cornelia. 2006. "Restoration Theory Applied to Installation Art." *Beiträge zur Erhaltung von Kunst un Kulturgut, Verband der Restauratoren* 2: 40–48.

Weyer, Cornelia, and Gunnar Heydenreich. 1996. "From Questionnaires to a Checklist for Dialogues." In *Modern Art: Who Cares?*, edited by IJsbrand Hummelen and Dionne Sillé, 385–388. Amsterdam: Foundation for the Conservation of Modern Art/Netherlands Institute for Cultural Heritage.

Wharton, Glenn. 2005. "The Challenges of Conserving Contemporary Art." In *Collecting the New: Museums and Contemporary Art*, edited by Bruce Altshuler, 163–178. Princeton: Princeton University Press.

Wharton, Glenn, and Harvey Molotch. 2009. "The Challenge of Installation Art." In *Conservation: Principles, Dilemmas and Uncomfortable Truths,* edited by Alison Richmond and Alison Bracker, 210–222. Burlington: Butterworth-Heinemann.

Wharton, Glenn. 2011. *The Painted King: Art, Activism, and Authenticity in Hawaii.* Hawaii: University of Hawai'i Press.

Willink, Joost, ed. 1997. *Roerend Erfgoed: Ruim een Halve Eeuw Rijkszorg voor Collecties.* Leiden: Primavera Pers/Amsterdam: Instituut Collectie Nederland.

Wimsatt, William K., and Monroe Beardsley. 1998. "The Intentional Fallacy." In *The Critical Tradition: Classic Texts and Contemporary Trends,* edited by David H. Richter, 748–756. Boston: Bedford. Originally published in 1946.

Winkel, Camiel van. 2007. *De Mythe van het Kunstenaarschap.* Amsterdam: Fonds voor Beeldende Kunst en Vormgeving.

World Heritage Committee. 1994. "Nara Document on Authenticity." *Convention Concerning the Protection of the World Cultural and Natural Heritage. Eighteenth Session, Phuket, Thailand, 12–17 December 1994.* http://whc.unesco.org/archive/nara94.htm.

Yaneva, Albena. 2003a. "Chalk Steps on the Museum Floor: The 'Pulses' of Objects in an Art Installation." *Journal of Material Culture* 8 (2): 169–188.

Yaneva, Albena. 2003b. "When a Bus Met a Museum: Following Artists, Curators and Workers in Art Installation." *Museum and Society* 1 (3): 116–131.

Interviews

Between 2004 and April 2009 I conducted around thirty-five semi-structured interviews with museum professionals and others involved in the care of contemporary artworks. Acknowledging that collecting and conservation are processes, key informants were interviewed several times over the course of my research. Unless stated otherwise, the job descriptions and affiliations mentioned below correspond to the positions held at the time of the interview. Apart from formal, semi-structured, audio-recorded interviews, the research is informed by many conversations with conservators, curators, artists, conservation researchers, registrators and others involved with the conservation of contemporary artworks. These more informal and ad hoc conversations are not included in the overview.

Arts, Ben. Technical staff, Van Abbemuseum, Eindhoven, The Netherlands. Eindhoven: November 2, 2006.

Baltussen, Louis. Head of conservation/storage manager, Van Abbemuseum, Eindhoven, The Netherlands. Eindhoven: November 2, 2006.

Bee, Andreas. Curator and vice director, Museum für Moderne Kunst, Frankfurt, Germany. Frankfurt: May 10, 2007.

Beerkens, Lydia. Conservator contemporary art in private practice, The Netherlands. Wijchen: May 27, 2005.

Berndes, Christiane. Curator of collection, Van Abbemuseum, Eindhoven, The Netherlands. Eindhoven: October 21, 2005 and March 27, 2007.

Bosch, Paula van den. Curator contemporary art, Bonnefantenmuseum, Maastricht, The Netherlands. Maastricht: December 19, 2003*; April 23, 2004.

Bossche, Phillip Van den. Curator of exhibitions, Van Abbemuseum, Eindhoven, The Netherlands. Eindhoven: January 13, 2005; March 17, 2007.*

De Buck, Anne. Conservation researcher, Stedelijk Museum Actuele Kunst, Ghent, Belgium. Ghent: March 18, 2004.*

Esche, Charles. Artistic Director, Van Abbemuseum, Eindhoven, The Netherlands. Eindhoven: March 27, 2007.

Glaser, Uwe. Storage Manager, Museum für Moderne Kunst, Frankfurt, Germany. Frankfurt: November 8, 2006.

Grevenstein, Alexander van. Artistic Director, Bonnefantenmuseum, Maastricht, The Netherlands. Maastricht: August 13, 2008.

Gruenning, Sylvia. Museum guard, Museum für Moderne Kunst, Frankfurt, Germany. Frankfurt (phone): May 5, 2007.*

Hoogeveen, Gert. Audiovisuals Department, Stedelijk Museum, Amsterdam, The Netherlands. Amsterdam: November 19, 2008.

Hummelen, IJsbrand. Conservator and Senior researcher, Cultural Heritage Agency of the Netherlands, Amsterdam, The Netherlands. Amsterdam: January 15, 2009.

Huys, Frederika. Conservator and Head of conservation department, Stedelijk Museum Actuele Kunst, Ghent, Belgium. Ghent: March 18, 2004.*

Ippolito, Jon. Former assistant-curator of film and media art, Solomon R. Guggenheim Museum, New York, NY, USA. Brussels: May 18, 2007.

Janik, Andreas. Technical support and facilities, Museum für Moderne Kunst, Frankfurt, Germany. Frankfurt: November 7, 2006.

Jones, Caitlin. Former Research fellow Guggenheim Museum, New York, NY, USA and Assistant Curator Global Groove 2004 Guggenheim Berlin. Utrecht: April 18, 2009.*

Kinoshita, Suchan. Artist, Maastricht, The Netherlands, Maastricht: February 3, 2006; April 20, 2006 (phone).*

Kittelmann, Udo. Director, Museum für Moderne Kunst, Frankfurt, Germany. Frankfurt: May 10, 2007.

Kleijn, Ineke. Coordinator contemporary art, Bonnefantenmuseum, Maastricht, The Netherlands. Maastricht: January 9, 2003 (phone)*; December 14, 2006*; June 19, 2008*; July 10, 2008; July 16, 2008.

Kramer, Mario. Curator of collections, Museum für Moderne Kunst, Frankfurt, Germany. Frankfurt: November 6, 2006.

Lang, Ulrich. Restorer, Museum für Moderne Kunst, Frankfurt, Germany. Madrid: June 3, 2005*; November 6, 2006; May 9, 2007.

Mattheus, Lore. Assistant Stella Lohaus Gallery, Antwerp, Belgium. Maastricht: May, 2004.

Mobark, Hussein. Janitor and coordinator security and guards, Museum für Moderne Kunst, Frankfurt Germany. Frankfurt: November 8, 2006.

Olamai, Susan. Conservator, assistant Ulrich Lang, Museum für Moderne Kunst, Frankfurt, Germany. November 6, 2006.*

Paesmans, Dirk. Artist and former student of Nam June Paik. Brussels: May 18, 2007.

Raymakers, Marina. Anthropologist and Head of Communication, Cultural Heritage Agency of the Netherlands, Amsterdam: October 8, 2007.

Reiss, Bernd. Registrar, Museum für Moderne Kunst, Frankfurt, Germany. Frankfurt: November 6, 2006.

Saueracker, Jochen. Artist and assistant Nam June Paik, Düsseldorf, Germany. Düsseldorf: December 12, 2008.

Terrier, Maryline. Conservator and assistant Joëlle Tuerlinckx, Ghent: August 31, 2005*; December 13, 2005.*

Wajun, Theo. Head of technical services, Van Abbemuseum, Eindhoven, The Netherlands. Eindhoven: October 17, 2006.

Wiel, Margo van de. Registrator of collection, Van Abbemuseum, Eindhoven, The Netherlands. Eindhoven: October 17, 2006; May 15, 2007*; March 21, 2007.*

* no audio recording available

Index

CONCEPTS/TOPICS

CONFERENCES/RESEARCH PROJECTS

XTTHX 1310 UCHI

122441

Arcaua

39.95

Feb 13, 2014

9 789089 644596